A Guide to America's World Heritage Sites

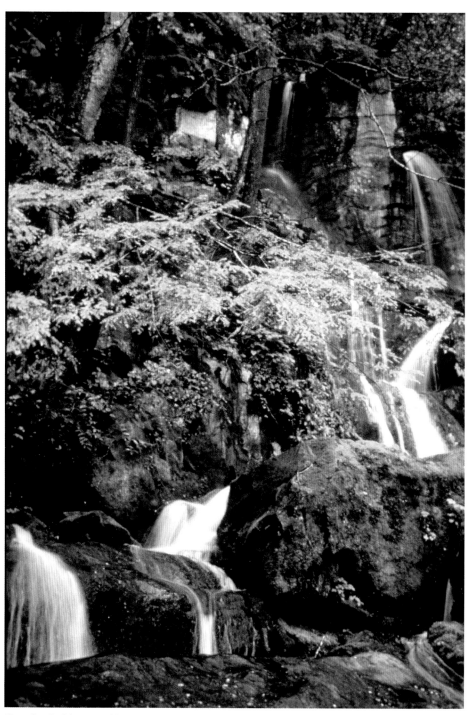

Great Smoky Mountains National Park is widely known for its outstanding collection of waterfalls.

A Guide to America's World Heritage Sites

THE HERITAGE OF HUMANITY

ROBERT E. MANNING

Globe
Pequot
Essex, Connecticut

Globe Pequot

An imprint of The Globe Pequot Publishing Group, Inc.
64 South Main Street
Essex, CT 06426
www.globepequot.com

Distributed by NATIONAL BOOK NETWORK

Front cover photos: Top left: Statue of Liberty; top right: Taos Pueblo; bottom left: Grand Canyon National Park; bottom right: Papahānaumokuākea

Back cover photos: Top left: La Fortaleza and San Juan National Historic Site in Puerto Rico; middle: Hawai'i Volcanoes National Park; right: Yellowstone National Park

Page v: La Fortaleza and San Juan National Historic Site in Puerto Rico, Waterton-Glacier International Peace Park, Independence Hall, Kluane/Wrangell–St. Elias/Glacier Bay/Tatshenshini-Alsek

Page vi: La Fortaleza and San Juan National Historic Site in Puerto Rico, Monticello and the University of Virginia in Charlottesville, Mesa Verde National Park, Yellowstone National Park

British Library Cataloguing in Publication Information available

Library of Congress Cataloging-in-Publication Data

Names: Manning, Robert E., 1946– author.
Title: A guide to America's world heritage sites : the heritage of humanity
 / Robert E. Manning.
Other titles: Heritage of humanity
Description: Essex, CT : Globe Pequot, [2024] | Includes index. | Summary:
 "A guide to the twenty-five World Heritage Sites scattered across the
 United States, including why they are so important, the visitor
 attractions they feature, and logistical advice on how to visit them"—
 Provided by publisher.
Identifiers: LCCN 2024001952 (print) | LCCN 2024001953 (ebook) | ISBN
 9781493081417 (paperback ; alk. paper) | ISBN 9781493081424 (electronic)
Subjects: LCSH: National Heritage Areas (United States)—Guidebooks. |
 United States—Guidebooks.
Classification: LCC E160 .M335 2024 (print) | LCC E160 (ebook) | DDC
 917.304—dc23/eng/20240402
LC record available at https://lccn.loc.gov/2024001952
LC ebook record available at https://lccn.loc.gov/2024001953

∞™ The paper used in this publication meets the minimum requirements of American National Standard for Information Sciences—Permanence of Paper for Printed Library Materials, ANSI/NISO Z39.48-1992.

CONTENTS

PART 1:
THE HERITAGE
OF HUMANITY

INTRODUCTION

There are lots of "best of" lists of visitor attractions—parks, historic sites, scenic drives, trails, etc.—that everyone must see and do. These are often called "bucket lists," and the internet is littered with them and there are bookshelves full of them. But there's only one "official" such list, ratified by 195 countries around the world (that's nearly all of them) and stamped with the considered approval of the United Nations; it's the World Heritage List. As you might expect, the list is long—well over a thousand sites (1,199 to be more precise, but the list continues to expand). You'd probably also expect the United States to be well represented, and it is; 1,199 sites divided by 195 countries comes to about six sites per country, and the United States boasts 25 World Heritage Sites, scattered widely across the American natural and cultural landscape, from Alaska to Puerto Rico and from Hawai'i to New York. Twenty-three states are represented, one US Territory, and two sites that are shared with Canada. Moreover, World Heritage Sites aren't just selected to join the prestigious World Heritage List, they're *inscribed* on it, a sign of the list's elevated global status.

Most importantly, these sites are duty-bound to be protected.

The twenty-five US World Heritage Sites join the world's most exulted cultural and natural sites and attractions. Iconic examples include the Great Wall of China, Stonehenge, Acropolis, Pyramids of Egypt, Taj Mahal, Angkor Wat, Roman Colosseum, Great Barrier Reef, Vatican City, Serengeti National Park, Galapagos Islands, Petra, and Machu Picchu. Many of the World Heritage Sites in the United States are equally eminent, including Grand Canyon National Park, Yellowstone National Park, Independence Hall, and the Statue of Liberty. But some are less well known, yet richly deserving, sites like Taos Pueblo, Mammoth Cave National Park, Mesa Verde National Park, Papahānaumokuākea, and Cahokia Mounds State Historic Site. Consider learning about and visiting US World Heritage Sites to more fully appreciate the natural and cultural history of the nation and the ways in which these sites contribute to the global heritage of humanity.

Part 1 of this guidebook briefly outlines the World Heritage Convention, its history, how it works, the types of sites included on

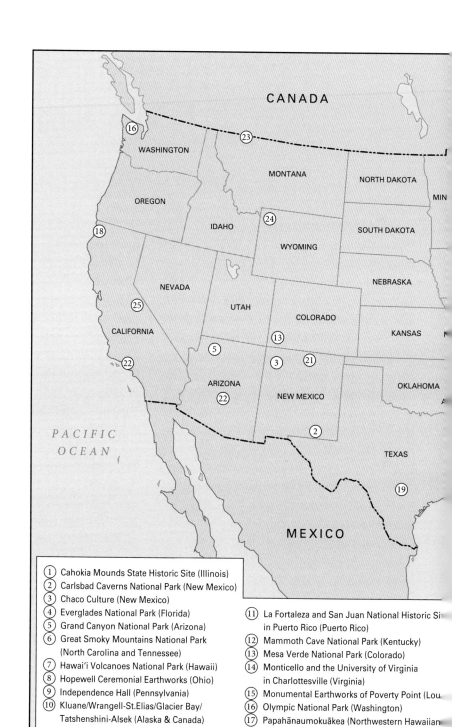

CANADA

WASHINGTON

⑯

⑱

OREGON

IDAHO

MONTANA

⑳ 24

WYOMING

NORTH DAKOTA

MIN

SOUTH DAKOTA

NEBRASKA

NEVADA

⑳ 25

UTAH

CALIFORNIA

⑬

COLORADO

KANSAS

⑳ 22

⑤

⑬

⑳ 22

ARIZONA

③

⑳ 21

NEW MEXICO

OKLAHOMA

② 2

PACIFIC
OCEAN

TEXAS

⑲

MEXICO

① Cahokia Mounds State Historic Site (Illinois)
② Carlsbad Caverns National Park (New Mexico)
③ Chaco Culture (New Mexico)
④ Everglades National Park (Florida)
⑤ Grand Canyon National Park (Arizona)
⑥ Great Smoky Mountains National Park
 (North Carolina and Tennessee)
⑦ Hawai'i Volcanoes National Park (Hawaii)
⑧ Hopewell Ceremonial Earthworks (Ohio)
⑨ Independence Hall (Pennsylvania)
⑩ Kluane/Wrangell-St.Elias/Glacier Bay/
 Tatshenshini-Alsek (Alaska & Canada)

⑪ La Fortaleza and San Juan National Historic Si
 in Puerto Rico (Puerto Rico)
⑫ Mammoth Cave National Park (Kentucky)
⑬ Mesa Verde National Park (Colorado)
⑭ Monticello and the University of Virginia
 in Charlottesville (Virginia)
⑮ Monumental Earthworks of Poverty Point (Lou
⑯ Olympic National Park (Washington)
⑰ Papahānaumokuākea (Northwestern Hawaiian

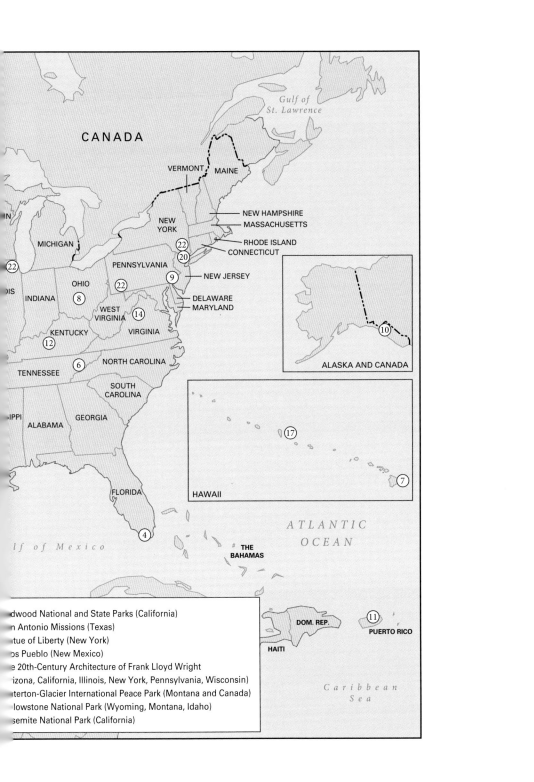

CANADA

Gulf of St. Lawrence

VERMONT MAINE

NEW HAMPSHIRE
MASSACHUSETTS

NEW YORK

RHODE ISLAND
CONNECTICUT

MICHIGAN

㉒

㉒

PENNSYLVANIA

NEW JERSEY

⑨

OHIO

㉒

INDIANA

⑧

DELAWARE
MARYLAND

WEST VIRGINIA ⑭

KENTUCKY

VIRGINIA

⑫

NORTH CAROLINA

TENNESSEE

⑥

SOUTH CAROLINA

ALABAMA GEORGIA

FLORIDA

④

lf of Mexico

THE BAHAMAS

ATLANTIC OCEAN

ALASKA AND CANADA

⑩

HAWAII

⑰

⑦

DOM. REP.

⑪

PUERTO RICO

HAITI

Caribbean Sea

dwood National and State Parks (California)
n Antonio Missions (Texas)
tue of Liberty (New York)
os Pueblo (New Mexico)
e 20th-Century Architecture of Frank Lloyd Wright
izona, California, Illinois, New York, Pennsylvania, Wisconsin)
terton-Glacier International Peace Park (Montana and Canada)
lowstone National Park (Wyoming, Montana, Idaho)
semite National Park (California)

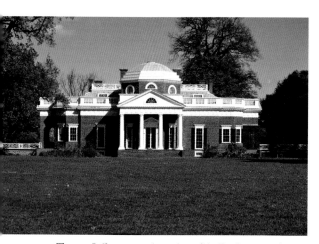

Thomas Jefferson was the author of the Declaration of Independence, third president of the United States, founder of the University of Virginia, and talented philosopher, scientist, and historian. He was also an accomplished architect, as reflected in the design of his home, Monticello, now a component of Monticello and the University of Virginia in Charlottesville World Heritage Site.

the World Heritage List, some of the issues associated with administration of the program, and the vital role the United States plays. If this type of information isn't of interest, or if you'd rather read descriptions of the US World Heritage Sites first, then skip to Part 2—the heart of the book—that presents illustrated descriptions of each of the twenty-five US World Heritage Sites, with special emphasis on the visitor attractions at each.

The World Heritage Convention

The system of World Heritage Sites around the globe is the signature component of the World Heritage Convention, an outgrowth of international interest in conserving the world's most significant natural and cultural places. While initial interest in the concept of the World Heritage Convention can be traced to the post–World War I period, it didn't

begin its journey into reality until establishment of the United Nations in 1945. Later that year, the United Nations created a specialized agency, the United Nations Educational, Scientific and Cultural Organization, widely known as UNESCO. The objective of the agency is to promote world peace and security through international cooperation in education, arts, science, and culture. An early UNESCO initiative was the International Campaign to Save the Monuments of Nubia, begun in 1960 in response to the plan to construct the Aswan High Dam on the Nile River in Egypt. This planned project would have inundated many ancient treasures of Egyptian civilization. The 1960 campaign accelerated archaeological research in the area to be affected by the dam, and the vital Abu Simbel and Philae temples were dismantled and reassembled on higher ground, where they are preserved today.

Success with this and other initiatives eventually led to development by UNESCO of the Convention Concerning the Protection of the World Cultural and Natural Heritage (usually abbreviated as "World Heritage Convention") in 1972, an international treaty. By 1975 the Convention had been ratified by the required minimum number of nations (technically called "states parties" or just "states") belonging to the United Nations, and the Convention went into effect. The World Heritage Convention may be the most important global conservation initiative.

The Convention has led to creation of several organizational entities and programs, including the World Heritage List (the sites that best represent the cultural and natural heritage of the world), the World Heritage

Committee (the rotating group of twenty-one nations that decide which sites will be inscribed on the World Heritage List), the World Heritage Centre (acting as the Secretariat for the Convention and offering advice to member nations on conservation and related issues), the World Heritage Fund (offering financial assistance to developing nations for conservation of World Heritage Sites), and the List of World Heritage in Danger (World Heritage Sites that face imminent threats from inappropriate development, global conflict, excessive visitation and/or inappropriate public use, or other reason). By 1978 criteria were developed for selecting sites to be inscribed on the World Heritage List, and Ecuador's Galapagos Islands became the first of twelve sites to be inscribed that year; the United States'

Yellowstone National Park and Mesa Verde National Park were among the initial twelve. Since that time, the list of World Heritage Sites has grown substantially, now numbering nearly 1,200 worldwide, with an outsized 25 in the United States.

The World Heritage Committee administers the World Heritage Convention and makes the final decision on which sites are inscribed on the World Heritage List. The US National Park Service Office of International Affairs administers US participation in the Convention. Nominations for the World Heritage List are accepted from member nations each year, though nations are currently allowed to nominate only one site per year. Development of nomination materials requires substantial documentation, and this tends to be a lengthy process; only sites that

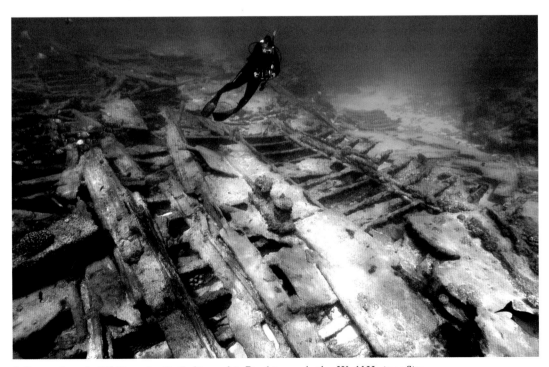

A diver explores the MS *Dunnottar Castle* shipwreck in Papahānaumokuākea World Heritage Site.

have been on a country's official "Tentative List" of sites for at least a year can be nominated. Review of nominated sites is thorough, including evaluation by subject matter experts, consideration by official advisory boards such as the International Council on Monuments and Sites (ICOMOS) and the International Union for Conservation of Nature (IUCN), and an on-site visit. The World Heritage Committee decides which sites will be selected for inscription on the World Heritage List; decisions are normally made by consensus, but occasionally by vote.

Sites considered for inscription on the World Heritage List must be determined to have "outstanding universal value," a key term that's at the heart of the World Heritage Convention. The Convention cites the following 10 criteria that are used to make this determination, and sites must meet at least one of these criteria (and often meet several of them):

1. To represent a masterpiece of human creative genius;
2. To exhibit an important interchange of human values, over a span of time or within a cultural area of the world, on developments in architecture or technology, monumental arts, town-planning or landscape design;
3. To bear a unique or at least exceptional testimony to a cultural tradition or a civilization which is living or which has disappeared;
4. To be an outstanding example of a type of building, architectural or technological ensemble or landscape which illustrates (a) significant stage(s) in human history;
5. To be an outstanding example of a traditional human settlement, land-use, or sea-use which is representative of a culture (or cultures), or human interaction with the environment especially when it has become vulnerable under the impact of irreversible change;
6. To be directly or tangibly associated with events or living traditions, with ideas, or with beliefs, with artistic and literary works of outstanding universal significance (the Committee considers that this criterion is to be used in conjunction with other criteria);
7. To contain superlative natural phenomena or areas of exceptional natural beauty and aesthetic importance.
8. To be outstanding examples representing major stages of earth's history, including the record of life, significant ongoing geological processes in the development of landforms, or significant geomorphic or physiographic features;
9. To be outstanding examples representing significant ongoing ecological and biological processes in the evolution and development of terrestrial, freshwater, coastal and marine ecosystems and communities of plants and animals;
10. To contain the most important and significant natural habitats for in-situ conservation of biological diversity, including those containing threatened species of outstanding universal value from the point of view of science or conservation.

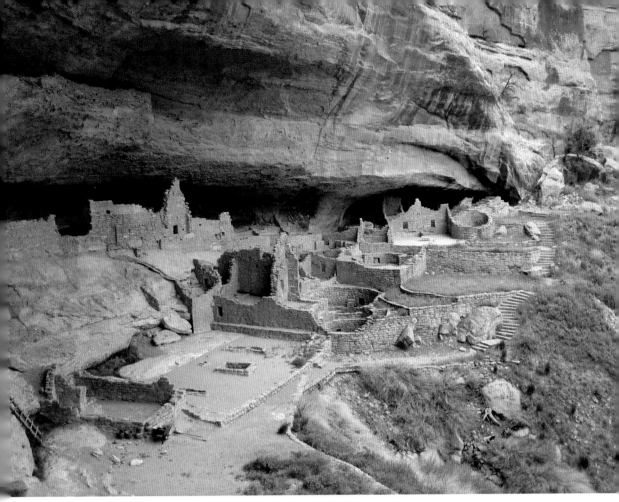

Mesa Verde National Park was one of the first sites inscribed on the World Heritage List.

Sites selected for inscription must meet the especially high bar of universal or global importance, and not be of just national significance. Moreover, host nations must make an explicit commitment to uphold and protect the outstanding universal values of the sites they nominate. Once a site is inscribed on the list, periodic monitoring of the site must be conducted and reported; monitoring is normally conducted every six years, more often if sites are judged to be in danger.

A second important term in the World Heritage Convention is "heritage." It's a rich and pleasing word that's a clear focus of the Convention, but it's been taking on new and expanding meaning over the more than 50 years of the Convention's existence. According to the *Oxford Dictionary of the English Language*, "heritage" refers to "the full range of our inherited traditions, monuments, objects, and culture." Merriam-Webster builds on this by suggesting that heritage is "something transmitted by or acquired from a predecessor: legacy, inheritance." In the context of the World Heritage List, these are the vital places and ideas that helped shape

the modern world, including its cultural and natural inheritance, and that must be passed along to future generations.

Equally important, heritage is increasingly recognized as having cultural and natural components, and this is evident in the wide-ranging list of historic and cultural monuments, as well as the diverse collection of distinctive landscapes and natural environments, that comprise the World Heritage List. The World Heritage Convention originally specified that two types of sites would be included on the World Heritage List: cultural and natural. However, more recently (and progressively), the meaning of "heritage" has begun to address the diverse and complex interrelationships between culture and nature. Over the millennia of human history, culture has defined and expressed the many ways humans relate to nature, including the components of the natural environment that we value, and how we've shaped nature, often in distinctive, pleasing, and sustainable ways. Nature has helped mold culture as well, and this is manifested in the many expressions of the natural environment found in history, philosophy, art, literature, lifestyles, and the contemporary expression of environmental conservation.

Though history is clear that humans haven't always respected the lessons that have flowed out of healthy and productive relationships between nature and culture, the World Heritage List is a hopeful sign that this is changing. Given this evolution in the notion of heritage, the World Heritage List now includes a third category of sites that are called "mixed," or, more eloquently, "cultural landscapes," in recognition that sites can have both natural and cultural qualities

that should be acknowledged, respected, and protected. The interaction between culture and nature, at least in some cases, might be just as important as either independently. For example, at Yellowstone National Park, one of the initial World Heritage Sites, the park's natural attractions—the world-famous thermal features, snowcapped mountains, wild rivers, rich meadows, iconic wildlife—justifiably overwhelm visitors. But the park has strong human and cultural connections as well: the presence of Native Americans for 11,000 years, the historic European-American settlement of the area, and establishment of the world's first national park in 1872. Moreover, the interplay of the cultural and natural—the worldview of Native Americans toward nature, the exploitation of nature by many European-American settlers, the commitment to preserving the area as a national park and now a World Heritage Site, and recognition of the ways in which nature can contribute to human wellbeing—are substantive and significant ideas that can and should enhance the power of this place to the world, and be celebrated as part of its outstanding universal value.

Other types of World Heritage Sites are "serial" and "transboundary." Serial sites are comprised of geographically discontinuous areas that are linked by their common natural and/or cultural values; The 20th-Century Architecture of Frank Lloyd Wright, a US World Heritage Site, is a good example. This site includes eight buildings scattered across six states, each building designed and constructed by Wright, the American architect who had such a powerful influence on architecture across much of the world. Transboundary sites are located in more than one

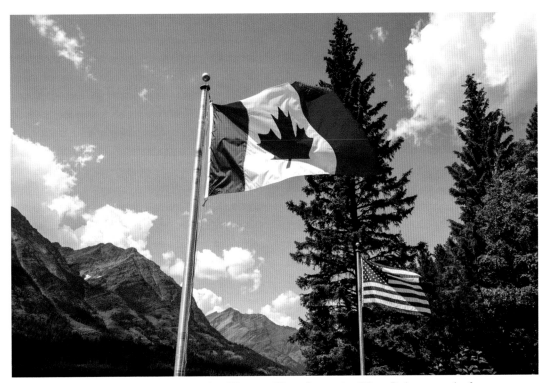
The Canadian and American flags fly side by side at Waterton-Glacier International Peace Park, an example of a transboundary World Heritage Site.

nation; Kluane/Wrangle–St. Elias/Glacier Bay/Tatshenshini-Alsek World Heritage Site straddles the US-Canadian border and was the first transboundary World Heritage Site. Other World Heritage Sites span multiple management entities; for example, Hopewell Ceremonial Earthworks includes a unit of the US National Park System and other sites managed by a nonprofit group. In all these cases, the World Heritage Convention allows for creatively spanning constraints of geography, politics, and administration in ways that allow a more holistic and cohesive approach to conservation and interpretation of outstanding universal values.

Americans can be proud of the leadership role the United States has played in the establishment and administration of the World Heritage Convention. Some scholars trace at least part of the initiative for the Convention to the concept of national parks that first emerged in the United States with establishment of Yellowstone National Park, widely regarded as the world's first national park. More recently, the United States hosted the first World Parks Congress in 1962; initiated and conducted a long-running International Short Course in the Administration of National Parks and Equivalent Reserves designed to share experience and expertise in park management with UNESCO member nations; carved out a special component of the nation's iconic Peace Corps program devoted to helping staff parks in developing countries;

was the first nation to ratify the World Heritage Convention; has served multiple terms as a member of the World Heritage Committee; and contributed the idea of combining natural and cultural heritage under a single international treaty (similar to the way the US National Park System includes both natural and cultural heritage sites).

Ironically, the United States has also had a checkered relationship with UNESCO, the United Nations entity responsible for administering the World Heritage Convention. The United States has twice withdrawn from UNESCO, once for perceived mismanagement of the agency (though other political considerations may have also been involved) and once as a protest against UNESCO's inclusion of Palestine as a UNESCO member. Despite these temporary withdrawals (though one lasted nearly 20 years), the United States continued its active role in the World Heritage Convention during these periods. The United States rejoined UNESCO in 2023.

Given the innovative and global character of the World Heritage Convention, it shouldn't be surprising that several potentially problematic issues have arisen. Many nations justifiably see inclusion of their county's sites on the World Heritage List as a sign of international prestige, and this has sometimes led to nomination of sites that may lack the necessary outstanding universal value. But the rigorous nomination, review, and approval process is designed to help alleviate this issue. Inscription of World Heritage Sites tends to attract more visitors and associated tourism-related development; ironically, this can begin to threaten these sites if host nations aren't well prepared to

manage this issue. But, in fairness, it should be noted that progressive and informed programs of heritage-based tourism can contribute to conservation of the outstanding universal values of World Heritage Sites, as well as the economic and social welfare of the local communities in which these sites are located. Another issue relates to national sovereignty; inclusion of a nation's properties on the World Heritage List can be viewed as giving up some element of control to the international community, and this may cause reticence to participate in the World Heritage Program. However, the reality is that host countries retain full sovereignty over their World Heritage Sites.

A related manifestation of the issue of sovereignty is the List of World Heritage in Danger, a statement by the World Heritage Committee that a World Heritage Site is subject to unacceptable threats to its outstanding universal values. Some nations may react badly to having one or more of their sites placed on this list. From the perspective of conservation, however, placement of a site on this list can lead to necessary management actions to address these threats. Two US World Heritage Sites have benefited from this process. The placement of Yellowstone National Park on the List of World Heritage in Danger helped the park fight off mining proposals on adjacent lands. Similarly, the placement of Everglades National Park on the list has assisted the park in its long-term battle over water withdrawals and agricultural and urban intrusions (though these issues remain far from resolved). In effect, placement of a site on the List of World Heritage in Danger is a signal to the host nation that the world is watching to see

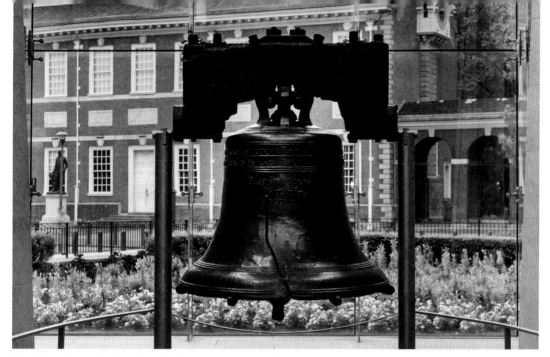
The Liberty Bell and Independence Hall are iconic symbols of American freedom, democracy, and self-governance, and are representative of the "outstanding universal values" celebrated at Independence Hall World Heritage Site.

that the host nation is living up to its commitment to protect the site's outstanding universal values.

A Guidebook to US World Heritage Sites

It's surprising that, until now, there's been no guidebook to US World Heritage Sites. Of course some US World Heritage Sites are included in other types of guidebooks, such as guides to the US National Park System. But a guidebook that's more fully inclusive of the 25 US World Heritage Sites, is focused primarily on them, addresses these sites within the framework of the World Heritage Convention, and leads readers to and through these signature sites is warranted and overdue. The World Heritage Convention and World Heritage List should be more fully understood and appreciated in the United States for their role in identifying and protecting the places that contribute so much to the global heritage of humanity, as well as promoting peace and solidarity among the nations of the world, the primary objective of UNESCO.

The material on the World Heritage Convention and its signature program of the World Heritage List that's included in Part 1 of this guidebook offers an important context within which to understand, enjoy, appreciate, and protect America's World Heritage Sites. But Part 2 of the book is its heart—descriptions of all 25 US World Heritage Sites, focusing on the outstanding universal values of each site and their principal visitor attractions. While some of these sites are already well known, others are not. It's important that the outstanding universal values of all these sites be widely appreciated, as this ultimately leads to public support for their protection.

PART 2: A GUIDE TO AMERICA'S WORLD HERITAGE SITES

As noted in Part 1, 25 sites in the United States have been inscribed on the World Heritage List, and this should make Americans proud. The heart of this book is a guide to these places. These World Heritage Sites are especially diverse in terms of their location, the natural and cultural heritage they represent, their visitor attractions, their size, and the administrative entities that manage them. Geographically, US World Heritage Sites are located in 22 states, 1 US territory, and the northwestern Hawaiian Islands; they're found from Alaska to Puerto Rico and from Hawai'i to New York. Two sites are shared with Canada. (See the map showing the location of these sites on pages 2 and 3.)

The diversity of natural and cultural resources represented is evident in the types of World Heritage Sites included in the World Heritage Program, which classifies sites as "natural," "cultural," and "mixed" (or, more progressively, "cultural landscapes"). Thirteen of the US sites are classified as cultural, eleven as natural, and one as mixed (or a cultural landscape). However, as noted in Part 1, a more realistic and contemporary assessment is that most of these World Heritage Sites include both natural and cultural resources.

The size of sites ranges from vast to compact; Kluane/Wrangell–St. Elias/Glacier Bay/Tatshenshini-Alsek World Heritage Site is immense, encompassing more than 24 million acres, the largest land-based protected area in the world. This is complemented by Papahānaumokuākea World Heritage Site, an even more extensive conservation area in the Pacific Ocean that's a staggering 384 million acres, one of the world's largest marine protected areas. At the other end of the spectrum, several sites range from a few city blocks to fewer than 100 acres. The administrative entities that manage the 25 US World Heritage Sites are also diverse; the largest number are managed by the US National Park Service, but other management entities include state park and related agencies, a US territorial government, three private foundations/nonprofit groups, a Native American Tribal government, Parks Canada, Province of British Columbia, Yukon Territory, US Fish and Wildlife Service, and the US National Oceanic and Atmospheric Administration.

Given the remarkable diversity of these sites, it's especially challenging to use a consistent format in the following 25 chapters that describe these sites. However, each

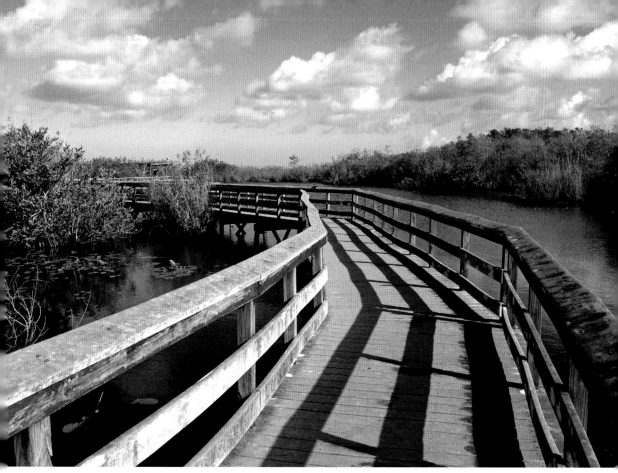

The Anhinga Trail in Everglades National Park, a World Heritage Site, offers visitors an outstanding opportunity to view the park's iconic wildlife.

chapter begins with a general description of the site, including the natural and cultural resources it protects. Much of each chapter is devoted to describing the visitor attractions of each site—the places that most visitors will want to see and experience. These attractions might include the primary geographic regions of the site, cultural resources such as buildings and monuments, stunning natural landscapes, scenic drives, trails, special guided and educational programs, and visitor centers. Each chapter concludes by noting some logistical issues and concerns, including seasons to visit, entry fees and permits, visitor facilities and services, and primary websites

to consult for the latest updated information. All chapters include high-quality color photographs to illustrate the text.

The 25 US World Heritage Sites are presented in the following chapters in alphabetical order by their official World Heritage Site name. Reading and learning about these places of such great international significance can be informative and rewarding. But readers should also consider visiting as many of them as possible to appreciate firsthand how our nation contributes to the heritage of humanity. In the process, become an advocate and supporter of US World Heritage Sites and the global World Heritage Convention.

CAHOKIA MOUNDS STATE HISTORIC SITE

Just a few miles east of St. Louis, Missouri, and across the Mississippi River, lie the remains of an ancient city—Cahokia—that rivaled the size, scale, and population of many contemporaneous medieval European cities. But this one was strikingly different in form, consisting of a series of enormous human-made earthen mounds, some topped by elaborate buildings and monuments; a complex of housing, ceremonial, and other public sites at ground level; and the remainder of the city radiating out into the hinterlands in a series of villages and agricultural lands. With a population that may have approached 20,000, this was the largest pre-Columbian settlement in the Americas north of present-day Mexico. But that population estimate could be more than doubled if one includes the mound centers of St. Louis (26 mounds) and East St. Louis (50 mounds) and scores of other surrounding communities in what archaeologists call "Greater Cahokia."

Cahokia was strategically located along major waterways (Mississippi, Missouri, and Illinois Rivers), and this helped support trading routes as far as the Great Lakes and Gulf Coast regions. Though most of the city has melted back into the earth, many of the mounds remain, and 70 are protected in Cahokia Mounds State Historic Site. This was the center of what archaeologists call the Mississippian Culture, which extended throughout the Mississippi Valley and the southeastern United States; it began to emerge around 900 CE and thrived between 1000 and 1350 CE. The settlement covered more than six square miles and included an estimated 120 earthen mounds. Cahokia began to decline during the 13th century and was abandoned by around 1350; reasons for this decline have been postulated as environmental degradation (overhunting, deforestation, and pollution), climatic changes, lengthy droughts, diseases, political and economic disruptions, and warfare; it was likely a combination of these factors.

Cahokia Mounds State Historic Site includes 70 mounds of three types: platform (a flat place on the top of the mound for a building or monument), ridgetop (long, narrow earthworks with a ridge running down

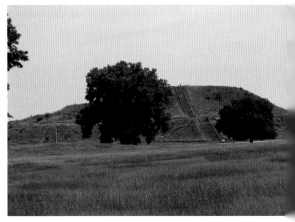

Monks Mound dominated the ancient Cahokia cityscape, rising in four terraces to a height of 100 feet; this was the largest earthen structure in the New World.

the central axis), and conical (a conventional circular mound shape). The majority were platform mounds, but many conical and ridgetop mounds served as funerary tumuli, though most residents were buried in conventional cemeteries. There is also a reconstructed portion of a nearly two-mile palisade or stockade (with periodic bastions or guard towers) thought to be primarily a defensive structure that protected the most important ceremonial and residential portions of the city. Monks Mound, the largest earthen structure in the New World, dominated the cityscape, covering 14 acres and rising in four terraces to a height of 100 feet; a 5,000-square-foot structure (perhaps a temple or chiefly residence) on top of this platform mound extended another 50 feet in height. And an astronomical observatory called "Woodhenge" (an obvious reference to Stonehenge and Woodhenge in England) consisted of a large circle of wooden posts.

Archaeologists suggest that Cahokia was a complex and sophisticated society that included a powerful political and economic hierarchy that orchestrated mound building and communal agriculture and trade. Construction of the earthen mounds required extensive digging and transportation of an estimated 55 million cubic feet of soil, sand, and clay from the surrounding floodplains, all carried by hand in woven baskets over a period of decades. All of this work was done with wooden and stone tools. Agricultural areas grew corn, squash, and several seed-bearing crops.

The original name of the area is unknown but was given the name "Cahokia" for the Native American tribe that arrived in the area in the 17th century and that the first French explorers encountered. The Cahokia do not appear to be descendants of the Mississippians. It's thought that Cahokia's development coincided with the Chaco Canyon society in the American Southwest that also constructed large-scale works in an apparently socially stratified society (see the Chaco Culture World Heritage Site chapter). The inhabitants of the city left no written records other than symbols on pottery, shells, wood, and stone objects. The historic site includes 2,200 acres (about 3.5 square miles), and includes 70 of the original mounds.

Cahokia was first protected by the State of Illinois in 1925 when the legislature authorized purchase of 144 acres as a state park. Today the enlarged site includes most of the original 120 mounds. Later designation as a state historic site added another layer of protection. The area was designated a National Historic Landmark in 1964 and listed on the National Register of Historic Places in 1966, adding to its reputation and protection. It was inscribed as a World Heritage Site in 1982. Cahokia Mounds State Historic Site is managed by the Illinois Department of Natural Resources and is supported by the nonprofit Cahokia Mounds Museum Society.

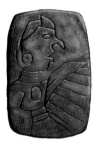

This avian-themed incised sandstone tablet titled *Birdman* was excavated at Monks Mound in 1971.

INTERPRETIVE CENTER

Cahokia Museum and Interpretive Center is the place to begin visits. The large architect-designed building opened in 1989, winning several awards. The center orients visitors to the complexities of the site and features numerous artifacts, graphics, and re-creations of daily life and architecture at Cahokia at the height of this civilization, based on discoveries of archaeologists and historians and their interpretations. There is no charge for admission, but a donation to this world-class interpretive center is appreciated. The Cahokia Museum Society operates a gift shop that features Native American artwork, jewelry, and crafts, as well as books on Cahokia, archaeology, and American Indian culture; all proceeds go to support the site.

VISITOR ATTRACTIONS

After an orientation at the Museum and Interpretive Center, visitors should walk as much of the site as time allows. Consider visiting the following attractions.

Monks Mound towers over the site, covering 14 acres and rising in four terraces to 100 feet; the base of the mound is slightly larger than that of the Great Pyramid of Egypt and Mexico's Pyramid of the Sun, but isn't nearly as tall. Walk the 156 steps that lead to the top of the mound to get a sense of the scale of this human-built earthwork and for views out over the site. Note in particular the view of the St. Louis Arch, and think about the meaning attached to such iconic structures throughout the ages. Monks Mound was the largest prehistoric earthwork in the Americas and was constructed in several stages. The name "Monks

It's a long climb to the top of 100-foot Monks Mound.

Mound" is a bit of a misnomer in that it was named for the community of Trappist monks who resided in the area of Cahokia between 1809 and 1813, after European settlement of the region.

The Grand Plaza, just south of Monks Mound, is an approximately 50-acre site that was made level by Cahokia residents in another impressive engineering project and used for large ceremonies/gatherings and ritual games.

Several "Woodhenges," large circles defined by a series of large wooden posts, were built by the original residents. They're thought to be "calendars" that aligned with the movement of the sun and marked equinoxes, solstices, and other celestial events. In 1985 a reconstruction of Woodhenge III was built with posts placed in the original

This reconstruction of an astronomical observatory called "Woodhenge" consists of a large circle of wooden posts.

excavated post positions. The 410-foot circle is marked by 48 posts and a central 49th observation post.

WALKING CAHOKIA

The public area of Cahokia includes 800 acres of the 2,200 acres preserved at the site, and all of this area can be explored on foot. Visitors should consider walking the grounds, including Monks Mound, Grand Plaza, and Woodhenge III, as described above. A guidebook has been developed for each of these sites, and each takes between a half hour and an hour to walk along the trails that also include interpretive signage at the site's major features. In addition, a 5.4-mile Nature/Culture Hike leads walkers through more remote areas of the site, explaining the culture of the Mississippian people, archaeological exploration that has been conducted, and the use of native plants for food, medicine, dyes, and fibers. A guidebook for this walk is available.

A Cahokia Mounds Augmented Reality Tour allows visitors to use their smartphones/tablets to visualize the settlement a thousand years ago, including its ancient buildings, people, and period landscapes, from the top of Monks Mound and other key points.

SPECIAL PROGRAMS

In addition to the elaborate exhibits and collections at the Museum and Interpretive Center, guided tours and personal interpretive programs are available seasonally and by appointment (though there is no charge, a donation is appreciated). Tours focus on the Grand Plaza and Monks Mound.

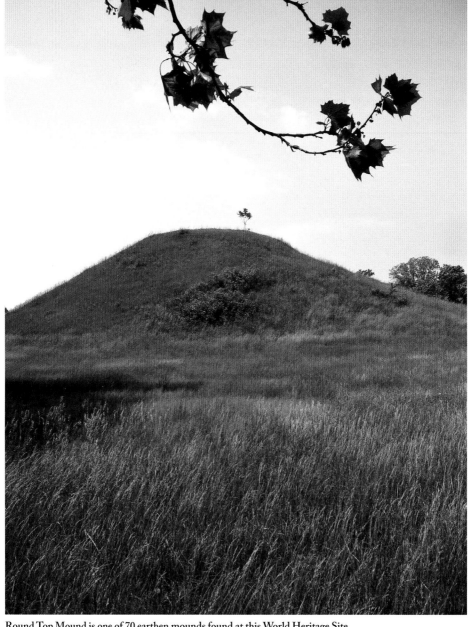

Round Top Mound is one of 70 earthen mounds found at this World Heritage Site.

LOGISTICS

Cahokia Mounds State Historic Site is located eight miles northeast of St. Louis, Missouri, in the town of Collinsville, Illinois (30 Ramey St., Collinsville, IL 622344). There are no accommodations on-site, but lodging and camping can be found in Collinsville and surrounding towns and, of course, St. Louis. Check the official website (cahokiamounds.org) for up-to-date information, including hours, events, tours, and other details, or call (618) 346-5160.

CARLSBAD CAVERNS NATIONAL PARK

The mysterious drawings on the cave walls near the cavern's entrance suggest that Native Americans entered what is now Carlsbad Cavern more than 1,000 years ago, but it's unlikely they explored its darkness. That was left to local cowboy Jim White, who was just 16 when he entered the cave in 1898. Local residents discounted his descriptions of the wondrous cavern he found, and few people were interested in the tours White offered to lead. Not until the US General Land Office dispatched a surveyor to the caverns in 1923 and members of the National Geographic Society toured the caverns the following year did the world begin to take notice of the immense and elaborate Carlsbad Caverns in the Guadalupe Mountains of New Mexico. In 1923 President Calvin Coolidge used the provisions of the 1906 Antiquities Act to establish Carlsbad Cave National Monument. Congress designated an expanded Carlsbad Caverns National Park in 1930, and in 1995 the park was recognized as a World Heritage Site.

Excitement over the park was driven by the size of the caverns—numerous giant subterranean chambers or "rooms" are connected by a maze of passages that measures 40 miles in total—and their extensive "decorations" and fanciful cave formations. And as it turns out, Carlsbad Cavern is only one of more than 100 caves in the park. Cave formation on this order is unusual and complicated. The origin of the caverns was a 400-mile-long reef in a great inland sea that covered what's now southeast New Mexico and west Texas some 260 million years ago. Tectonic forces eventually lifted this limestone formation into what are now the Guadalupe Mountains. Slightly acidic rain and groundwater seeped through the limestone, dissolving it to create the caverns. This process was accelerated by sulfuric acid from large oil and gas deposits lying below the limestone formation. Over the past four to six million years, groundwater filtered through the cave roofs, carrying dissolved calcite from the limestone, and this material—drop by billions of drops—was deposited on the ceilings, floors, and walls of the caverns, creating magical and wonderful speleothems. Water from the ceilings formed stalactites and soda straws, and water falling onto the floors created stalagmites. When stalactites and stalagmites met, they formed impressive columns. Elaborate draperies were created where water ran down a slanted ceiling, and flowstone formed where water ran over the surface of a wall or floor. Small cave pearls developed as layers of calcite built up around grains of sand, lily pads made of stone formed on the surface of pools that collected in the caves, and rimstone is found where pools of water collected in the caves. Popcorn formed where water evaporated and left behind aragonite, similar to calcite but with a different crystal structure. Carlsbad is

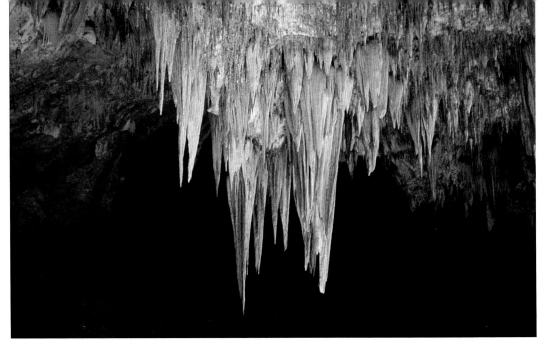
A group of huge stalactites known as The Chandelier hangs from the ceiling of the Big Room of Carlsbad Caverns.

world-renowned for its number and variety of speleothems.

Carlsbad Cavern is home to several species of bats, the only species of mammals that fly (some other mammals glide), including several hundred thousand Brazilian free-tailed bats, and they put on quite a show when they're in residence. Typically, bats call Carlsbad Cavern home from mid-April to early November; they migrate south to tropical areas in Mexico for the winter. During the day, the bats reside in great densities on the ceilings of Bat Cave, a location that is not accessible to visitors. But at dusk, the bats fly from the cave in great swarms to feed on insects in the nearby Pecos and Black River Valleys, where they may consume up to half their body weight in moths and other insects in a single night. Their nightly flight from the cave may take up to an hour or more for all the bats to emerge, and they return to the cave the next morning. A ranger-led program on bats is held each evening, culminating in the flight of the bats, and it all makes great theater.

The bats use a well-developed process of echolocation to find their prey (and avoid other objects), emitting ultra-high frequency sounds that are reflected back to guide their flight. During the day, the cave serves the important function of a maternity roost. Females typically give birth to one pup in June and rely on the darkness of the cave and its location away from predators and other disturbances for safety. Pups cling to their mothers or the ceiling for four to five weeks before they're ready to fly. As many as 300 bats may crowd into one square foot of ceiling space, which raises the question of how mothers find their pups when they return from the hunt. Scientists think mothers can remember a pup's location, scent, and the sound of its cry.

Before Carlsbad Cavern was widely recognized for its scientific and tourism values,

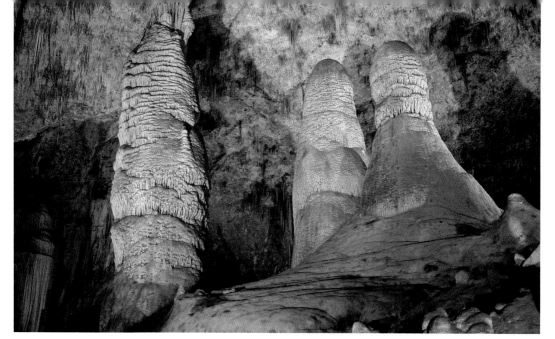

Giant and Twin Domes: Giant Dome is a column because it connects the floor and the ceiling, but the nearly identical Twin Domes are stalagmites because they don't quite reach the ceiling (at least not yet!).

it was "mined" for its extensive bat guano deposits; mining occurred in Carlsbad Cavern in the early 1900s and in other park caves until 1957. The guano was gathered and lifted 170 feet out of the cave before being packed in gunnysacks and sold to citrus growers in California. Jim White participated in this venture. However, the business ultimately failed, and White went back to exploring the caverns and leading trips. Shortly after the area became a national monument, White was appointed its first chief ranger. Exploration continues in the park and is yielding sometimes astonishing finds. For example, Lechuguilla Cave was discovered in 1986; it extends more than 150 miles (several times the length of Carlsbad). Given the pristine and fragile nature of this area, Lechuguilla Cave is open only to scientific exploration.

VISITOR ATTRACTIONS

Carlsbad Caverns has a well-deserved reputation for its huge subterranean "rooms," an extensive system of passageways that connect them, and elaborate and fanciful cave formations. Self-guided and ranger-led tours are available, as are "wild cave" tours for the more adventurous.

The many impressive rooms contained in the caverns, the number and variety of cave "decorations," and the passageways that connect these features make Carlsbad a world-class visitor attraction. The evening flight of the bats exiting the caves (described in more detail below) is a true phenomenon of nature. And don't overlook the beauty and curiosity of the vast Chihuahuan Desert lands that overlay the park.

VISITOR CENTER

The park visitor center is located at the end of the seven-mile entrance road that turns off NM 62 and NM 180. This excellent facility includes hands-on exhibits that explain the formation of the cavern and the natural and cultural history of the park. A 16-minute film, *Hidden World*, is shown at frequent intervals. The visitor center includes a small restaurant that features local foods and a bookstore and gift shop (sales from this Western National Parks Association bookstore help support park research and management).

DRIVING TOURS

The seven-mile park entrance road is a pleasant drive with nice views of the surrounding landscape and opportunities to see park wildlife. But the 9.5-mile Walnut Canyon Desert Drive is a purpose-built scenic drive with 18 signed stations where visitors can learn more about the large and interesting Chihuahuan Desert portion of the park. This is a one-way loop off the main park road; the gravel surface is generally suitable for passenger cars, but larger vehicles are not recommended. Get a copy of the free interpretive brochure at the visitor center.

HIKING PARK TRAILS

All visitors will want to walk through the major portions of the caverns that are accessible to visitors—about three miles—and these tours are briefly described below. But there are other options as well, including other caves in the park and a network of 50 miles of interesting trails on the extensive surface of the park above the caves.

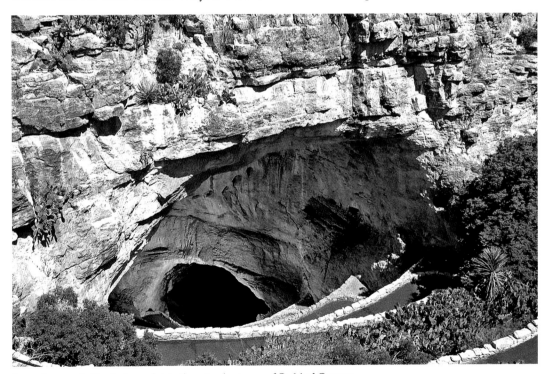

A set of steep switchbacks descends into the natural entrance of Carlsbad Caverns.

Big Room Route/ Natural Entrance Route/ King's Palace Tour

There are three basic options for touring the attractions of Carlsbad Caverns. The Big Room Route is a 1.25-mile self-guided tour of the huge, 8.7-acre Big Room, the most famous portion of the park. Here you'll see features such as the Bottomless Pit, Giant Dome, Rock of Ages, and Painted Grotto. This area can be reached by an elevator and is partially wheelchair accessible. An informative audio guide is available from the bookstore in the visitor center. The Natural Entrance Route eschews the elevator and descends 750 feet along a 1.25-mile paved trail to the Big Room. Highlights of this route include Bat Cave (which may not be entered), Devil's Spring, Green Lake Overlook, and the Boneyard. King's Palace Tour is a one-mile, 90-minute ranger-guided walk through four highly decorated, scenic chambers. At one point the ranger turns off all lights for a sense of the true blackness of the cave environment, a highlight of the tour!

Slaughter Canyon Cave

This is a "wild" cave in a different location in the park where there are no paved walkways or electricity; only headlamps light the way! This is a 5.5-hour ranger-guided adventure that roughly simulates the conditions under which caves were originally explored, and illustrates how this process continues even today. Sturdy walking shoes are required as well as drinking water. Participants in this

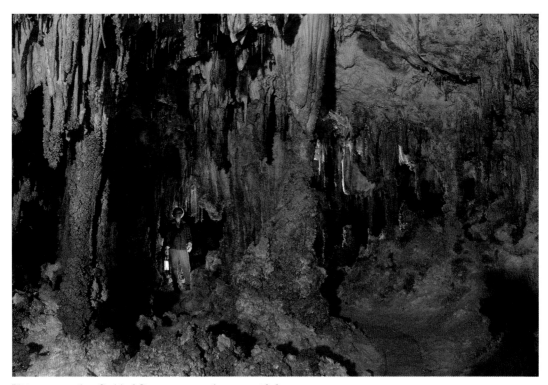

Visitors can explore Carlsbad Caverns on several ranger-guided tours.

adventure gather at the visitor center, where they are fitted with helmets (with lights) and gloves. All participants then drive to more remote Slaughter Canyon (named for an early rancher in the area) and climb a strenuous half-mile trail to reach the cave entrance. Rangers guide visitors through the cave and its expansive rooms and features. Walking can be slippery; fixed ropes offer welcome assistance in a few places.

Rattlesnake Canyon Trail

Yes, the main attractions at Carlsbad are underground, but the park includes a large surface area that offers a range of hiking opportunities. There's something intriguing about walking in the park, knowing there's a labyrinth of world-class caverns just below your feet. The hike in Rattlesnake Canyon is a favorite; it departs from the Walnut Canyon Desert Drive (described above); this little-visited, shallow canyon features a diversity of Chihuahuan Desert plants and animals (as the name suggests, there are rattlesnakes; you're unlikely to see any, but always look where you're placing your feet and hands). This is a seven-mile out-and-back hike (of course you can turn around at any time), or you can link to other trails to make it a shorter or longer loop. The trail quickly drops into the canyon and then alternates between stretches of conventional trail and the bottom of the wash, which is marked with cairns. At about 1.5 miles, the trail divides. The trail to the left continues in Rattlesnake Canyon to the park boundary,

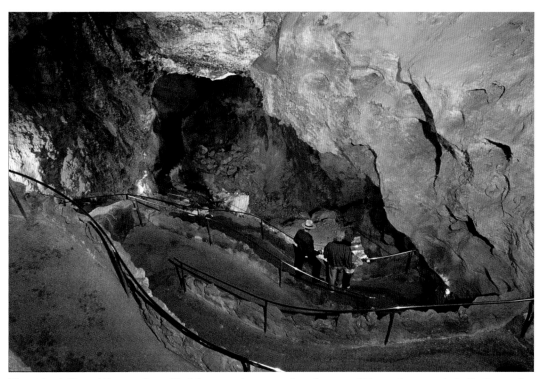

The 1.25-mile Natural Entrance Route Trail showcases the route early explorers would have taken to reach the Big Room of Carlsbad Caverns.

where you must turn around. The trail to the right heads up North Rattlesnake Canyon (where you'll find the remains of early 1900s Stone Ranch) and then intersects the Guadalupe Ridge Trail. Turn right here and follow this trail through pretty Walnut Canyon (look for cairns where the trail is faint) back to the Scenic Loop Road. *Note:* The junction with the Loop Road is about a mile farther along the loop than where you started, so you must walk back to where you parked your car.

SPECIAL PROGRAMS

The park offers a variety of ranger-guided hikes, most of them tours of the caverns (the tour of Slaughter Canyon Cave, described above, is one of the most adventurous). Take advantage of these tours as your time permits. However, a marquee program is the nightly Bat Flight Program. As dusk approaches, visitors gather at the Bat Flight Amphitheater (near the visitor center) for an interpretive program on the bats that have occupied the caverns for centuries. The program's crescendo is the flight of thousands of bats as they fly out of the cavern to feed for the night in surrounding areas, an unforgettable sight. The bats are only in residence in the cavern from late May through October (they relocate to warmer Mexico during the colder months). Like all national parks, Carlsbad offers the popular Junior Ranger Program.

LOGISTICS

The park is open year-round, although winters can be cold and snowy and summers can be hot. Timed entry tickets for Carlsbad Cavern are strongly recommended and are available online at recreation.gov and by calling (877) 444-6777. There is no campground or other lodging in the park (other than backcountry camping, which requires a permit). There's a commercial campground just outside the park, and more visitor facilities and services are available in the town of Carlsbad, about 20 miles from the park entrance. The temperature in the caves is a relatively constant 56 degrees Fahrenheit, so bring a jacket, and wear sturdy nonskid shoes. Cave formations are much more delicate than they might appear, and you are not allowed to touch them; they are easily damaged, and oils from the skin permanently discolor the rock. Photography is generally allowed, although you may not step off the paved trails for this or any other purpose. A limited-service cafeteria is located near the Big Room of Carlsbad Cavern, and there's a surprisingly good cafeteria in the visitor center. Check for the most up-to-date information at the park's official website: nps.gov/cave.

CHACO CULTURE

Astonishing archaeological evidence documents the presence of Native American people in a vast region of the southwestern United States for more than 2,000 years. Centered in Chaco Canyon in northwestern New Mexico, but radiating out into the surrounding four corners region, the Chaco Culture people established a network of residential and other sites that include highly organized, multistory "great houses" featuring hundreds of rooms and ceremonial areas and an elaborate system of carefully engineered and constructed roads that connected these culturally important sites. Many of the roads that were built are still discernible. This collection of archaeological sites is dispersed over three administrative areas: Chaco Culture National Historical Park, Aztec Ruins National Monument (both administered by the US National Park Service), and five remote sites on lands managed by the US Bureau of Land Management.

Chaco Culture was a vast pre-Columbian civilization that existed from the mid-9th to

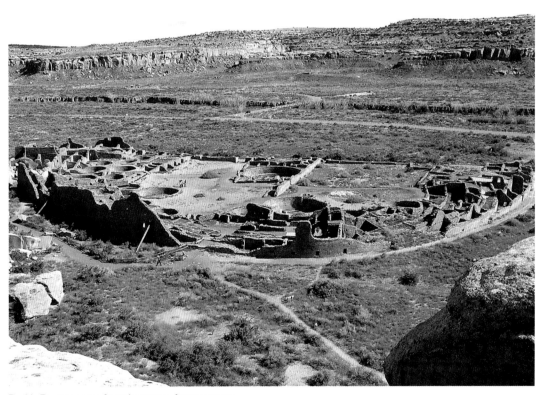

Pueblo Bonito as seen from the surrounding mesa tops

early 13th century, reaching its zenith between about 1020 and 1110. The archaeological places preserved in this World Heritage Site are the centers of this advanced civilization— the iconic remains of residential, ceremonial, and political life, as well as trade routes throughout this large geographic region.

Chaco Canyon proper, the heart of Chaco Culture National Historical Park, is the cultural center of the Chacoan civilization that flourished a thousand years ago. Chaco Canyon National Monument was established in 1907 by President Theodore Roosevelt, reestablished as Chaco Culture National Historical Park in 1980, and inscribed as a World Heritage Site in 1987. Aztec Ruins National Monument was established in 1923 and is part of the World Heritage Site.

Much of Chaco Cultural World Heritage Site is high-desert land featuring sagebrush and many species of cactus, along with scattered forests of piñon pines and junipers and occasional riparian areas that feature scarce water and associated forests of cottonwoods and willows. This land supports a variety of animals, including mule deer, elk, pronghorn, bobcats, badgers, foxes, and large "towns" of prairie dogs. Notable birds include roadrunners, hawks, owls, and ravens. This arid high-desert landscape is wild and starkly beautiful.

The Chacoan people were intimately aware of the natural environment in which

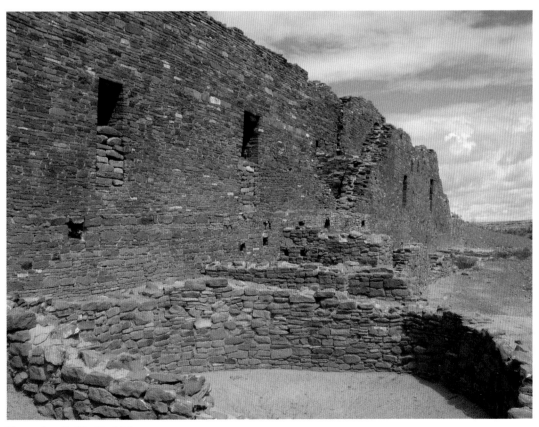

The south wall of Pueblo del Arroyo

they lived, including the night sky and associated seasonal cycles. Resulting insights helped guide the timing of agricultural practices and ceremonial events. Evidence suggests that great houses and ritualistic kivas were sited and oriented in ways that reflected the placement and movement of the sun, moon, and other celestial bodies. Interpretive programming at Chaco Culture National Historical Park (described below) addresses the importance of the night sky during Chacoan times, as well as the present.

VISITOR ATTRACTIONS

Primary visitor attractions are spread over Chaco Culture National Historical Park and Aztec Ruins National Monument. At the former, several important dwelling sites are readily accessible. Pueblo Bonito, the most iconic site in the park, is located 4.5 miles from the visitor center on the Canyon Loop Drive. This exceptionally large "great house" included some 800 rooms along with two great kivas (ceremonial sites), dozens of smaller ones, and a large central plaza. The site occupies three acres and rises to five stories in places. The 0.6-mile (round-trip) trail to and through this site climbs several short but steep rises. Una Vida is another Chacoan great house—a large, multistory structure. However, it has been preserved in its natural state with virtually no excavation and/or repairs, appearing much as it was discovered in recent time. A one-mile round-trip trail through the site, including associated petroglyphs, begins at the park's visitor center; the trail can be rocky and steep in places. Hung Pavi is another unexcavated Chacoan great house containing approximately 150 rooms,

a great kiva, and an enclosed plaza. Most of the site is covered in a protective layer of windblown sand and native vegetation and is accessible via a quarter-mile round-trip trail that starts two miles from the visitor center on the Canyon Loop Drive.

Chetro Ketl is the second-largest great house, covering more than three acres; it's located 4.5 miles from the visitor center on the Canyon Loop Drive and is accessed by a half-mile round-trip trail that includes a few short steep sections. Casa Rinconada and Small Villages is located six miles from the visitor center on the Canyon Loop Drive and is representative of the smaller and more typical villages that existed in association with the great houses. The trail that accesses the site is a half mile (round-trip) and climbs a few short steep sections. Pueblo del Arroyo is located 5.5 miles from the visitor center on the Canyon Loop Drive and is typical of great house structures. The site is accessed by a quarter-mile round-trip trail that is steep in a few short stretches. Trail guides for all these sites are available at the visitor center. If you plan to visit both Pueblo Bonito and Chetro Ketl, consider walking the quarter-mile Petroglyph Trail that connects them. Look carefully along the cliff face between these sites where you can see petroglyphs high on the cliff (binoculars will help you see the petroglyphs more readily).

Chaco Canyon National Historical Park includes other dwelling sites that are located beyond Chaco Canyon proper. These sites are sometimes referred to "outliers." Check at the visitor center for the locations of these sites and if they're open to the public. These outliers extend well beyond the park into other parks and protected areas throughout

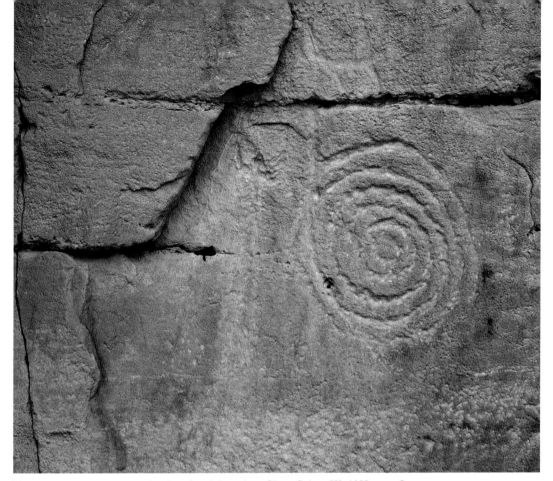

This spiral petroglyph is a type of rock art found throughout Chaco Culture World Heritage Site.

the vast four corners region and are clear evidence of the geographical extent of the Chaco Culture. Examples include Aztec Ruins National Monument (part of the World Heritage Site; see below), Canyon de Chelly National Monument (Arizona), Mesa Verde National Park (Colorado), Chimney Rock National Monument (Colorado), and Edge of the Cedars State Park (Utah).

Aztec Ruins National Monument is much smaller than Chaco Culture National Historical Park and is just north of Aztec, New Mexico. It's also part of Chaco Culture World Heritage Site. The primary attraction is the large great house that began as a satellite city of Chaco Canyon. This site was the social, economic, and political center of the Chaco cultural region after the settlements in Chaco Canyon eventually declined. The site includes a great house that exhibits skillful stone masonry, well-preserved wood roofing, and original mortar in some walls; visitors are allowed to enter the ceremonial great kiva. The short Aztec West Self-Guided Trail leads visitors to and through the great house.

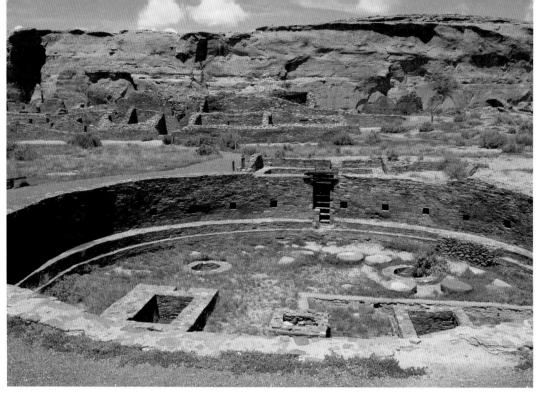

Like most pueblos at Chaco Culture National Historical Park, Chetro Ketl includes a great kiva.

VISITOR CENTERS

Two visitor centers help orient and guide visitors to this World Heritage Site, one at Chaco Culture National Historical Park and one at Aztec Ruins National Monument. The visitor center at Chaco offers educational displays about the park's cultural and natural history, and access to rangers and volunteers who can answer questions and help plan visits to the park. It also includes a museum with exhibits on Ancestral Pueblo daily life, an orientation film, and a small bookstore.

The visitor center at Aztec Ruins is locally known as "Earl's House" because the building began as the home of pioneering archaeologist Earl Morris. The visitor center provides an orientation to the park and an informative video that offers diverse perspectives from Pueblo people, Navajo tribal members, and archaeologists. Pick up a trail guide to and through the great house and see 900-year-old artifacts in the park's museum.

SCENIC DRIVES

Chaco Culture National Historical Park offers the nine-mile Canyon Loop Drive that begins at the visitor center. This narrow paved road is easily passable by passenger cars and can be traveled by bicycle as well. The road accesses five major Chacoan sites, including iconic Pueblo Bonito; short trails take visitors to each of these sites. Though the road is only nine miles, stops at each of these attraction sites will take a day or more and are a highlight of a visit to the park.

WALKING PARK TRAILS

In addition to the short trails to Chaco's major attraction sites, there are four back-country hiking trails at Chaco Culture National Historical Park. The Wijiji Trail is three miles round-trip and leads to a later-period Chacoan great house that exhibits exceptional symmetry and uniform masonry, probably because it was constructed all at once rather than over several time periods, like most other great houses. The South Mesa Trail is an approximately four-mile loop trail leaving from the Casa Rinconada Trailhead. The popular Pueblo Alto Trail is a 5.5-mile loop that features a striking mesa-top aerial view of Pueblo Bonito. The Penasco Blanco Trail is the longest backcountry hike at 7.5 miles round-trip. All of these trails offer sweeping views of the mesa tops and the impressive road network that was such an important part of the Chaco cultural system. Hikers must sign in at the trailhead self-registration stations to access these trails; it's advisable to talk to rangers at the visitor center before embarking on any of these hikes. A trail guide booklet for all these trails is available at the visitor center bookstore.

Aztec Ruins National Monument offers two trails in addition to the one to and through the great house (described above). The short Heritage Garden and Native Plant Walk features crops traditionally grown in prehistoric times, including corn, beans, squash, sunflowers, and gourds, as well as other wild plants Chacoan residents relied on for thousands of years. A 1.5-mile section of the Old Spanish National Historic Trail leads from the park over the Animas River to the town of Aztec's historic downtown.

SPECIAL PROGRAMS

As noted earlier, advanced astronomical observations were important to the Chaco Culture and explicitly designed into construction of great houses and several petroglyph panels. Because Chaco Culture National Historical Park is relatively isolated from urban light sources, the night sky remains relatively pristine and is featured in park programs. There's a small observatory in the park, the subject of selected public programs; park rangers and volunteers present night sky programs, and there's an annual Astronomy Festival in September. Sunrise programs are presented at selected great houses at the spring and autumn equinoxes and summer and winter solstices. Interpretive programs on other aspects of the park are also offered; see the "calendar" tab on the park's website for dates, times, and locations. The National Park Service Junior Ranger Program is also offered.

LOGISTICS

Chaco Culture National Historical Park is remote and challenging to reach. The primary entrance is from the north on CR 7900, directly off US 550 at mile 112.5; follow signs to the park. This route includes 8 miles of paved road and 13 miles of rough dirt road, the last few miles of which can be very rough. From the south, take NM 57 directly off NM 9; this is a drive of 20 miles on a very rough dirt road. Neither CR 7900 nor NM 57 are passable in inclement weather, and visitors should be wary of driving RVs on these roads. It's wise to call the park and ask for up-to-date road conditions.

There is no lodging in the park, but there's a campground that can accommodate small RVs. The closest large town with a selection of accommodations is Bloomfield, New Mexico, approximately 60 miles from the northern entrance to the park. Aztec Ruins is more accessible, just north of the town of Aztec, New Mexico. There are no lodgings in the park, but they are readily available in the town of Aztec and nearby Bloomfield. Summers in both parks can be hot and winters cold, with occasional snow; spring and fall are especially nice times to visit. The latest up-to-date information on these two parks can be found at their official websites: nps.gov/chcu, and nps.gov/azru.

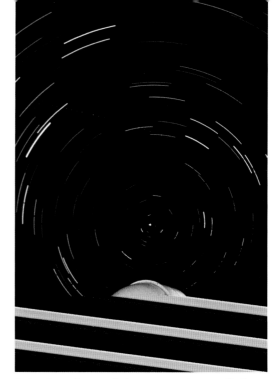

A time-lapse photograph shows concentric star trails above the dome of Chaco Observatory.

EVERGLADES NATIONAL PARK

In her remarkable book *The Everglades: River of Grass*, Marjory Stoneman Douglas wrote: "There are no other Everglades in the world. They are, they have always been, one of the unique regions of the earth, remote, never wholly known. Nothing anywhere is like them." At more than 1.5 million acres, the park that Douglas did so much to help establish and preserve is one of the largest national parks in the continental United States, and most of the park is the grand wilderness named in her honor. Of course Douglas was right: Everglades National Park is truly unique, so much so that it was inscribed as a World Heritage Site in 1979.

This national park is significant for three reasons. First, there's the natural history of the area, the vastness that's a blend of the tropical and the temperate, part Caribbean and part North American. This mix of environments has led to remarkable biological diversity. Second, this was the first national park established to honor biological diversity; prior to establishment of Everglades in 1947, national parks were designed primarily to protect scenic beauty, not necessarily ecological integrity. Third, despite establishment of the national park, it remains threatened by water diversions, agricultural development, urban growth, climate change, and other issues. These ongoing threats have inspired what may be the grandest environmental restoration effort in American history. But is it enough?

The park, occupying much of the southern tip of Florida, represents only about one-fifth of the original Everglades ecosystem, which continues north to the massive region of Florida that's drained by the Kissimmee River and Lake Okeechobee. The underlying geology of the park is primarily limestone, formed by a shallow marine environment that deposited calcium carbonate in the form of sand, seashells, and coral. This almost uniformly flat limestone is covered in fresh water much of the year and is the primary aquifer for this extensive region of Florida.

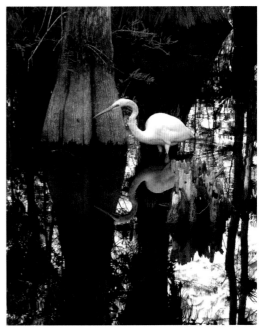

A great egret hunts in a cypress forest at Everglades National Park.

The park is surprisingly diverse, constituting several types of ecosystems. In addition to its extensive network of freshwater marshes that carry water south (slowly, about 100 feet per day), extensive marine and estuarine areas surround much of the park, and large complexes of mangrove forests line long stretches of the coast. These ecosystems offer habitat for a great variety of wildlife: an impressive 40 species of mammals, more than 50 species of reptiles, more than 350 species of birds, and nearly 300 species of salt- and freshwater fish. The glamour species include black bears, alligators, American crocodiles, manatees, the critically endangered Florida panther, four species of sea turtles, and a great variety of wading birds and songbirds. Alligators are freshwater species readily seen throughout the park, while crocodiles are marine animals with a more restricted range.

Humans occupied the Everglades region as early as 20,000 years ago, but most of these Native Americans lived primarily in coastal areas. The National Park Service (NPS) estimates that there were as many as 20,000 Indigenous people in the Everglades region when the Spanish encountered them in the late 16th century. These native people formed the Seminole Nation in the early 19th century and were forcibly relocated to Indian Territories west of the Mississippi. A few hundred avoided resettlement by living in what is today Big Cypress National Preserve, just north of Everglades. Some Seminoles and members of the similar Miccosukee tribe live in and around the modern-day park and are consulted in national park management.

Modern settlement of South Florida began in earnest in the 19th century, with initial efforts focusing on draining the land by diverting water into canals leading out to the sea. Since the 1950s, an extensive system of water-control structures—canals, levees, gates, spillways, and pumping stations—has been created to move much of this water to South Florida's rapidly growing cities. Development has had the unfortunate consequence of depriving what is now the national park of the water that's vital to the survival of its specialized and water-dependent plants and animals and the complex interactions among them. Concern over the deteriorating condition of Everglades emerged in the early 20th century and escalated over the next few decades, led by citizen environmental groups. In 1930 Congress established Everglades National Park, but the park was not dedicated until 1947. However, that has not stopped the diversion of water from the park, which has now grown to an ecological crisis.

In response, Congress passed the Water Resources Development Act in 2000, authorizing $7.8 billion for a 25-year Everglades restoration project, but much of the promised funding has not materialized. Ironically, this leaves Everglades—the first national park to be established primarily for ecological preservation—as one of the most threatened national parks in the nation, perhaps the world. Other increasingly urgent threats to the park include climate change (in the form of more frequent and violent hurricanes and rising sea levels that may result in massive saltwater intrusion into the park's vast freshwater ecosystems), and introduction of exotic, non-native plants and animals (for example, release of unwanted pet Burmese pythons into the Everglades has resulted in an estimated population of tens of thousands of these aggressive animals).

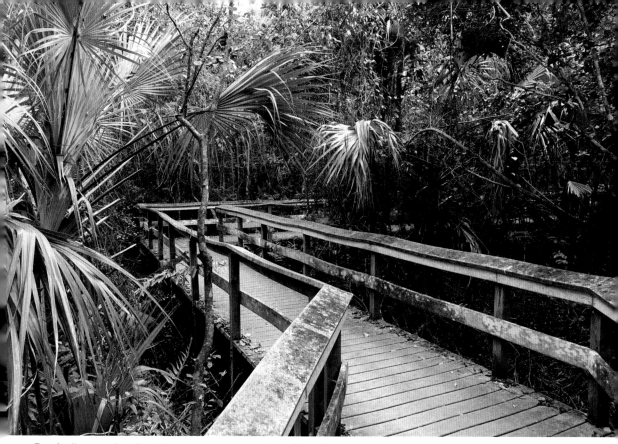

Boardwalks are used to allow visitor access to watery portions of the park.

VISITOR ATTRACTIONS

Of course the vast wetlands of the park are the primary visitor attraction, including the diverse plants and animals that have evolved in this specialized region. Be prepared to appreciate the stark beauty of this expansive and biologically diverse landscape. There are many ways for visitors to experience and appreciate the park: driving park roads, hiking its trails, exploring its visitor centers, biking, canoeing/kayaking, taking boat tours (including airboats where authorized), watching wildlife, camping, and fishing.

The park has several distinctive ecological regions, including extensive freshwater marshes, rich marine and estuarine areas, large complexes of coastal mangrove forests, and isolated uplands of pine forests. All of these areas are easily accessible in the park's several attraction "districts"—Royal Palm, Flamingo, Shark Valley, and Gulf Coast—that are serviced by visitor-friendly facilities and services.

VISITOR CENTERS

The National Park Service typically places a big emphasis on visitor centers, and they offer an important way to learn about the parks and help plan visits. Everglades is no exception, offering a generous four visitor centers around the perimeter of the park. The Shark Valley Visitor Center is located closest to Miami on the north side of the park and offers educational displays,

a video, information materials, and a small shop. The visitor center marks the start of a 15-mile paved bicycle/tram trail in the park that's a highlight for many visitors and features a striking mid-century modern observation tower. Bicycle rentals are available. Two short walking trails—Bobcat Boardwalk and Otter Cave Trail—are nearby. The Ernest F. Coe Visitor Center is located on the east side of the park and offers orientation films, educational displays, information materials, and a small bookstore; several popular trails begin a short drive from here. The Guy Bradley Visitor Center is located at Flamingo on the southwest tip of the Florida peninsula and offers modern exhibits with a focus on the Florida Bay marine ecosystem; services including boat tours, a campground, boat and bicycle rentals, a marina and store, a gas station, restaurant, eco-tents, and lodging. The Gulf Coast Visitor Center on the northwest side of the park was badly damaged by Hurricane Ian in 2017 and has been temporarily replaced by a small visitor contact station; plans call for a new visitor center honoring Marjory Stoneman Douglas. The area includes a canoe/kayak launch and offers wilderness campsites.

DRIVING TOURS

Since there's little road development in the park, there's only one option for a substantive scenic drive. The main park road, an extension of FL 9336 that enters the park on the east side and services several park attractions, runs for 38 miles to Flamingo on the edge of Florida Bay. The road passes through a variety of landscapes, including pine rockland forests, cypress forests, saw grass marshes,

lakes and ponds, and extensive coastal mangrove forests. Special attractions include the Anhinga Trail, Pinelands Trail, Pa-hay-okee Overlook, West Lake Trail, Mrazek Pond, and the mangrove forests at Flamingo. Several of these trails are described below.

HIKING PARK TRAILS

Because so much of the park is a vast wetland, the hiking trail system isn't extensive. Nevertheless, take the opportunity to experience and appreciate the park in the more intimate way that only walking can offer. And if that's not intimate enough, you can always go on a truly immersive hike called "slough slogging." Read on . . .

Anhinga Trail

If there's a signature walk in Everglades, it's got to be the Anhinga Trail. Like a number of the park's trails, it's short—less than a mile—and it's all on a paved berm and elevated boardwalk over the saw grass marsh of Taylor Slough. The boardwalk keeps feet dry and makes for a great extended viewing platform as well. Anhingas are large fish-eating birds common in freshwater areas of the park; here, they perch on the railings of the boardwalk and nest in adjacent trees from January through early summer, making themselves readily visible. Other notable birds in the area include double-crested cormorants, roseate spoonbills, black vultures, wood storks, herons, egrets, and moorhens. American alligators are also common in the area and are most easily seen in the winter and spring, when fish tend to congregate in remaining wet areas. Look closely in the water for fish, turtles, and water snakes. Look

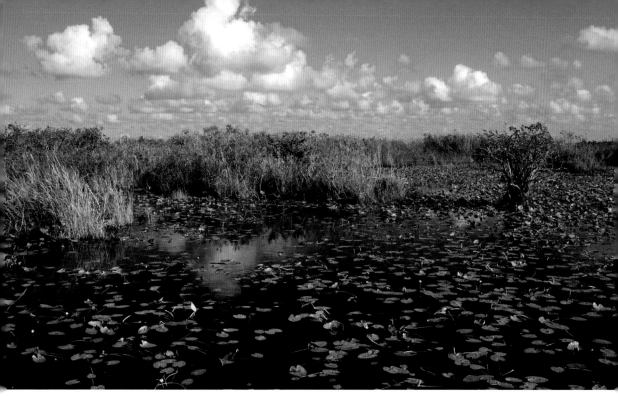

The extensive and distinctive Everglades landscapes of water and marsh grasses seem to go on forever.

as well for several kinds of epiphytes, or air plants—ferns, orchids, and bromeliads—that grow in the surrounding trees. This and other trails served by boardwalks are fully accessible to wheelchairs.

Pa-hay-okee Overlook

Just off the park's main road and served by a short elevated trail, this area offers one of the most stark but striking views in the park. The name of the overlook is derived from the Seminole language and means "grassy waters." Saw-grass prairies that seem to extend forever, just like the one you'll see before you, make up much of the Everglades region. These prairies are dynamic ecosystems—rivers, really—with water that may be only a few inches deep but miles wide; they

flow at an almost imperceptible rate. Punctuated with hammocks of hardwood trees, the vast prairie to the north is the southern edge of the massive Shark River Slough, a complex of prairies that flow south and west through the park, carrying water from Lake Okeechobee and Big Cypress Swamp to the Gulf of Mexico. As this fresh water meets the Gulf, it creates a brackish water estuary that supports an expanse of mangroves that protect the shoreline from erosion and serve as a nursery for a host of marine organisms.

Mahogany Hammock

This is another of the park's short, elevated boardwalks just off the park's main road. A hammock is formed when the park's underlying limestone is slightly higher than the

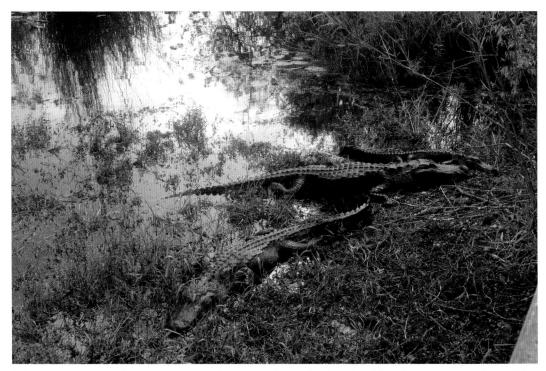
Alligators are common in the park and are most often seen in winter and spring, when fish tend to congregate in the remaining wet areas.

surrounding area, allowing soil to accumulate and ultimately offering dryer habitat for trees. Hammocks feature the beautiful West Indian mahogany and a diversity of other plants. Both the vast prairie and clearly defined moat of deeper water help protect the hammock from periodic lightning-caused fires. Look carefully for warblers and other songbirds during fall migration and spring, barred owls, a variety of snakes, ferns, bromeliads, and orchids. But watch out for the poison ivy that tends to drape from trees.

Shark Valley

Shark Valley is located in the northern portion of the park, directly off Tamiami Trail (US 41), and is one of the main attractions of the park. It features a 15-mile paved elongated loop that starts at the visitor center just beyond the park entrance. Cars are not allowed on the loop; instead, there are several options for seeing this area, including walking, biking, and a two-hour narrated tram tour. Bike rentals are available. If this is too much riding and not enough walking, consider walking along the route for as long as you wish. (Be careful—the sun is hot, and it's easy to become dehydrated.) On a walk of just a mile or two, you're likely to see alligators, turtles, and lots of birds, some of them up close and personal!

Slough Slogging

The park offers a very unusual form of hiking called "slough slogging." As the name suggests, this involves walking through the

marshes and cypress domes of the park, sometimes up to your knees (or beyond). No high-tech equipment is needed—just long pants, socks, and a pair of (preferably old) lace-up shoes. The NPS regularly conducts ranger-guided slough slogs, and this is the recommended way to experience the Everglades up close.

Wilderness Waterway

A special trail for paddlers and boaters, the Wilderness Waterway is found along the west coast of the park, running nearly 100 miles and connecting Flamingo and Everglades City. This travel route runs through the vast Marjory Stoneman Douglas Wilderness and requires wilderness navigation and camping skills; check the NPS website (noted below) for details. A wilderness camping permit is required.

SPECIAL PROGRAMS

Like nearly all national parks, Everglades offers a rich program of ranger-led activities,

Coastal areas of the park offer world-class opportunities for kayaking and canoeing.

and Everglades sports an especially active and diverse array. There are three geographic centers of activity. In the Royal Palm region of the park, the suite of programs includes a guided walk along the world-renowned Anhinga Trail, a bike tour (sign up at the Ernest F. Coe Visitor Center), evening programs on the natural and cultural features of the park, a starlight walk, a tour of a US Army Nike missile site located in the park, and a slough slog. The Flamingo region of the park offers daily paddling and boating activities; programs on manatees, ospreys, and crocodiles; evening programs; and night-sky viewing. The Shark Valley region offers its signature Shark Valley tram tours, a variety of guided walks and bike trips, and night-sky programs. The Gulf Coast region offers guided paddle trips, boat tours, and special programs on a variety of topics, including astronomy and the night sky. And don't forget about the NPS's always popular Junior Ranger Program, offered at multiple locations. Ranger-led activities are more numerous during the park's winter dry season (see below). Log onto the park's "calendar" for a schedule of programs. In addition to these NPS programs, the nonprofit Everglades National Park Institute offers a variety of immersive programs.

LOGISTICS

The geography of the park defines how visitors can access it. By definition, most of the park is a vast wetland, and few roads have been constructed in the area in order to maintain its ecological integrity. The park has three entrances, which are not connected. The Homestead entrance is considered the main entrance with the primary park road; the nearest towns are Homestead and Florida City. This entrance leads to the Ernest F. Coe Visitor Center and accesses the Royal Palm and Flamingo regions of the park. The Shark Valley entrance is directly off US 41 (Tamiami Trail) and is the closest to the greater Miami region; this entrance offers access to the Shark Valley Visitor Center. The Gulf Coast entrance is in Everglades City south of Naples and offers access to the 10,000 Islands mangrove estuary.

A vital consideration for visiting Everglades is the weather. There are only two seasons: wet and dry. The former generally lasts from May through October; the latter, November through April. The wet season is often rainy, hot, and humid. Periodic hurricanes also occur then. Perhaps worst of all, swarms of mosquitoes can make life miserable. Visit during the dry season, if possible.

In addition to lodging and camping facilities in the park, a variety of options are available in surrounding towns. The park has two campgrounds: Long Pine Key, near the Homestead entrance, and Flamingo, located in Flamingo, 38 miles south of the Homestead entrance. Wilderness camping is allowed in selected areas of the park but requires a permit. For the most up-to-date information, see the park's official website: nps.gov/ever.

GRAND CANYON NATIONAL PARK

Grand Canyon National Park is clearly one of the crown jewels of the US National Park System and one of the most well-known World Heritage Sites as well, attracting visitors from around the United States and the world. If you need any convincing, take the short walk from the visitor center on the South Rim of the canyon to famous Mather Point for some of the park's most iconic views and listen carefully for the variety of languages visitors are speaking. Get a sense of the scale of this massive canyon—278 serpentine miles long, as much as 18 miles wide, and a mile deep—by appreciating that you're seeing just a small portion of it as you peer out from any of the park's overlooks.

The canyon is an open book of geologic history that dates back nearly two billion years; it also includes a rich cultural history and a staggering suite of recreational opportunities. The park's 1.2 million acres in northern Arizona are surrounded by other public lands and Indian reservations, making it seem vast. Early Colorado River explorer Major John Wesley Powell wrote that the Grand Canyon is the "most sublime spectacle on earth," and President Theodore Roosevelt added that it is "the one great sight which every American should see." Indeed, calling the canyon "Grand" seems almost an understatement.

Of course the park's primary attraction is its geology that allows scientists—and

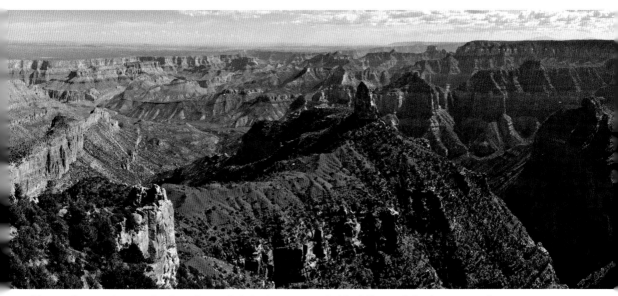

The view from nearly 9,000-foot Point Imperial, the highest point on the North Rim, includes the transition from a narrow winding river canyon to the truly "grand" canyon for which this World Heritage Site is so famous.

visitors—to peer a mile deep inside the earth. The upper portion of the canyon, so strikingly visible from the rims, is a series of sandstone, limestone, and shale layers that were deposited millions of years ago—remnants of ancient seas, deserts, sand dunes, and swamps. Nearer the bottom of the canyon, in its inner gorge, lie the very oldest rocks—the dark, metamorphic "basement" rocks that are nearly two billion years old. The canyon was created by a gradual uplifting of the vast Colorado Plateau and the erosive downward force of the Colorado River and its ancestral rivers, as well as the erosive forces of water running off the rims of the canyon, wind, and the freeze-thaw cycle.

The mighty Colorado River drains much of the southwest quadrant of the United States and is a vital source of water in this arid land. The river rises in the Rocky Mountains and flows 1,450 miles before emptying into the Gulf of California. Rio Colorado is Spanish for "red river" and references the natural color of the river as a result of sediment that's washed into it from the surrounding arid lands. However, the section of the river that flows through Grand Canyon is now often clear as a result of the Glen Canyon Dam, constructed just upstream of the park in the 1960s. The dam slows the flow of the river, causing most of the sediment to be deposited at the bottom of the reservoir; when water is released through the dam, it comes from near the bottom of Lake Powell and it tends to be clear and cold. Consequently, the riparian habitat of the river, including many species of plants and animals, has been greatly altered. Recently, the dam has been operated in a way to more closely mimic the natural flow of the river, though the long-term drought in the Southwest is making this more challenging.

The canyon represents a wide range of elevations, from the Colorado River at roughly 2,000 feet to the 7,000-foot South Rim and the nearly 9,000-foot North Rim (the vast Colorado Plateau is tilted slightly to the south). Consequently, flora and fauna are highly diverse. South Rim forests are primarily piñon pines and Utah junipers, with some Gambel oaks and ponderosa pines, while the North Rim features Engelmann spruce, Douglas and white firs, ponderosa pines, and quaking aspen. The inner canyon is highly arid, showcasing such plants as sagebrush, creosote bush, scrub oak, yucca, and assorted cactuses. Prominent mammals in the park include elk (which have only recently migrated into the park), mule deer, mountain lions, bighorn sheep, coyotes, and ringtails. Commonly seen birds include ravens (amuse yourself by watching them play in the air currents directly above the canyon rim), nuthatches, juncos, jays, chickadees, and flickers. The endangered California condor has been reintroduced to this region, and these giants of the sky are often seen in the park.

Like many western national parks, Grand Canyon has a colorful history. This area of the Southwest has been the home of a number of groups of native or Indigenous people for 10,000 years. Three reservations border the park, and 11 tribes are currently recognized by the federal government as traditionally associated with what is now the park; these tribes are consulted on how the park is managed. The first European visitors were the Spanish in the 1540s, but

they found little of interest, only a massive barrier to transportation. Later, prospectors explored the canyon for minerals, generally without great success. In 1869 John Wesley Powell, a one-armed Civil War veteran and scientist, and his small party were the first Euro-Americans known to have floated the Colorado River through the Grand Canyon. This is a great American adventure story, since the river was rumored to have massive waterfalls and other hazards. Powell and his small band of men endured great danger and hardship on their long voyage, but they were successful in mapping this area and assessing the availability of water and the limits this would place on economic development of the region. In the late 19th and early 20th centuries, the Santa Fe Railroad began to develop the canyon for tourism, building a spur line to the South Rim and constructing the elegant El Tovar Hotel. President Theodore Roosevelt established Grand Canyon National Monument in 1908, Congress established Grand Canyon National Park in 1919, and the park was inscribed as a World Heritage Site in 1979.

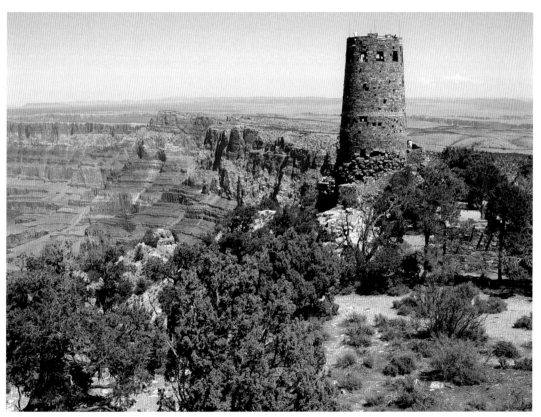

The 70-foot Watchtower at Desert View offers striking views out over this portion of the Grand Canyon. The structure is a replica of Native American architecture constructed in 1932.

VISITOR ATTRACTIONS

Of course the park's primary visitor attraction is the Grand Canyon, itself—this mighty, mile-deep gash in the earth that winds 278 miles through this large national park. And there are lots of ways to experience and appreciate it. Scenic roads lead to two major access points on the South and North Rims. These roads were constructed to offer easy access to visitors and feature great views; stop often at viewpoints along these roads and see the canyon from many perspectives. Several scenic driving tours are described below.

Hiking is another way to experience the park, offering visitors a more intimate way to see and appreciate the canyon. There are extensive and relatively easy walks along the South Rim, and these are highly recommended. In addition to the views out over and into the canyon, these walks include attractions such as two park visitor centers, the Yavapai Museum of Geology (in addition to learning more about the canyon here, you'll enjoy some of the most spectacular views of the canyon through the building's picture windows), and the park's historic district, including the lovely El Tovar Hotel and dramatic Kolb Studio. The first phase of the studio was built in 1904 by colorful brothers Emery and Ellsworth Kolb and served as their photography studio for decades. The building clings to the edge of the canyon near the Bright Angel Trailhead and now serves as an art gallery and gift shop. More immersive but challenging hikes can be taken into the canyon—all the way to the Colorado River if desired—but hikers must be prepared for the long, difficult hikes back up to the Canyon rims. Several iconic hikes are described below.

Two unusual ways to see and experience the Grand Canyon are float trips on the Colorado River through the canyon and mule rides on the Bright Angel and North and South Kaibab Trails. Float trips are long and adventurous, featuring the river's mighty rapids and hiking into otherworldly side canyons. Mule trips can be either day or overnight. See the park's website for details and links to concessioners that operate these adventures.

Other attractions include Desert View, about 30 miles east of Grand Canyon Village. Desert View is transitioning into an inter-tribal cultural center. A large watchtower was constructed in 1932, referencing similar Ancient Puebloan structures found at Mesa Verde National Park and other Native American sites in the Southwest; the watchtower offers great views of the canyon. Tusayan Pueblo Archaeological Site features the remains of a small Ancestral Puebloan village and a short self-guiding trail; the site is located on the drive between Grand Canyon Village and Desert View. The Grand Canyon Railway offers an interesting way to travel to and from the park; the train provides service to the South Rim from the town of Williams, located about 60 miles to the south. Bicycles can be a good way to experience the park (though they are restricted to park roads)—especially the scenic Hermit Road, where no cars are allowed during most of the year; bikes can be rented near the Grand Canyon Visitor Center.

The vast majority of the park is considered "backcountry," where there are few or no visitor facilities with the exception of trails, campgrounds, and Phantom Ranch (described below). Nearly all the park is

open to hiking, but a permit is needed for overnight visits. Advice about hiking is available from the park's Backcountry Information Center on the South Rim and on the park's official website. Several popular hiking options are briefly described below.

VISITOR CENTERS

If this is your first visit to the Grand Canyon, you'll be well served to look through the park's official website as you're planning your visit and then stop at one of the park's visitor centers as you arrive. Here you'll find displays on park history and natural history, maps and other helpful materials, and knowledgeable

Visitors descend into the Grand Canyon on mules via the famous Bright Angel Trail.

rangers and volunteers to help you plan your visit and answer any questions you might have. The largest visitor center is on the South Rim and is part of a contemporary mall that features the large Grand Canyon Visitor Center (where you can see two films about the park and other displays and ask rangers for information and advice) and the adjacent Grand Canyon Conservancy Park Store, where you can find maps, books, educational materials, and gift items. Take the time for the short walk to Mather Point and your first view of the canyon, passing through the tribal medallion, representative of the tribes traditionally associated with the Grand Canyon. This area is also the hub of the park's sophisticated and visitor-friendly shuttle bus system (see Logistics below). The smaller but historic Verkamp's Visitor Center is located in Grand Canyon Village, also on the South Rim. As the name suggests, the North Rim Visitor Center is located on the North Rim of the park, a long drive from the South Rim (see Logistics).

DRIVING TOURS

Several park roads offer delightfully scenic drives with lots of viewpoints over and into the Canyon. The Hermit Road starts at Grand Canyon Village and extends for seven miles to Hermit's Rest. The road is closed to automobiles most of the year, but the park's free shuttle bus system travels the road, with stops at the nine major viewpoints. The shuttle bus doesn't operate during the winter months, and the road is open to automobile traffic at this time. Desert View Drive (also known as East Rim Drive) is a lovely 30-mile route that connects South Rim Village with

Desert View and offers many stops at iconic canyon overlooks and picnicking opportunities. As the name suggests, Desert View provides striking views out over this portion of the Grand Canyon, especially from the 70-foot-high historic Watchtower. The interior walls of the tower feature murals by Hopi artist Fred Kabotie. AZ 67 (also known as the Kaibab Plateau–North Rim Parkway) travels 42 miles from the rural community of Jacob Lake to the North Rim of the canyon, traveling through the Kaibab National Forest for approximately 30 miles before entering the park. The drive includes stately forests of pine, fir, and aspen; large, lush meadows; and culminates at the canyon's dramatic North Rim. At more than 8,000 feet in elevation, the North Rim gets substantial snow and is open only from May to October (check the park website for specific dates).

HIKING PARK TRAILS

The Grand Canyon offers a full range of hiking opportunities, both along the rims and down into the canyon; the park includes nearly 600 miles of trails. Some of these hikes can be challenging, even dangerous; however, proper preparation, including an informed choice of trails, can make these hikes safe and enjoyable, and a highlight of a park visit.

Grand Canyon Rim Trail

The Grand Canyon Rim Trail is underappreciated. Many visitors to Grand Canyon's South Rim walk out to a few overlooks of the canyon and take a brief stroll through Grand Canyon Village. Technically, they experience the Rim Trail, but they're missing a very special opportunity. Walking the

14-mile Rim Trail can be done in a day, but a better approach is to linger and soak in what you're sensing. Take two or more days to walk the Rim Tail and you'll be filled with a deeper appreciation of the wonder that's the Grand Canyon. The Rim Trail lies directly on the South Rim of the canyon and extends from Yaki Point (the trailhead for the South Kaibab Trail) in the east to Hermit's Rest in the west. It's paved for much of its length and is gently graded, with some sections being wheelchair accessible. The Rim Trail can offer remarkable peace and quiet, even moments of solitude, to say nothing of the ever-changing views of the canyon. The park's extensive shuttle bus system serves the trail, allowing you to walk as long and far as you want and then return to your origin by bus (or vice versa). A 1.3-mile section of the Rim Trail (between Verkamp's Visitor Center and the Yavapai Museum of Geology) is the Trail of Time, a special, award-winning interpretive trail that tells the geologic history of the park. Here a series of rocks and associated exhibits explain how the Grand Canyon was formed; each meter walked along the trail represents a million years in the canyon's geologic history.

Bright Angel Trail

The Bright Angel Trail is one of the most storied and iconic trails in all the national parks and is one of the two primary trails into the canyon. The trail connects the South Rim to the Colorado River over 10 miles of dramatic scenery, a mile of descent, and nearly two billion years of geologic history—a breathtaking hike by any definition. Given the natural and well-founded tendency to want to hike into the canyon, and the rewards of the very

different perspective it offers, visitors should consider walking the Bright Angel Trail, but only with the proviso that they're appropriately thoughtful about how far to walk. Hiking to the river and back on the Bright Angel Trail is a substantial undertaking (this is a 20-mile round-trip hike that includes 5,000 feet of elevation loss and gain) and requires planning, conditioning, and preparation. The NPS strongly discourages visitors from attempting this hike in a single day. The canyon can be very hot—well over 100 degrees Fahrenheit at the bottom in summer—and drinking water is available at only three places along the trail. The hike can be done more safely and enjoyably in two or more days, with overnights at Havasupai Gardens Campground and Bright Angel Campground and/or Phantom Ranch (a rustic lodge and restaurant) at the bottom of the canyon. Consider hiking to other destinations along the trail and then returning to the trailhead on the South Rim; popular sites include 1½ Mile Resthouse (3 miles round-trip), Havasupai Gardens (9.6 miles round-trip), and Plateau Point (12 miles round-trip). All these destinations offer the genuine experience of being in the canyon.

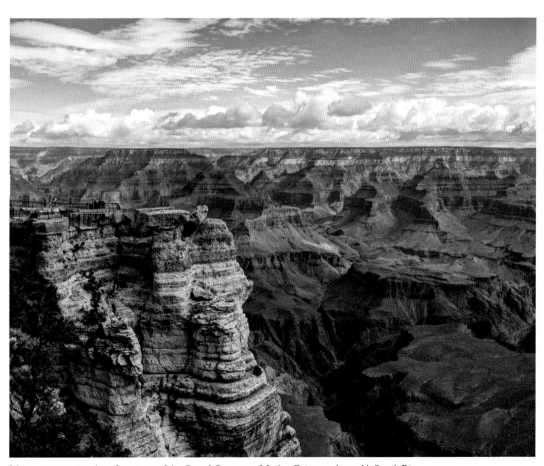

Most visitors enjoy their first views of the Grand Canyon at Mather Point on the park's South Rim.

South Kaibab Trail

The 7.2-mile South Kaibab Trail is the other of the two primary routes from the South Rim to the Colorado River and starts at Yaki Point, accessible by shuttle bus. "Kaibab" is Paiute and means "mountain lying down," their term for the Grand Canyon. Much of the trail follows a natural ridgeline in the canyon, resulting in spectacular panoramic views. At 14.5 miles to the river and back, this is a shorter route than the Bright Angle Trail, but it's also steeper and offers no drinking water. The NPS strongly discourages visitors from attempting this hike in a single day. The hike can be done more safely and enjoyably in two or more days, but there are only two reasonably accessible accommodations, Bright Angel Campground and Phantom Ranch, both at the bottom of the canyon. As with the Bright Angel Trail, consider hiking to other destinations along the trail and then returning to the trailhead on the South Rim. Popular sites include Cedar Ridge (3 miles round-trip) and the Tip Off (9 miles round-trip). Once again, both of these destinations offer the genuine experience of being in the canyon, something the vast majority of Grand Canyon visitors don't have.

Colorado River via the South Kaibab and Bright Angel Trails

Okay, you've decided to hike to the Colorado River, starting and ending at the South Rim. If you've given this appropriate consideration and prepared yourself, then congratulations: This is one of the world's great hikes. This is the classic route to the river and back, starting and ending on the South Rim. The South Kaibab Trail (7.2 miles and relatively steep) leads down to the river, and the Bright Angel Trail (about 10 miles with a gentler grade, a campground along the way, and drinking water) leads back up. Both trails are well maintained, and wayfinding is easy. Spending at least one night at the bottom of the canyon will make for a safer and more enjoyable adventure.

Rim-to-Rim Across Grand Canyon

Of all the fine hikes in the National Park System, this is one of the most iconic: a more than 21-mile cross section of the canyon's nearly two billion years of geologic history, including crossing the Colorado River and hiking two of the canyon's most fabled trails. Since the canyon's North Rim is a thousand feet higher than the South Rim, most hikers walk from north to south (saving themselves some elevation gain). The North Kaibab Trail drops off the 8,000-foot North Rim at Bright Angel Point and follows the natural fault line of Bright Angel Creek, an ancient route for Indigenous people through the canyon, taking just over 14 miles to reach the Colorado River. Cottonwood Campground is 6.8 miles from the North Kaibab Trailhead and offers an overnight option. As the trail approaches the Colorado River, hikers reach Bright Angel Campground (7.2 miles from Cottonwood Campground) and Phantom Ranch, both located on a substantial delta formed where Bright Angel Creek flows into the Colorado River, and the only overnight options. The following day, hikers cross the Colorado River on one of two bridges in this area—the only bridges along the nearly 300 miles of the river in the park. After crossing the river, hikers can choose between the Bright Angel Trail and the South Kaibab

Trail to reach the South Rim. This hike offers an overwhelming sense of satisfaction by completing one of the most iconic hikes in all the world. The hike includes the logistical challenge of getting to the North Rim to start your hike (see the park's website for commercial shuttle services or inquire at the park's visitor centers by phone or email to explore current shuttle options for hikers). Be warned that hikes into the canyon are often referred to as "mountain climbing in reverse"—you descend first and then must ascend the often-steep trails. Don't underestimate this challenge.

SPECIAL PROGRAMS

The National Park Service offers a sweeping array of interpretive programming that includes campfire talks, nature walks, and other activities. See schedules on the park's official website (under "calendar"), in the park's visitor centers, in the park's free newspaper, and on the NPS app. These offerings also include the NPS's award-winning Junior Ranger Program. The Grand Canyon Conservancy Field Institute, a nonprofit friends group of the park, conducts a suite of immersive and educational adventures in the park; see their website (grandcanyon .org) for more information.

LOGISTICS

Grand Canyon is a large national park—more than 1,900 square miles—larger than the state of Rhode Island, and includes several distinctive regions: the South Rim, Desert View, the North Rim, the Colorado River, and park's vast backcountry. The South Rim is the primary destination and includes most of the park's visitor facilities and services. The South Rim is further divided into the South Rim Visitor Center (and adjacent Mather Point viewing area), Market Plaza (with a large store, post office, and campgrounds), and the Historic District (including the railroad depot, historic lodges, and shops). Desert View is also on the South Rim but located approximately 30 miles east of Grand Canyon Village. The North Rim (including the North Rim Visitor Center and campground) is a 212-mile drive from the South Rim and is open only spring through fall (see the park's website for dates each year). The Colorado River is open to world-class float trips, but arrangements must be made well in advance. The vast backcountry is open to hiking and camping, but overnight trips require a permit. See the park's website for information and links regarding Colorado River float trips and hiking permits.

Grand Canyon offers a great range of lodging options. On the South Rim you'll find the historic El Tovar Hotel and Bright Angel Lodge, as well as several motels. The South Rim also has two large campgrounds at Grand Canyon Village and another at Desert View, east of the village. A few miles south of Grand Canyon Village, just outside the park entrance, lies the gateway town of Tusayan, with campgrounds and a range of contemporary motels. On the North Rim is the historic Grand Canyon Lodge, built by the Union Pacific Railroad; the lodge offers motel-style rooms and cabins. There's also a campground. The South Rim of the park is open year-round, but winters can be cold and snowy and summers are sometimes hot; visit the park in the offseason if possible—spring is especially nice when wildflowers are at their peak. Phantom

The park's modern and efficient transit system allows South Rim visitors to enjoy the park without the stress of searching for a parking spot.

Ranch, at the bottom of Grand Canyon, is a rustic lodge with cabins and dormitories and serves family-style meals.

The South Rim of the park offers an impressive shuttle bus system that services all major visitor attractions; this is a model for many of the heavily visited national parks in the United States. The buses run often, are quiet, reduce the carbon emissions of automobiles, help visitors avoid the problems of road congestion and lack of parking, and take visitors to and from most visitor attractions, facilities, and services. And they're free! The hub of the shuttle bus system is at the South Rim Visitor Center, where there's lots of parking; buses follow several standard routes. The free park map and newspaper available at all entrance stations and visitor centers provide details on how and when to ride the buses.

Like all US national parks, Grand Canyon has an official National Park Service website (nps.gov/grca) and the NPS app for the park (download it before entering the park). These are the most accurate and up-to-date sources of park information.

GREAT SMOKY MOUNTAINS NATIONAL PARK

Great Smoky Mountains National Park is a land of superlatives, and this is clearly ratified by its inscription on the World Heritage List. As part of the great range of Appalachian Mountains, the Smokies are among the oldest mountains on Earth, once as high as the present-day Alps and Rockies. Ultimately, natural forces eroded, sculpted, and rounded them into the more gentle landscape we see today. The park is the most biodiverse of all the US national parks; more than 20,000 species have been documented, and scientists believe that as many as 100,000 species may live here. The park is one of the largest nature reserves in the eastern United States and attracts more than twice as many visitors each year as any other national park.

The park's more than 500,000 acres lie along the spine of the Great Smoky Mountains, half in North Carolina and half in Tennessee. It includes dramatic mountain vistas, rocky streams, many impressive waterfalls, old-growth forests, a remarkable array of flowering plants, iconic wildlife, traces of Cherokee civilization, and remnants of early American settlements. The park's characteristic "smoke" is actually fog or mist derived from rain and evaporation. The park has more than 800 miles of trails, including 71 miles of the iconic Appalachian Trail.

The remarkable biodiversity of the Great Smokies is the park's defining characteristic; no place of equal size outside the tropics can compare. The reasons for this biodiversity start with the underlying geology of the area. The mountains were formed more than 200 million years ago when the North American and African tectonic plates collided, creating this range of mountains. The area was far enough south to be spared the effects of recent ice ages; thus the mountains have had a million years without major geologic change, giving them an especially long period for plants and animals to evolve and diversify. Other factors contributing to the park's biodiversity include its wide range of elevations (from less than 1,000 feet to nearly 7,000 feet) and its abundant precipitation. Lower elevations of the park average 55 inches of precipitation a year; upper elevations can receive up to 85 inches. The park includes more than 100 species of trees and 1,600 species of flowering plants; in both cases, this is more than any other US national park.

This redbud tree is a good example of the astonishing biodiversity of Great Smoky Mountains National Park.

Prominent types of vegetation include old-growth forests, with many specimens predating European settlement. Among the park's extensive collection of flowering plants, masses of showy mountain laurel and rhododendrons draw visitors from around the world. Other interesting vegetation patterns include the park's "balds," treeless areas on a number of mountain summits. The origin of balds is mysterious; ecologists have posited that they may be due to fire, grazing, violent storms, or even of Native American origin. They offer visitors stunning views of the surrounding landscape and are a destination of several of the park's most popular trails.

Of course this park's wide range of habitats means that many animals thrive in the park, including 70 species of mammals. Iconic examples include black bears, white-tailed deer, red and gray foxes, and elk. This is the largest protected bear habitat in the East, home to approximately 1,500 bears, and the National Park Service has recently reintroduced elk to the park. Open areas such as Cades Cove and Cataloochee offer good wildlife-viewing opportunities. The park is home to more than 250 species of birds, 40 species of reptiles, and over 60 species of fish. A remarkable 31 species of salamanders reside in the park, perhaps more than any other place on Earth.

Like all US national parks, Great Smoky Mountains is experiencing a variety of ecological challenges. The park suffers from air pollution, though clean air legislation has brought some recent improvements. Visibility has been diminished, but more importantly, this pollution has degraded the park's high-elevation red spruce population. Introduction of the hemlock woolly adelgid in 2002 has devastated many of the old-growth hemlock forests—notice this issue particularly along US 441 north of The Chimneys, where the "redwoods of the East" are clearly in trouble.

For centuries before there was a national park, the Cherokee people lived in this area in a sophisticated society that hunted and gathered in the forests. Spanish explorer Hernando de Soto discovered numerous Cherokee villages in 1540 while traveling through the southern Appalachian Mountains. However, under the Indian Removal Act of 1830, more than 15,000 Cherokee were marched out of their homelands for resettlement in Oklahoma to make way for gold mining and early American settlement. About 4,000 perished on this arduous, six-month journey, the infamous Trail of Tears.

Frontier people began settling the area in the 18th and early 19th centuries, and the park's popular Cades Cove community is an excellent example of this rural, self-sufficient lifestyle. The community once had nearly 700 residents and is remembered today with three surviving churches, several log homes, barns, a gristmill, and a blacksmith shop. However, the Civil War severely disrupted life in this region. The early 20th century saw clear-cutting of large areas of virgin forests, and this led to calls for preservation of the area. Early park supporter Horace Kephart publicly asked, "Shall the Smoky Mountains be made a national park or a desert?" The park was finally established in 1934, helped by a $5 million gift from John D. Rockefeller Jr. Since most of the land included in the park was privately owned, these properties had to be purchased, and many people were eventually displaced, causing some resentment

This mill is one of many historic buildings protected in Great Smoky Mountains National Park.

among local families that lingers to the present day. The park was inscribed as a World Heritage Site in 1983.

VISITOR ATTRACTIONS

As the name of the park suggests, the Great Smoky Mountains are the heart of the park; this ancient range of mountains is an iconic part of the larger Appalachians. Though the mountains rise only about 6,500 feet, this concentration of peaks, row upon row of them with their gently rounded shapes, is especially pleasing to the eye. And their distinctive "smoke" gives them their name. With nearly 400 miles of roads and 800 miles of trails, there are lots of options for seeing and appreciating these distinctive mountain landscapes.

Newfound Gap Road bisects the park, rising to Newfound Gap at just over 5,000 feet. In southern Appalachian vernacular, a "gap" is a low point in the ridgeline of a mountain range (New Englanders call these places "notches" and Westerners call them "passes"). Newfound Gap wasn't located until 1872; thus its "Newfound" moniker. In ecological terms, the 3,000-foot rise in elevation along Newfound Gap Road is roughly equivalent to experiencing the range of biological conditions from Georgia to Maine.

At 6,643 feet, Clingmans Dome is the highest point in the park and a popular short

hike (see the description below). The final climb up the observation tower offers quintessential views out over the forested ridges of the Smoky Mountains that seem to go on forever (though the obvious decline of much of the surrounding forest is troubling).

From a scientific perspective, the park's remarkable biological diversity is its distinguishing characteristic. Visitors can get a sense of this ecological richness by appreciating the many species of plants and animals. The park's diversity of wildflowers, along with the biological abundance of the area's old-growth forests, rightly capture the attention of many visitors. And these widely varying habitats support diverse wildlife; the park's large population of black bears is a good example.

The human history of the park is a vital element of its appeal as well. While there are few physical manifestations of Native American presence in the park, the early history of European-American settlers is found in several important locations, including the communities of Cades Cove and Cataloochee, that preserve early settlements, including cabins, mills, churches, and school buildings.

The steep gradients in the park and abundant rainfall combine to produce countless waterfalls that delight many visitors. Grotto, Laurel, Abrams, and Rainbow are some of the largest and most popular falls, but smaller falls and cascades abound, just waiting to be discovered by visitors.

The famous Appalachian National Scenic Trail (more popularly known as the "AT"), the nearly 2,200-mile route from Georgia to Maine, runs for 71 miles through the park. The AT roughly follows the border between North Carolina and Tennessee

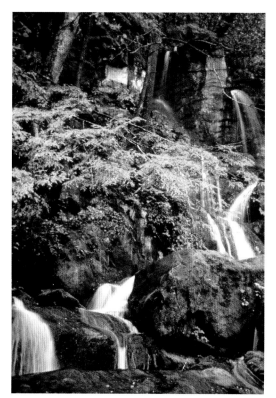

Great Smoky Mountains National Park is known for its extensive collection of waterfalls.

along the width of the park, reaching its highest point at Clingmans Dome. The trail is marked with white blazes and served by a series of overnight shelters. Consider a short (or longer?) walk on this iconic trail (see the description of the hike to Charlies Bunyon below; overnight hikes require a permit).

VISITOR CENTERS

Visitor centers are always the best place to begin your exploration of the national parks, and Great Smokies has four of them! Be sure to get a free park map and newspaper at any of these visitor centers. These visitor centers also have educational displays, knowledgeable staff, books about the park

and surrounding region, gift items, and restrooms. Sugarlands Visitor Center is in the North District of the park near Gatlinburg, Tennessee; it serves as the Backcountry Permit Office too if you plan to do some backpacking in the park. Oconaluftee Visitor Center is in the South District of the park near Cherokee, North Carolina. The adjacent Mountain Farm Museum includes a collection of historic log structures. Cades Cove Visitor Center is roughly halfway around the Cades Cove Loop Road and is in the center of a large cluster of historic buildings where you can learn about Southern mountain life and culture. The visitor center at Clingmans Dome is small (it's technically a "visitor contact station"), but it's a good place to get your questions answered.

DRIVING TOURS

Great Smoky Mountains National Park is large—more than 800 square miles—so driving park roads is a popular way to appreciate the area. And there are 384 miles of roads to choose from! The 32-mile Newfound Gap Road traverses the park, anchored at Cherokee, North Carolina, in the south and Gatlinburg, Tennessee, in the north. The road climbs 3,000 feet to reach its namesake Newfound Gap, a 5,046-foot pass through the Smoky Mountains and the boundary between North Carolina and Tennessee. A large parking area at the gap allows for great views and for a hike on the famous Appalachian Trail (see the description of the hike to Charlies Bunion below). Just south of the gap, a 7-mile spur road leads to Clingmans Dome and a short walk to the observation

tower that offers what may be the best views in the park from the "top of old Smoky."

The 11-mile Cades Cove Loop Road is another popular drive (reached from Little River and Laurel Creek Roads). Cades Cove is a broad valley in the northwest area of the park that features scenic beauty, frequent wildlife sightings, and a large cluster of historic buildings. Cherokee people hunted in Cades Cove for hundreds of years, and European pioneers settled here in the early 1800s. The Loop Road features three churches, a working gristmill, barns, log houses, and other restored structures. Lots of trails are accessible from this area, and the Loop Road is usually closed to vehicles on Wednesdays in summer, offering a more peaceful alternative to bikers and hikers.

Eleven-mile Cove Creek Road on the eastern side of the park leads to the historic village of Cataloochee. This lovely valley was once one of the largest and most prosperous settlements in what is now the park; residents farmed and catered to early tourists. Buildings include two churches, a school, and several homes and associated outbuildings. More recently, a herd of elk has taken up residence. The last part of the road is unpaved and narrow, but is generally passable with appropriate caution.

Roaring Fork Motor Nature Trail is a 5.5-mile loop road near Gatlinburg that caters to a leisurely drive featuring mountain streams, lovely forests, and historic buildings, as well as trails that lead to park waterfalls, including popular Rainbow Falls.

Though the Blue Ridge Parkway isn't in the park, it leads directly to the park's front door at the northern entrance. This

This bull elk is one of a growing herd that has been reestablished in the park.

lovely road wanders 469 miles, connecting Great Smoky Mountains National Park and Shenandoah National Park to the north. The parkway was designed specifically to take advantage of views and other attractions along the ridgelines of the southern Appalachian highlands, and the winding character of the road, changes in elevation, and associated low speed limit afford a leisurely long-distance trip, often called "America's Favorite Drive."

HIKING PARK TRAILS

Walking/hiking park trails is the most intimate and rewarding way to experience and appreciate national parks, and Great Smoky Mountains is a great example. As noted earlier, the park includes more than 800 miles of trails, making it a hiker's delight.

Clingmans Dome Observation Tower Trail

Reaching the summit of the park's highest mountain at 6,643 feet (the third-highest mountain in the East) is a great place to begin. The summit of the dome is topped by

an iconic and fanciful observation tower that offers the best views in the park. The walk is a 1-mile journey (round-trip) on a paved trail, but it's steep in places before you reach the 375-foot-long ramp of the observation tower and the viewing platform. But there they are—row after row of lush mountain ridges, often muted by the area's characteristic "smoke." Unfortunately, you can't help noticing that many of the trees in the foreground are dead or dying. Several factors are conspiring to kill trees in the park, including acid rain, ozone, climate change, and the non-native balsam woolly adelgid (an insect introduced from Europe). On the way down the trail, note signs for the Appalachian Trail that runs right through this area, and consider bagging a few steps on the famous "AT."

Charlies Bunion Trail

This hike begins and ends at Newfound Gap, the highest point on the park's striking Newfound Gap Road. From the parking lot, step onto the iconic AT and enjoy a walk of 4 miles (each way) along this world-famous trail. There are several steep ascents, but the trail is generally well maintained and is marked with white blazes that characterize the AT throughout its nearly 2,200 miles. At mile 3, there's a short side trail to Icewater Spring Shelter, one of the many shelters along the AT; visit it to get a sense of the life of an AT thru-hiker. At mile 4, a short path on the left leads to Charlies Bunion, a steep, rocky promontory with staggering views. The side path forms a loop around the rocks and returns to the AT, where you should retrace your steps to Newfound Gap. By the way, the unusual name comes from an early park supporter who, on a 1920s hike

in the area, said the promontory looked like the bunion on the foot of his hiking companion (presumably Charlie!).

Ramsey Cascades Trail

In a park filled with waterfalls, Ramsey Cascades may be the most impressive, and it has the added advantage of a striking trail that leads to its base. The is an 8-mile out-and-back hike that features gaudy spring wildflowers, groves of rhododendrons, and old-growth forests that feature giant tulip trees, so called for their distinctive flowers. Much of the trail follows and crosses several "prongs," the local name for streams. The last quarter mile is a bit of a scramble that brings you to the base of the falls. The boulders that frame the falls make a great place for a well-deserved and scenic picnic lunch before retracing your steps to the trailhead. Resist climbing up and around the falls, which can be dangerous—even fatal.

Laurel Falls Trail

It's hard to resist hiking to so many of the park's waterfalls, and here's one for the whole family. Laurel Falls are sublime and are reached by a 1.3-mile (one way) paved trail. Most of the walk to the falls is gently uphill (and the return trip gently downhill!). It's also one of the park's nature trails—be sure to get a copy of the brochure at the trailhead. This is a popular trail, and for good reason; you get a lot of reward for relatively little effort. Nearly everyone turns around at the falls and returns to the trailhead, but there's an option to continue along the (now-unpaved) trail through an old-growth forest and on to Cove Mountain.

Mount LeConte/Alum Cave Trail

The hike to the summit of Mount LeConte may be the park's most glorious. Though the mountain is only the park's third highest at 6,593 feet, it's a favorite of many

Hikers can climb to the summit of Mount LeConte using several trail options.

Great Smokies hikers. Several trails lead to the summit of iconic Mount LeConte, but Alum Cave Trail may be the most popular because it features open views and a number of natural attractions, including Alum Cave Bluffs, two varieties of rhododendrons, and Arch Rock. It's the shortest route to the summit (about 10 miles round-trip and 3,000 feet of elevation gain), but also the steepest. Just before you reach the summit, you pass LeConte Lodge; built in the 1920s, it's a rustic resort (some might say romantic) of cabins and a restaurant, the only accommodations in the park. (The lodge sometimes offers pack lunches for hikers.) A short scramble beyond the lodge brings you to High Top (the true summit) and Myrtle Point, which offers the finest views from the summit area. Hike back down to the trailhead, or choose one of the other trails (Boulevard, Rainbow Falls, and Bullhead Trails are good options) to add variety (but you'll need a shuttle between trailheads).

Quiet Walkways

The park also offers an innovative series of hiking opportunities that make an appealing alternative to the sometimes-crowded trails, such as those noted above. These Quiet Walkways have no special destination but simply wander through some of the lovely landscape that is the Great Smokies. Look for the small signs and parking areas along park roads and sample some of these walks that feature a refreshing measure of beauty, solitude, and natural quiet.

SPECIAL PROGRAMS

The park offers several special programs that span the annual calendar. The Wildflower Pilgrimage is held in the spring; given the expansive biodiversity of the park, its prolific wildflowers are world renowned. The fall Music of the Mountains festival celebrates the rich musical traditions of the Southern Appalachians. The Smokies Harvest Celebration is held in the fall and features interactive demonstrations such as blacksmithing, apple cider pressing, broom-making, sorghum processing, and woodworking. The Holiday Homecoming and Festival of Christmas Past celebrate Christmas in the Smokies with traditional music, crafts, demonstrations, and storytelling. Check the park's website (noted below) for dates of these special programs.

Like all US national parks, Great Smoky Mountains offers a variety of interpretive programs led by National Park Service rangers; see the schedule of activities in the park's free newspaper, on the park's official website, at visitor centers, and on the NPS app. And don't forget the NPS's popular Junior Ranger Program.

LOGISTICS

The park is open year-round, but winter weather can be harsh, with snow and ice. Spring brings the peak of wildflowers and makes a wonderful season to visit. Fall is also an excellent time to visit, although October is a very popular month for fall foliage. The park's many attractions and its proximity to

population centers means the summer visitor season can be especially crowded. The park's main access road, US 441 (Newfound Gap Road), is especially scenic and provides access to many trailheads. This and the road that services the Cades Cove area of the park are often heavily congested. Rise early on the days you visit these areas to avoid traffic and to find a parking spot. Although there is no fee to enter the park, there is a fee for parking anywhere in the park for more than 15 minutes. Parking passes are available at visitor centers, automated kiosks, or online at Recreation.gov. Check the park's website for more information.

Rustic and colorful LeConte Lodge is the only hotel in the park; it's a backcountry facility requiring a challenging hike to reach it (see the above section on trails/hiking). The lodge serves hearty meals to hungry hikers, and the views are epic. Reservations are required, with most dates booked a year in advance. See the lodge's website (lecontelodge.com) for more information. More conventional hotels and motels, along with other commercial facilities and services, are found in the gateway towns of Gatlinburg and Pigeon Forge, Tennessee, and Cherokee, North Carolina. There are 10 campgrounds in the park, although none have RV hookups; there are many commercial campgrounds outside the park. Only (very) limited food and beverage services, groceries, and convenience items are available in the park; there are no gas stations. All of these services are readily available in the surrounding towns of Gatlinburg, Pigeon Forge, Cherokee, and Townsend. Find the most complete and up-to-date information on the park at its official website: nps.gov/grsm.

HAWAI'I VOLCANOES NATIONAL PARK

Visitors to Hawai'i Volcanoes National Park have front-row seats to one of the most dynamic landscapes on earth. Of course all the Hawaiian islands are of volcanic origin, but the island of Hawai'i, generally called the "Big Island," is the only one of the eight major islands that's still volcanically active. In fact, it has two of the world's most active volcanoes. Mauna Loa is massive, rising nearly 14,000 feet above the surrounding ocean. Measured from its base on the ocean floor, some 18,000 feet below sea level, it's Earth's largest mountain, much higher and more massive than Mount Everest. Its bulk is estimated at an astonishing 19,000 cubic miles. Mauna Loa last erupted in 1984. Kīlauea is much shorter—only a little more than 4,000 feet above sea level—but is especially active, erupting more or less continuously since 1983, including the highly destructive lava flows in 2018. This is the world's longest lived historical volcanic eruption, and scientists believe it could continue for much longer.

Hawai'i sits in the Pacific Ocean directly on top of a place in the Earth's crust where lava pushes up under the mantle of the planet, powering active volcanoes; Hawai'i Volcanoes is at ground zero. The park was established in 1916, and scientists have been studying these volcanoes for many years, learning much about the creation of these special islands and the very birth of the planet. The park is so important to scientists

and the public that it was designated a World Heritage Site in 1987.

All the Hawai'ian Islands were created by undersea volcanic activity, a process that began some 70 million years ago and continues today on the island of Hawai'i. Magma and other materials emitted from these volcanoes hardened and grew over time, eventually breaking through the surface of the sea to create a chain of islands. Visitors to the park can often witness this process firsthand as lava flows cool (sometimes dramatically reaching the ocean) and solidify into new land. The island of Hawai'i is the youngest in the archipelago and is still very volcanically active, as manifested nearly everywhere in the park. Another island is now forming to the southeast of Hawai'i as a result of an undersea volcano called Lō'ihi; however, it's not expected to break the surface of the ocean for another 200,000 years or so.

Volcanoes emit two types of lava, both found in abundance at Hawai'i Volcanoes. A'a lava flows are composed of a layer of brittle fragments or cinders called "clinkers," very rough and challenging to walk on and tough on shoes. Extremely hot liquid lava (more than 2,000 degrees Fahrenheit) creates pahoehoe lava flows; they're characterized by ropey, corrugated surfaces and cracks caused by contraction during cooling. It can also be rough, but is generally easier to walk on than a'a. Other materials emitted from

The 2023 eruptions in the park offered visitors jaw-dropping views of the power of Kīlauea.

the park's volcanoes include gasses and ash. Since all of these materials can be very dangerous to humans, visitors must follow park regulations to help ensure their safety.

The range of elevations in the park—from sea level to nearly 14,000 feet—is exceptional, and this gives rise to many types of environments, including lava deserts, rain forests, coastal beaches, and an alpine mountain summit. After the Hawaiian Islands emerged from the sea, they were eventually colonized by many forms of life. This was a long process, as the islands are among the most isolated places on earth, more than 2,000 miles from any continent or other significant landmass. The islands were initially populated by plants and animals through the processes of "wind, water, and wings." Seabirds such as noddies, albatross, and plovers flew directly to the islands as soon as they were habitable for resting and nesting; other birds were blown to the islands by wind and storms. Some of these birds carried seeds clinging to their wings and in their digestive tracts. Seeds, insects, spiders, snails, and other forms of life were carried to the islands on floating ocean debris. All of these plants and animals adapted to this new environment, evolving in the process and creating new species and subspecies. This colonization took place over more than 30 million years; as a result, a remarkable 90 percent of island's native plant and animal life is endemic, meaning it naturally occurs nowhere else on Earth. Unfortunately, humans have more recently introduced other forms of life, and these newer species threaten much of the island's natural diversity. Even the state bird, the nēnē, or Hawaii'an goose, is now threatened by competition from other wildlife. In addition to terrestrial species, the warm, shallow waters that surround the island support humpback whales, sea turtles, many species of fish, and other marine animals.

It's believed that the first humans on the islands traveled there around the year 1100. These people were probably from the present-day Marquesas, with later arrival by Tahitians (Society Islands) who sailed and paddled double-hulled canoes a remarkable 2,500 miles. The boats were loaded with supplies such as pigs, dogs, and chickens, as well as plants such as taro, sweet potatoes, coconuts, sugarcane, bananas, and medicinal plants to support colonization of the islands. Many native Hawaiians consider Kīlauea Volcano a sacred place, the body of Pele, the goddess of Hawaiian mythology. Captain James Cook landed on the island several times in the late 18th century, but was eventually killed by the inhabitants. Tourism emerged as one of the island's primary economic activities in the middle of the 19th century, and this gave rise to a movement to create a national park on the islands of Hawai'i and Maui. Hawai'i Volcanoes National Park was established in 1916, becoming the eleventh US national park and the first to be formed on what was then a US territory. It was inscribed as a World Heritage Site in 1987.

VISITOR ATTRACTIONS

Visiting the dramatic and dynamic land-scape that is Hawai'i Volcanoes National Park is a privilege; see firsthand some of the foundational geologic processes that have shaped the landscape here and in many regions of the world. This is a rarity: geol-ogy on a human time scale. Take the time to learn about it and the opportunity to see it firsthand at ground level on the park's roads

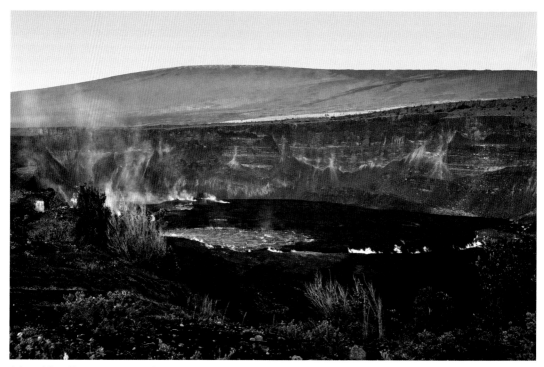

A large lake of lava remains in a volcanic crater a few days after a recent eruption.

and trails, and at the visitor center, exhibits scattered around the park, and through the park's interpretive programs.

VISITOR CENTER

The park's Kīlauea Visitor Center is located just beyond the park entrance station and should be the first stop for new park visitors. The building includes educational exhibits and related information, and is staffed by park rangers and volunteers who can help plan visits and provide the latest information on park conditions (remember, the park is a highly dynamic landscape). The Hawai'i Pacific Parks Association operates a park store here that stocks books, posters, and related park materials; proceeds benefit park programs.

DRIVING TOURS

The park's network of paved roads supports two driving tours, excellent ways to see the park. Be sure to stop at overlooks and other points of interest. Crater Rim Drive is a dramatic 11-mile route that circles the rim of Kīlauea Caldera. Major stopping points include Uēkahuna (an important site of native Hawaiian cultural practices and a great viewpoint); Kīlauea Overlook (perhaps the most dramatic view of the caldera); Wahinekapu (feel the heat from the steam vents below); Ha'akulamanu (note the colorful sulfur crystals and other minerals deposited by the volcano along the trail and boardwalk); Kīlauea Overlook (peer directly into the volcanic crater); Nāhuku (also known as Thurston Lava Tube, a 500-year-old cave where a river of

Hikers enjoy the park's extensive trail network.

lava once flowed); Puʻupuaʻi Overlook (views of Kīlauea Iki Crater and a massive cinder cone); and Keanakākoʻi Crater (a pit crater that has been active for centuries).

Chain of Craters Road is a spectacular 38-mile (round-trip) road that branches off Crater Rim Drive and leads to the Pacific Ocean, where it dead-ends due to a massive lava flow that covers the road. Major stopping points include Luamanu and the July 1974 Flow (lava entered this pit crater in 1974); Puhimau Crater (a dramatic chasm/pit crater); Piano Crater (a large pit crater); Puʻuhuluhulu cinder cone (a short hike to this cinder cone offers views of the Maunaulu lava shield); Mau Loa o Maunaulu (a dramatic expanse of lava flows); Kealakomo Overlook (views out over the Pacific Ocean); Alanui Kahiko (view of the Old Chain of Craters Road, covered by a lava flow in 1972); Puʻuloa Petroglyphs (a sacred site and large grouping of petroglyphs); and Hōlei Sea Arch (a lava rock arch extending into the Pacific Ocean).

HIKING PARK TRAILS

Hawaiʻi Volcanoes is laced with more than 150 miles of trails that include black sand beaches, arid deserts, rain forests, and the volcanoes themselves. What better way to see and appreciate these places than to walk through them? More than half the park is designated wilderness, offering intimate opportunities to experience these remarkable natural and cultural resources. However, you must accept the realities of the changes that occur in the park—sometimes on a daily basis—that close some park roads, observation areas, and trails. You must also respect

the potential dangers that are inherent in this experience by heeding all warnings issued by park managers. It's strongly advised that you check the park's website (noted below) and speak with rangers for up-to-date information. Mahalo.

Crater Rim Trail

As the name suggests, this trail encircles Kīlauea's large summit caldera, offering many dramatic views of its volcanic features and the surrounding landscape. See and hear gases and steam as they rise from the floor of the caldera and its 400-foot cliffs and appreciate the lush rain forests that line much of the Crater Rim Trail. The trail offers stunning views from many perspectives as it circles the large crater, and Crater Rim Drive offers many access points to the trail. This is a long loop trail (more than 11 miles), but it is relatively flat; most hikers select sections of the trail to walk. *Note:* Parts of the trail may be closed due to volcanic activity, including emission of dangerous gases, so check the park's current conditions at the visitor center and on the park's official website.

Kīlauea Iki Trail

After circling portions of Kīlauea's summit caldera, it's time to take this unusual opportunity to walk into this major volcanic crater and across the floor of a solidified, but still-steaming, lava lake. Along the floor of the volcano, see steam vents, cinder and spatter cones, and pass the Puʻu Puaʻi cinder cone, source of Hawaiʻi's highest lava fountain, an impressive 1,900 feet, recorded in 1959. This is a 2.4-mile out-and-back walk that leads through a rain forest before it descends 400 feet into the crater.

Damage to park infrastructure is often caused by volcanic eruptions and associated earthquakes and landslides; be sure to follow signs and messaging while in the park.

Pu'u Loa Petroglyphs Trail

Native Hawaiian culture is often depicted in petroglyphs, images carved in stone, and more than 20,000 of these striking images are found along the Pu'u Loa Trail, just off the Chain of Craters Road as it approaches the Pacific Ocean. The trail is a boardwalk constructed over a vast, 500-year-old lava field and offers excellent views of many of the petroglyphs found here. Native Hawaiian elders placed the piko (umbilical cord) of their children at this site in hopes their offspring would have a long and prosperous life. This 1.4-mile out-and-back trail is generally easy. Please stay on the boardwalk and off the lava and petroglyphs; refrain from making rubbings of petroglyphs.

Nāpau Trail

A few miles down the park's impressive Chain of Craters Road is the Mauna Ulu Trailhead, which provides access to the Napāu Trail, a route that passes many interesting volcanic features, especially Mauna Ulu Crater, Pu'uhuluhulu cinder cone, and Pu'u 'Ō'ō volcanic cone. Mauna Ulu erupted from 1969 to 1974; its name translates to "growing mountain," a reference to the height it attained. The summit of Pu'uhuluhulu cinder cone is easily reached on a short side trail and offers wonderful views all the way to the sea. Pu'u 'Ō'ō erupted from 1983 to 2018, and its especially large lava flows covered miles of the park's landscape, burying the park's Coastal Highway in more than 100 feet of

Visitors are welcome to hike through the park's impressive Thurston Lava Tube.

lava and pouring into the sea to make new land. Today you can hike the Nāpau Trail for seven miles to Puʻu ʻŌʻō, where there is a designated campsite (which requires a permit); the trail is mostly over massive flows of both aʻa and pahoehoe lava, and the going is slow. However, Puʻuhuluhulu is only 2.5-miles (round-trip) from the trailhead and an excellent destination.

SPECIAL PROGRAMS

Like nearly all national parks, a series of interpretive programs are offered regularly and vary in subject matter. Presenters include park rangers, scientists, Hawaiian practitioners of art and culture, and Hawaiian musicians. Check the park's website (noted below) for days, times, and locations.

LOGISTICS

The park is open year-round, but fall is normally the driest period. Due to the extreme range in elevations, the climate varies substantially from place to place. For example, beaches are normally warm and breezy, the summit of Kīlauea can be wet and cold, and elevations over 10,000 feet can drop below freezing with occasional snow. The historic Volcano House offers dramatic lodging perched directly on the rim of Kīlauea Caldera. There are also two campgrounds in the park, Kulanaokuaiki and Nāmakanipaio (the latter also offers several camper cabins). County and state campgrounds are located outside the park, as are B&Bs, motels, and other lodgings. For the most up-to-date information, be sure to check the park's official website: nps.gov/havo.

HOPEWELL CEREMONIAL EARTHWORKS

Hopewell Ceremonial Earthworks is a serial World Heritage Site located in south-central Ohio. It's a collection of eight archaeological sites that feature monumental earthen structures representative of a larger number of the original such sites scattered across this sizable geographic region. The World Heritage Site is managed by two agencies, the US National Park Service and the nonprofit Ohio History Connection. The Hopewell Culture is the apex of what archaeologists call the Woodland period of prehistoric Native American cultures; sites celebrated at Hopewell Ceremonial Earthworks date from approximately 1 to 400 CE. The Woodland period is distinguished from the earlier Archaic period and the later Mississippian period. Like the Archaic period, peoples of the Hopewell Culture practiced hunting and gathering but also pursued small-scale agriculture in garden plots and lived in widely dispersed settlements scattered throughout the region. In the later Mississippian period, people lived in large villages and practiced large-scale agriculture. (See the chapters on Cahokia Mounds State Historic Site and Monumental Earthworks of Poverty Point for examples of the Archaic and Mississippian periods in pre-Columbian North America.)

The Hopewell Culture is internationally recognized for its construction of substantial earthworks that featured large enclosures, often in a wide variety of nearly exact geometric shapes (such as circles and squares) that incorporated standard units of measurement. These earthworks were used for ceremonial and other cultural purposes, not for habitation or defense, and some were precisely aligned for astronomical purposes. The earthen walls of the enclosures are among the largest earthworks in the world that were not constructed and used as fortifications; this distinguishes them from other earthworks found throughout much of the world, which include tumuli (usually burial sites) and hill forts. Many of the Hopewell sites were built at a monumental scale. For example, earthen walls up to 12 feet high outlined geometric shapes more than 1,000 feet across, and conical and loaf-shaped mounds were up to 30 feet high. The massive scale of the Hopewell earthworks is illustrated by the fact that four structures the size of the Colosseum of Rome would fit within the Octagon, just one of the Hopewell sites, and the famed circle of monoliths at England's Stonehenge would fit into one of the small auxiliary earthwork circles adjacent to the Octagon. The impressive size of these structures is magnified by the fact that they were all constructed by hand, without the advantage of wheeled carts or mechanical means.

The Hopewell Culture is internationally recognized for its construction of substantial earthworks, often in a wide variety of nearly exact geometric shapes that incorporated standard units of measurement.

Archaeological evidence suggests that these large earthworks were used primarily for ceremonial and other social/cultural purposes; members of the Hopewell Culture lived in very small family/social groups that were widely dispersed throughout the geographic area. Some of the sites at Hopewell Ceremonial Earthworks include burial mounds that were constructed using an elaborate process. First, a large ceremonial building was constructed of poles and bark with a plastered clay floor. Fires burned in clay basins, and associated ceremonies were conducted; when these rituals were funerals, human bodies were cremated and the ashes entombed on the floor of the building beneath a small mound of clay. Eventually the wooden building was dismantled and a large mound constructed on the site; construction of the mound occurred in stages over many social/cultural gatherings.

Another distinguishing feature of the Hopewell Culture is the presence of many artifacts made from exotic materials imported from distant sources, indicating that these sites were important social/cultural centers with connections to communities in much of eastern North America and beyond. People of the Hopewell Culture traveled long distances—as far north as the

Upper Peninsula of Michigan, as far west as the Rocky Mountains, and as far south as the Gulf of Mexico—by foot and by boat to collect fine examples of exotic materials, including obsidian, copper, mica, pipestone, flint, sharks' teeth, and whelk and other seashells. It's likely that these materials were also brought to the Hopewell sites as gifts by residents of these distant places. These materials were fashioned by Hopewell artisans into spearpoints, geometric cutouts, effigies, pipes, and other ritualistic objects.

The term "Hopewell Culture" references the impressive collection of massive earthworks, the physical manifestation of this distinctive period of pre-Columbian American history, and the broad network of economic, political, and spiritual beliefs and practices associated with them. "Hopewell" is simply derived from the late 19th-century M. Cloud Hopewell family, which owned land where early excavations were conducted. The impressive earthworks and associated artifacts of this World Heritage Site represent a flourishing culture that exhibited remarkable achievements in the fields of engineering, mathematics, astronomy, and art.

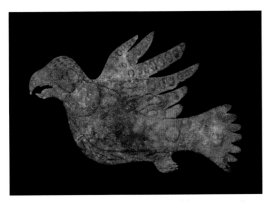

This stylized copper bird is an example of the many artifacts made from exotic materials imported from distant sources.

It's important to note the connection between this World Heritage Site and contemporary Native American people who trace their cultural origins and connections to these times and places. For example, the Shawnee are believed to have lived in this region of Ohio for many generations before European-American settlement of the area, but were forced to relocate to Oklahoma by the provisions of the Indian Removal Act of 1930. At the 2023 inscription of the World Heritage Site, Shawnee Chief Glenna Wallace, who had worked for years to help advance the nomination of the area, stated to the World Heritage Committee: "I want people to know that the tribes are still in existence, still striving to keep our language and culture. We're here. We're alive; part of our heart will always be in Ohio."

VISITOR ATTRACTIONS

Hopewell Ceremonial Earthworks includes many visitor attractions that are best organized and described by the eight principal sites included in the World Heritage Site. The first five of the following attraction sites are part of the large Hopewell Culture National Historical Park managed by the US National Park Service; the remaining three sites are managed by the Ohio History Connection, a nonprofit group.

Most of the original earthwork structures throughout the region have been damaged by centuries of erosion and, more recently, by years of agricultural plowing and planting and by early archaeological excavations that weren't executed to contemporary standards. (Contemporary archaeology at the site is conducted more sensitively, focused

on non-burial areas, and in consultation with local Indian tribes.) Visitors must use some imagination—along with educational materials, displays, and collections—to fully appreciate the scale of many of these earthworks. However, some of the earthworks have been reconstructed and managers now mow grasses ("interpretive mowing") in open areas in a manner that helps visitors envision the location and size of the earthworks.

Hopewell Mound Group

This may be the most important ceremonial location within the World Heritage Site. This complex encompasses 130 acres with an earthen wall of over two miles enclosing an immense sacred space that included 29 burial mounds. One of the mounds was the largest ever built by the Hopewell; Hopewell Mound 25 was 500 feet long and 33 feet high. An especially large collection of finely crafted art made of exotic materials has been excavated at the site, including a mica bird claw, a copper bear paw, and a mica hand

with elongated fingers stretching upward—all iconic images of the Hopewell Culture. The site includes a 2.5-mile interpretive walking trail, restrooms, and a picnic shelter.

Mound City Group

This important site is the only nearly fully restored earthwork complex that is on intact base layers and has an extensive record of field research. The large site (nearly 17 acres) consists of 25 mounds of varying sizes surrounded by a low earthen wall. A gateway is present on the eastern side and the western side. The mounds take both spherical and loaf-shaped forms, rise to nearly 18 feet, and are up to 100 feet in diameter. During World War I, US Camp Sherman, a military training center, occupied the Mound City site; reconstruction of the site began shortly after this military facility was decommissioned after the war. A one-mile nature trail surrounds the earthworks and visits the Scioto River. Visitors are welcome to walk respectfully through the mound

Some of the locations in this World Heritage Site include surrounding lands and waters that feature native plants and animals (such as these wood ducks).

area, though walking is not allowed on the mounds or earthen walls.

Hopeton Earthworks

The complex of earthworks at this site includes an 18-acre Great Circle with a diameter of more than 1,000 feet (the circle's dimensions were replicated at four other earthworks sites in the region), a nearly 20-acre square, at least two small circles, and two linear parallel walls of nearly 2,400 feet built to align with the sunset on the winter solstice. Various modern technologies have been used at the site to locate almost 14,000 artifacts. The site includes a 1.1-mile (round-trip) walking trail that leads to an overlook.

Seip Earthworks

Almost two dozen giant geometric earthwork complexes were constructed by the Hopewell people on the high terraces along Paint Creek and Scioto River Valleys; one of the most impressive was Seip Earthworks. This site includes almost two miles of an embankment wall enclosing nearly 90 acres, a large partial circular enclosure over 1,600 feet in diameter, a smaller circle with a diameter of nearly 1,000 feet, and a precise square with sides of nearly 1,000 feet. The complex design of this site was replicated at four other earthwork complexes in this geographic area, strongly suggesting that the Hopewell people had a common unit of measurement 2,000 years ago and that they understood mathematical relationships between circles and squares. Seip Earthworks includes an enormous central burial mound (sometimes referred to as Seip Mound) that has been reconstructed. A number of iconic artifacts have been found here, including the famous clay Seip Head and some of the few intact samples of Hopewell cloth woven of milkweed fibers and dyed to create patterns of circles and curves that reference the area's earthworks. The site includes a short network of trails and interpretive signs.

High Bank Works

This nearly 200-acre site includes multiple earthworks located on a terrace above the Scioto River. The two major features are a circle and an octagon, each approximately 1,000 feet in diameter. Eight smaller mounds were located inside the octagon, corresponding to the eight points that intersect the outer walls; six of these points form gateways to the octagon, and one connects to the large circle. The large circle has one gateway and is opposite a smaller circular enclosure that is 250 feet in diameter. Other earthen structures at the site include additional circles and two nearly parallel embankments that extend about 2,000 feet. High Bank Works is reserved for archaeological research and is generally not open to visitation except for occasional ranger-led hikes; check the park's official website (noted below) for dates and times.

Fort Ancient Earthworks and Nature Preserve

Fort Ancient is the largest hilltop enclosure in North America, a 126-acre plateau that's part of the first state park in Ohio (established in 1891). The name of the site is a misnomer because contemporary interpretation of archaeological evidence suggests that the Hopewell Culture earthworks didn't serve a defensive purpose. This elevated site sits above the Little Miami River, and the

human-built embankments rise as much as 23 feet. Sixty-three gateways or notches pierce the embankments, and finely crafted ceremonial objects of exotic materials have been found here. The site includes several mounds, including some covered in limestone. Morehead Circle, near the site's museum, was likely a so-called "Woodhenge" (referencing England's Stonehenge), a circular arrangement of wooden posts in three concentric circles. The site is thought to be a remarkable example of the Hopewell Culture's astronomical sophistication; for example, two of the gateways/notches noted above form a sort of calendar on the land. At sunrise on the winter solstice, these notches line up to point to the location where the rising sun emerges above the horizon. There's even evidence that the Hopewell people understood the complex 18.6-year lunar cycle.

This site also includes a nature preserve and features 2.5 miles of trails. The wooded Mound Trail takes walkers to small, secluded mounds; another short trail connects the earthworks to the Little Miami River, where it's thought ancient visitors to the site climbed from their boats to the ceremonial earthworks. The walks include an attractive landscape with diverse plants and animals native to the area. The site also includes a large museum.

Great Circle Earthworks

As the name suggests, this exceptionally large circular earthworks is nearly 1,200 feet in diameter, is surrounded by 8-foot-high walls, and includes a 5-foot-deep moat. The Great Circle encloses an area of approximately 50 acres. The Great Circle was originally connected to another enclosure called

Most areas in this World Heritage Site include pathways leading to earthen mounds and other features.

the Octagon Earthworks (see below). The remarkable size of this structure has probably contributed to its relatively undisturbed condition.

Octagon Earthworks

Also with a descriptive name, this large earthworks is constructed in the form of an octagon (eight-sided structure), with each wall measuring about 550 feet long and from 5 to 6 feet high. A primary purpose of the Octagon and associated structures (a set of parallel walls and several mounds) is believed to be astronomical. The complex structures are aligned to the four moonrises and four moonsets that mark the limits of a complicated 18.6-year-long lunar cycle. When viewed from Observatory Mound, the moon rises at the northernmost point of the 18.6-year cycle of the lunar orbit within one-half degree of the Octagon's exact center. A golf course with country club was built on some of the property during contemporary times, but visitors are still welcome to view the earthworks from a small platform outside the wall or walk a short path around the outside of the wall.

LOGISTICS

The eight earthwork sites are located in rural south-central Ohio, an area generally referred to as the Ohio River Valley. The nearest city is Columbus, about an hour to the north. Visitor centers are located at Mound City, Great Circle, and Fort Ancient and are good places to start your visit. Here you'll find knowledgeable staff, educational displays and exhibits, a short film, and some period artifacts discovered throughout the region.

Hopewell Culture National Historical Park offers the National Park Service's popular Junior Ranger Program.

As noted earlier, the eight sites described above are managed by two entities. The first five sites are part of Hopewell Culture National Historical Park (a unit of the National Park System); the other three sites are managed by the nonprofit Ohio History Connection. All sites are generally open most days during daylight hours, but it's wise to check the websites of these management entities for the latest information (National Park Service: nps.gov/hocu; Ohio History Connection). Accommodations, camping, and other visitor facilities and services can be found in the region's small towns and in Columbus.

Walking through this impressive collection of remarkable ancient earthworks is a good way to appreciate them, their size, and the labor and expertise needed to construct them. However, visitors shouldn't walk directly on the earthworks and shouldn't remove any artifacts. Unmanned aerial vehicles (UAVs/drones) are not allowed at any of the sites.

The museum at the Mound City Group displays examples of the artifacts found throughout Hopewell Ceremonial Earthworks, including this raven effigy pipe.

INDEPENDENCE HALL

Independence Hall in Philadelphia, Pennsylvania, is the symbol of American freedom, democracy, and self-governance, perhaps the most important historic building in the nation. Here the Founding Fathers of the fledgling country debated and adopted the Declaration of Independence on July 4, 1776, and signed the US Constitution in 1787, which powerfully and eloquently told the world: "We hold these Truths to be self-evident, that all Men are created equal." The American concepts of freedom and democracy are foundational to American history and have had a profound effect on people from around the world. These universal ideas have become models for the charters of many nations, including the United Nations (a precursor

organization, the League to Enforce Peace, was founded in Independence Hall), and may be considered to mark the modern era of government. The universal character of the site is reflected in the millions of annual visitors that come from every state in the nation and almost every country around the globe, and the more recent use of the building as a site for speeches and demonstrations in support of democratic and civil rights movements.

Independence National Historical Park was established in 1948 to protect and manage Independence Hall and about 20 surrounding historic buildings and places associated with the birth of the American republic, and this complex provides important historical context and perspective. The

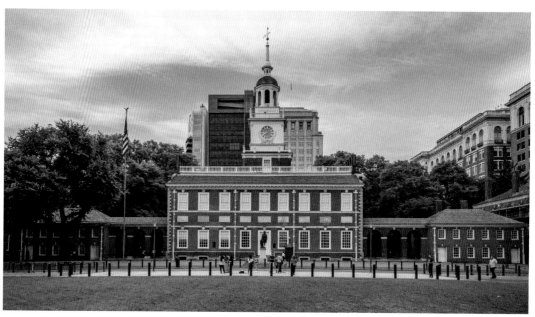

America's Declaration of Independence was signed in aptly named Independence Hall.

park is managed by the US National Park Service. This chapter describes both Independence Hall and the larger contextual park. Independence Hall was inscribed as a World Heritage Site in 1979 in recognition of its role in influencing governments worldwide.

Despite its symbolic importance, Independence Hall is a modest redbrick building designed in Georgian style that was first occupied in 1753 as the Pennsylvania Statehouse; the building included a steeple that was designed to hold a large bell, ultimately called the Liberty Bell. But as most American schoolchildren know, the original bell suffered cracks (more than one!), probably because of flaws in the casting or its being too brittle. The bell was replaced by another larger bell (called the Centennial Bell, presented to the City of Philadelphia in honor of America's Centennial). The original bell is on display in the park's Liberty Bell Center. Independence Hall has been restored several times, notably in 1831 by architect John Haviland, and by the National Park Service in 1951–1972 to return the building as closely as possible to its 1776 appearance. The current building includes two two-story wings that were added in 1897–98 and are reconstructions of the historical wings.

VISITOR CENTER

If this is your first visit, consider starting at Independence Visitor Center, operated by the National Park Service and staffed by

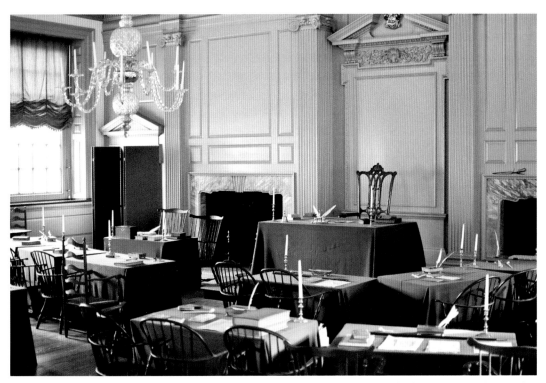

In 1776 the Continental Congress declared independence from Great Britain in this room of Independence Hall. In 1787 the US Constitution was debated and signed here.

rangers and other knowledgeable personnel (including representatives of the City of Philadelphia, available to advise visitors about other city attractions, lodgings, and restaurants). This modern, sophisticated center includes a variety of interactive exhibits where you can learn about the history of the site and the people associated with it. For example, exhibits allow visitors to imagine signing the US Constitution, touch a replica of the crack in the Liberty Bell, and use the center's large map to locate park sites. Three short films are shown in the building's theater, including a virtual tour of Independence Hall. The center includes amenities such as restrooms, loaner wheelchairs, a cafe, and free Wi-Fi.

VISITOR ATTRACTIONS

Independence National Historical Park includes a number of attractions associated with Independence Hall and the Liberty Bell. Of course these two sites are the primary attractions, but consider allocating more time for your visit to enhance your understanding and appreciation of Independence Hall, its history, and the stories of the important historical figures associated with it.

Independence Hall

Independence Hall is the centerpiece of both the park and the World Heritage Site. Known as "the birthplace of the United States" and "the birthplace of democracy," this building is the site of the Second Continental Congress in 1776, where the Declaration of Independence was signed. Eleven years later, delegates to the Constitutional Convention created and signed the United States Constitution. Important elements of the building include the Assembly Room where these documents were signed; the Pennsylvania Supreme Court Chamber; the many bells and clocks of the building, including the Liberty Bell and Centennial Bell; and the building's steeple, designed by architect William Strickland in 1828. Ironically, the second floor of the building is where "freedom seekers"—men, women, and children who had escaped slavery but were accused of being "fugitive slaves" under the provisions of the 1850 Fugitive Slave Act—were tried and stood to lose their liberty. A ticket is required to enter Independence Hall most of the year; see the park's website (noted below) for the latest information on how to purchase a ticket. A ticket entitles visitors to a short ranger-guided tour of the building. The "Great Essentials" exhibit is located in the West Wing of Independence Hall and includes the original printed copies of the Declaration of Independence, Articles of Confederation, US Constitution, and what is believed to be the silver inkstand into which 56 signers dipped their pens to sign the Declaration of Independence and, in the process, "mutually pledge their lives, their fortunes, and their sacred honor." Independence Hall is located in Independence Square; security screening is required to enter the building.

Liberty Bell/Liberty Bell Center

The Liberty Bell, with its large plainly visible crack, is housed in the Liberty Bell Center near Independence Hall. Of course the bell is the primary attraction, and it's popular (at

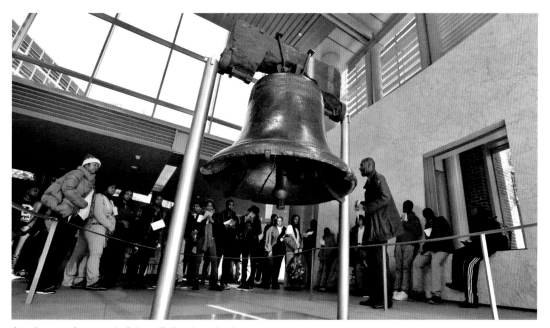
A park ranger discusses the Liberty Bell with a school group.

least among younger visitors) to take a selfie in front of the bell (popularly known as a "bell-fi"). But there are also exhibits about the bell on the left side of the hallway in the Center; examples include the founding of the State House Bell (which became known as the Liberty Bell) and the use of the bell by abolitionists, women's suffrage activists, civil rights leaders, and others because of the bell's symbol of equality. No ticket is needed for admission, but security screening is required.

Congress Hall

This historic building is also located in Independence Square. It was built as the Philadelphia County Courthouse and was home to the US Congress from 1790 to 1800, when this city was the temporary capital of the United States. The House of Representatives met on the first floor and the Senate on

the second. Political disputes among members led to the birth of the two-party system. President George Washington was inaugurated here, and when John Adams was inaugurated here as the second president, it was a model of the power of democracy and the peaceful transfer of power. No ticket is required most of the year, but entrance is by guided tour only from March through December; security screening is required.

Old City Hall

This building, also on Independence Square, was finished in 1791 and served as City Hall for Philadelphia. While the city served as the nation's capital, the building was also used by the federal judiciary, including the Supreme Court, where this branch of the new government debated the role it should play in this democratic context.

The 18th Century Garden offers a welcome green space within Independence National Historical Park. The garden features species of trees, shrubs, and flowers that were commonly grown in the city prior to 1800.

The President's House

Presidents Washington and Adams once lived and worked at a house on this spot, but the house was demolished in 1832. The foundations remain as an unusual and suggestive re-creation of the house. Exhibits and videos explore the tension between slavery and freedom, sometimes told from the perspective of the enslaved people who once lived and worked here.

Free Quaker Meeting House

This lovely 18th-century building tells the story of minority citizens in the early United States and the historic tension between religion and politics.

Washington Square

This beautifully landscaped park offers a welcome respite from the surrounding historic buildings and beckons visitors to take a relaxing walk. The park includes an 1869 watering trough for horses and dogs, two guardhouses from the early 20th century, interpretive panels, and the Tomb of the Unknown Soldier of the American Revolution.

Public Gardens

Three charming and historic gardens grace the Independence Square vicinity. The 18th Century Garden features local garden plants that were popular during the 1700s and formal landscape design elements during

colonial times. The Rose Garden includes many varieties of antique roses and a short section of cobblestone paving from the 19th century. Thirteen magnolia trees line the perimeter of the Magnolia Garden; spring offers prolific magnolia and azalea blossoms.

Declaration House

Thomas Jefferson lived at this site while he drafted the Declaration of Independence, expressing the progressive ideas of freedom and democracy as derived from Enlightenment philosophers. The building underwent substantial alterations before it was demolished in the 1800s, but it was rebuilt by the National Park Service in 1975 and includes exhibits about the Declaration of Independence, a brief video, and a parlor and bed chamber as they might have appeared when Jefferson lived here.

Franklin Court

The complex known as Franklin Court explores the life of Benjamin Franklin, who signed both the Declaration of Independence and the US Constitution. The courtyard features two dramatic steel "ghost" structures marking the locations of Franklin's home and his grandson's printing business; look closely for the foundations of the original home embedded in the ground. The Benjamin Franklin Museum tells the story of Franklin's colorful life through his five principal character traits: ardent and dutiful, ambitious and rebellious, motivated to improve, curious and full of wonder, and strategic and persuasive. Each of the five primary "rooms" of the museum focuses on one of these traits. The museum includes a video about Franklin and a museum store. The Franklin Court

The Signer statue commemorates the spirit and deeds of all who devoted their lives to the cause of American freedom.

Printing Office illustrates the importance of the printed word in the American Revolution and founding of the nation. The original printing office no longer survives, but the current building includes examples of its original equipment. A National Park Service ranger demonstrates the printing process. The "Fragments of Franklin Court" exhibit is an archaeological display of the artifacts found in Franklin Court.

OTHER ATTRACTIONS

Other visitor attractions include City Tavern, a reproduction of a tavern that served Benjamin Franklin, George Washington, and John Adams; the Merchants' Exchange Building, which includes a public exhibit on the site's

history and preservation and houses National Park Service offices; the New Hall Military Museum, once the War Department for the new nation; the Portrait Gallery in the Second Bank, a lovely Greek Revival building housing the Second Bank of the United States and now displaying a collection of more than 100 portraits of "worthy Personages," many of them leaders of the Revolutionary War; the Museum of the American Philosophical Society in Philosophical Hall, owned and operated by the American Philosophical Society, the oldest learned society in the United States and founded by Benjamin Franklin for "promoting useful knowledge"; the Dolley Todd House, the home of future first lady Dolley Madison; the Bishop White House, the home of Reverend Dr. William White, restored to illustrate the lifestyle of upper-class Philadelphians in the late 18th century; and the Germantown Whitehouse where George Washington lived for two short periods; interactive exhibits in the nearby Bringhurst House offer insights into the life of Washington and his household, including his enslaved servants.

LOGISTICS

Independence Hall World Heritage Site and the larger Independence National Historical Park are located in Philadelphia's Old City Cultural District near the Delaware River and are accessible by automobile and public transit. Independence Hall is located in Independence Square, and the larger park occupies several city blocks, stretching between 2nd and 7th Streets on the east and west, respectively, and Vine and Arch Streets to the north and south, respectively. This portion of the city includes many museums and other attractions. Most of the major attraction sites in the park, including Independence Hall, are open year-round, though some require tickets during most of the year except January and February; be sure to check the park's official website (nps.gov/inde) for the most up-to-date information. Some sites (including Independence Hall and Liberty Bell Center) also require security screening, which can be time-consuming; travel lightly to speed up the process. Ranger-guided tours are offered at many park sites, and the park participates in the NPS Junior Ranger Program.

Philadelphia is a big, sophisticated city with a very large selection of lodging and restaurants. Philly cheesesteaks are part of the city's lore, so consider trying one (or more!). America's National Parks Store in Independence Square offers souvenirs and fine gift items; a portion of sales revenue goes to support the park's programming.

KLUANE/WRANGELL-ST. ELIAS/GLACIER BAY/TATSHENSHINI-ALSEK

Straddling the border of Alaska and Canada, this vast complex of four parks and conservation areas is the largest protected land area in the world. The World Heritage Site can truly be called immense, as it includes more than 24 million acres—more than ten times the size of Yellowstone National Park (see the chapter on Yellowstone National Park later in this book). Inscribed in 1979, it was the first binational World Heritage Site. The site contains two national parks in Alaska (Wrangle–St. Elias National Park and Preserve and Glacier Bay National Park and Preserve) and two areas in Canada (Kluane National Park Reserve in Yukon and Tatshenshini-Alsek Provincial Park in British Columbia). This combined area conserves a remarkable diversity of landforms and associated plants and animals, the cultural heritage of many groups of indigenous people, and offers wilderness recreation opportunities of the highest order. For the purposes of the World Heritage Site, issues of common concern across the four parks are managed in a coordinated manner.

The four adjacent parks that comprise the World Heritage Site form a combined land region that is approximately 430 miles long and 90 miles wide in a generally northwest to southeast orientation. The parks share a collection of some of the most iconic natural features in North America, including

A young black bear climbs a tree in Wrangle–St. Elias National Park and Preserve; the park offers habitat for both black and grizzly bears.

active geologic forces such as the movement of massive tectonic plates, volcanic activity, copious amounts of rain and snow, and formation and movement of hundreds of glaciers. These natural forces have given rise to land- and waterscapes that range from deep bays and oceans to some of the highest mountains in North America; great rivers that flow into the sea; lush low-elevation

rain forests; and collections of iconic wildlife, including grizzly and black bears, Dall sheep, caribou, moose, wolves, and wolverines, along with marine mammals such as whales and sea lions.

VISITOR CENTERS

Three of the parks included in this World Heritage Site have visitor centers that allow guests to orient themselves and plan their activities. Kluane includes the Kluane National Park and Reserve Visitor Centre (located in the Da Ku Cultural Centre) in Haines Junction, Yukon, and the Thehál Dhál Visitor Centre (located a one-hour drive north of Haines Junction on the Alaska Highway). The former includes award-winning exhibits, engaging interpretive panels, cultural artifacts, a high-definition video, and kids exhibits and interactive games; the latter features exhibits designed in collaboration with local First Nations citizens, a deck where you can use the spotting scope to look for Dall sheep in spring and fall, and trained staff.

Wrangell–St. Elias National Park and Preserve includes two visitor centers. The Copper Center Visitor Center is located at mile 106.8 of the Richardson Highway, 10 miles south of Glennallen, Alaska, and is part of a campus-like setting. Facilities and services include the visitor center, bookstore, exhibit hall, theater, restrooms, picnic tables, an amphitheater, the Ahtna Cultural Center, scenic overlooks, and short hiking trails. The

Wrangle–St. Elias includes some of North America's highest and wildest mountains.

Kennecott Visitor Center is in Kennecott, Alaska, and is housed in the historic Blackburn School. Facilities and services include exhibits, a park film, bookstore, ranger talks and guided walks, and assistance with planning your visit to the park.

The Glacier Bay National Park Visitor Center is located in the Glacier Bay Lodge in Bartlett Cove and includes natural and cultural history exhibits, an information desk, and a bookstore and reading area. Park rangers show films about the park, lead walks, and offer evening programs in conjunction with tribal programs at the nearby Tuna Shuká Hit (Huna Tribal House).

VISITOR ATTRACTIONS

The primary visitor attractions are the four parks and preserves that make up this especially large World Heritage Site. They're all composed primarily of wilderness, and even though each is a separate management area, many of their primary visitor attractions—large landscape-scale natural features, geologic processes, distinctive plants and animals—are shared across this complex of parks and preserves. Most of the 24 million acres of the site are remote and often require substantial backcountry experience and expertise to visit. Consequently, much of the area must be appreciated through the dramatic views into the parks at a number of access points and along adjacent roads, or enjoyed vicariously by simply knowing and appreciating that this vast region of wilderness is being protected. Nevertheless, there are ways to enjoy and appreciate many of the places within the parks, as outlined below.

Kluane National Park and Reserve

This large national park protects a spectacular Canadian landscape in southwest Yukon. This wilderness of mountains includes Canada's highest peak, 19,551-foot Mount Logan, along with dramatic glaciers and the valleys they've carved, boreal forests, lovely lakes, iconic wildlife (including wolves, bears, lynx, caribou, moose, wolverines, mountain goats, and Dall sheep), and the heritage of First Nations people. The park lies within the traditional territories of the Champagne and Aishihik First Nation and Kluane First Nation. Driving portions of the Alaska Highway and Haines Road that skirt the boundary of the park offers spectacular mountain vistas, roadside exhibits, and interpretive trails. Popular Kathleen Lake, accessible by car, has boating, hiking (including the challenging King's Throne Trail), and camping. Other visitor activities in the park include hiking/backpacking, flightseeing over the park (special tours land on ice fields), mountaineering, and rafting the Tatshenshini and Alsek Rivers (see Tatshenshini-Alsek Provincial Park below).

Wrangell–St. Elias National Park and Preserve

Established in 1980, Wrangell–St. Elias is the largest US national park, a staggering 13.2 million acres in south-central Alaska. The park protects much of the St. Elias Mountains, which include most of the highest peaks in the United States, featuring 18,008-foot Mount St. Elias; these high mountains are the result of a massive manifestation of

plate tectonics. Other components of the park incorporate extensive glaciers, ice fields, volcanoes, and the wild Alaska coastline in the southern portion of the park, as well as the remains of the boomtown of Kennecott, one of the world's richest copper mines, which operated in the early 20th century (now a US National Historic Landmark). The park is the homeland of several groups of First Nation people, including the Ahtna, Upper Tanana, Eyak, and Tlingit tribes.

Given the size of the park, it's helpful to think of it as divided into five geographic areas. The Copper Center area is located along the Richardson and Edgerton Highways and includes the Copper Center Visitor Center; access to the park from the visitor center requires a one-hour drive or the use of one of the local flight services. A highlight of the area is Kennecott Mines National Historic Landmark, including the remains of this large mining complex and associated structures. However, it's an eight-hour drive from Anchorage to reach the site, and the last 59 miles are on the gravel McCarthy Road.

The Nabesna Road area offers a scenic drive starting from the Tok Cutoff Highway. Stop at the Slana Ranger Station for current conditions and suggestions for visiting the area. The Yakutat and Coast area is accessible by plane or boat only, and the scenery is great. Contact the park headquarters in Copper Center for suggestions about appropriate visitor activities. The Hubbard tidewater glacier in this region of the park can be seen from cruise ships, and this has become increasingly popular. The vast Backcountry area of the park is remote and usually far from roads and trails. For experienced and adventurous visitors, backpacking, river rafting, mountaineering, and staying in a public-use cabin can be highly rewarding.

Glacier Bay National Park and Preserve

Glacier Bay National Park and Preserve in southeast Alaska is a highlight of the state's famed Inside Passage. It includes 3.3 million acres of mountains, dense rain forests, glaciers, wilderness rivers, wild coastline, deep fjords, and its signature Glacier Bay, a large inlet off the Gulf of Alaska. The park's highly varied terrain and coastal waters support an array of terrestrial and marine wildlife, including brown and black bears, moose, wolves, deer, mountain goats, and bald eagles, as well as whales, seals, sea lions, and sea otters. The area has been home to the Huna Tlingit people for as long as 9,000 years; most lived in small villages along the shores of Glacier Bay, but they were driven out of the region by the glacial advance of the Little Ice Age of the 1700s. Descendants of these people now live outside the park but still consider it their homeland. Most visitors access the park from Glacier Bay in boats, the vast majority on large commercial cruise ships, a tradition that goes back a hundred

A humpback whale breaches in Glacier Bay.

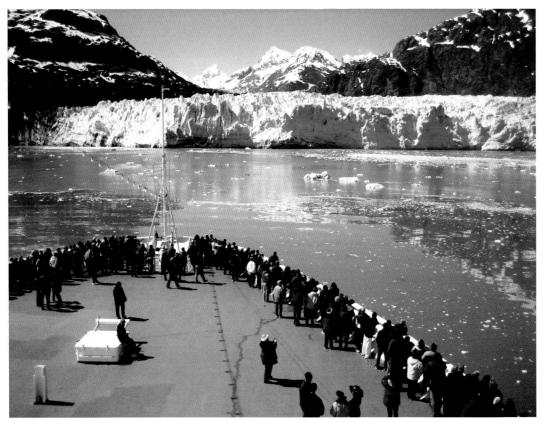

A cruise ship approaches Margerie Glacier in Glacier Bay; cruise ships and boat tours are a popular way to visit this remote national park.

years. Prospective visitors should check to be sure their cruise itinerary includes Glacier Bay, as the number of ships allowed in the park each day is limited to protect the area and offer an especially high-quality visitor experience. The park has an unusual outreach program whereby a National Park Service ranger boards cruise ships and offers an educational narrative for the daylong visit to the park and the journey up the West Arm of the bay. Other types of boats can enter the bay as well, and a daily cruise in a small boat is conducted by the Glacier Bay Lodge at Bartlett Cove. This "day boat" berthed at Bartlett Cove also carries campers to two locations

on the shores of Glacier Bay. A small number of visitors also enter the park on raft trips on the Alsek River (see Tatshenshini-Alsek Provincial Park below). Contemporary Huna Tlingit people have recently constructed Xunaa Shuká Hít (Huna Ancestor's House) at Bartlett Cove, the first permanent clan house in Glacier Bay since the 1700s; park visitors are welcome to visit and learn about the history and culture of these people. Bartlett Cove is the only developed area in the park and includes a small lodge, a visitor center, and a camping area. A few short trails radiate out from this area, and adventurous travelers can rent a kayak and paddle a short

distance into the bay. Still more adventurous travelers can backpack through portions of the park's large trailless wilderness, but this requires considerable experience and expertise. Bartlett Cove is accessible by water and small planes.

Tatshenshini-Alsek Provincial Park

This large provincial park in the very northwestern corner of British Columbia, Canada, borders Alaska and Canada's Yukon and is directly adjacent to Kluane National Park and Reserve to the north and Glacier Bay National Park and Preserve and Wrangle–St.

Elias National Park and Preserve to the west and southwest. Like the other parks in the World Heritage Site, it features tall mountains, including 15,325-foot Mount Fairweather (the tallest peak in the province), and impressive glaciers. But its signature attractions are its namesake rivers, the Tatshenshini and the Alsek, and their abundant iconic wildlife, featuring an especially dense population of grizzly bears as well as Dall sheep, caribou, mountain goats, moose, wolves, wolverines, eagles, falcons, and trumpeter swans. The Tatshenshini and Alsek (the former is a large tributary of the latter) are long, glacial rivers that cut through the surrounding

Rafting the Tatshenshini and Alsek Rivers is a world-class wilderness adventure.

mountains, creating great U-shaped valleys and ultimately flowing into the Gulf of Alaska. The rivers are often described as "one of the most magnificent river systems on earth" and "North America's wildest rivers." The great valleys carved by the Tatshenshini and the Alsek connect the higher elevation, colder mountains in the east to the warmer lower elevations to the west, creating an especially varied range of rich wildlife habitats and natural wildlife corridors. Over the centuries, numerous First Nation peoples have lived in this area, including the Tlingit and Southern Tutchone, who built fishing villages along the rivers; the eastern edge of the park follows an ancient trade route used by the Chilkat (a Tlingit) people to barter with the Tutchone. The government of British Columbia manages the park in collaboration with the Champagne-Aishihik First Nations.

The park offers world-class outdoor recreation opportunities, although access to the park is challenging. Rafting the Tatshenshini and/or Alsek River (on commercial or private ventures) is the glamour trip, but it's long (ten to twelve days), challenging, and especially remote. (A day trip can be taken on the Tatshenshini.) The Alsek River flows through appropriately named Turnback Canyon, and this section should be portaged (which requires aircraft support). River trips normally end at Dry Bay, Alaska, in Glacier Bay National Park and Preserve; air service must be chartered to return to the head of the river. Another option is driving along the section of the Haines Highway that borders the park on the east for dramatic views into the park. There is only one marked and maintained trail in the park, the 5.5-mile Chuck Creek Trail; this is only moderately difficult, and the trailhead is directly off the Haines Highway. Backpacking and mountaineering trips are allowed but require substantial experience and expertise, as well as a permit.

LOGISTICS

The logistics of visiting this huge and remote World Heritage Site are complex and daunting. Of course, given its far-north location, most visitation is limited to the summer months. The most common means of access are flying to nearby cities and towns (Anchorage, Skagway, Haines, and Yakutat, Alaska; Whitehorse and Haines Junction, Yukon) and then driving the region's roads (AK 1, including the Tok Cutoff; Richardson Highway; Edgerton Highway; Haines Highway) that skirt portions of some of the parks. Glacier Bay National Park is most commonly accessed on large commercial cruise ships. Consult the websites of the four parks and protected areas that comprise the World Heritage Site for detailed trip planning and the latest information on any permits or other special conditions that might apply (parks.canada.ca/pn-np/yt/kluane; nps.gov/wrst; nps.gov/glba; bcparks.ca/tatshenshini-alsek-park/). Contact the relevant park management agencies for suggestions and answers to any questions you might have.

LA FORTALEZA AND SAN JUAN NATIONAL HISTORIC SITE IN PUERTO RICO

The Archipelago of Puerto Rico was discovered by Europeans in 1493 on the second voyage of Christopher Columbus to the New World; like his other voyages, this was supported by Spain. In 1508 Spain's Juan Ponce de León arrived on the island to establish a Spanish settlement. Though small, Puerto Rico is strategically located as the easternmost of the Greater Antilles in the Caribbean Sea and the first major island with fresh water, food, shelter, and supplies such as wood that sailors could reach after their long journey across the Atlantic Ocean from the seagoing countries of Europe. Even more important, Puerto Rico was the "front door" to the much larger New World lands of Mexico and Central and South America and their coveted gold, silver, and gems. Spain was quick to act, claiming Puerto Rico and aggressively defending it for several hundred years with an extensive system of military fortifications constructed beginning in the 16th century and continuing for several hundred years.

The Spanish fortifications in Puerto Rico were focused on protection of the city of San Juan and its strategic harbor in San Juan Bay. These fortifications and the walls constructed around the city are prominent

A reenactment at San Juan National Historic Site commemorates the 18th-century Spanish defense of San Juan in the 1797 British attack on Puerto Rico.

examples of European military architecture and engineering adapted to the Caribbean context, and are representative of the rise and power of the Spanish empire. This Spanish system of fortifications in San Juan is the earliest European construction in the United States and one of the oldest in the

New World. These fortifications were chal-lenged several times by England, France, the Netherlands, and the United States over their long history, with mixed results.

VISITOR CENTER

A visitor center serving San Juan National Historic Site, one of the two principal components of the World Heritage Site, is located in the large and historic Castillo San Cristóbal. A World War II bunker built in 1942, the building served as Joint Command Center to coordinate the defense of the city and Puerto Rico during the conflict. Visitors are welcome to join ranger-led orientation talks about the fortifications, and the visitor center offers a film (in English and Spanish) on the long, elaborate, and important history of the park and La Fortaleza.

VISITOR ATTRACTIONS

The World Heritage Site includes five major attractions, all part of the defensive fortifi-cations of San Juan that were constructed over several hundred years. Together these sites eventually formed a sophisticated and deliberately designed "defense-in-depth" sys-tem with multiple sites and substantial vari-ety and redundancy. Four of these sites are tightly clustered around the city of San Juan; the fifth is on the peninsula on the opposite (western) side of the entrance to San Juan Bay. Fortaleza is owned by the Common-wealth of Puerto Rico; the other four attrac-tions are part of San Juan National Historic Site, managed by the US National Park Ser-vice. The World Heritage Site was inscribed in 1983. With only a few exceptions, visitors are welcome to walk through the attractions of this World Heritage Site.

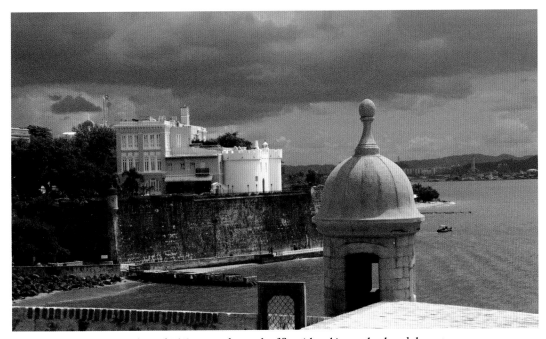

La Fortaleza, built between 1533 and 1540, is a good example of Spanish architectural style and elements.

La Fortaleza

The first large structure constructed to defend San Juan, La Fortaleza ("The Fortress") was built between 1533 and 1540. The original fort included a circular tower and four massive stone walls surrounding a large patio; the tower was named Torre del Homenaje ("Tower of Homage"). A second tower was added at the end of the 16th century. During the 1640 reconstruction of the fort, the chapel of Santa Catalina, which was originally located just outside the structure's defensive walls, was incorporated into the fort; consequently, the fort is also called Palacio de Santa Catalina ("Saint Catherine's Palace"). The fort is a good example of Spanish architectural style and elements, including tiled roofs, sunlit patios, galleries, graceful arches, grilled doorways, wrought-iron, tile, and mahogany staircases. Despite its defensive prowess, the fort was subject to periodic attack by the English and the Dutch, and the Spanish added other fortifications throughout its long occupation of Puerto Rico. The fort was captured over the years, first by the English in 1598 and then by the Dutch in 1625, who burned much of the city of San Juan. Consequently, it was determined that the location of the fort was inadequate to protect the city, and more fortifications were added at more strategic sites.

The structure has been the official residence of the governor of Puerto Rico since 1544, the oldest executive mansion in continuous use in the Americas. A major reconstruction of the fort in 1846 changed its military appearance to that of a palatial facade, and the complex of buildings and grounds consists of several attached buildings that included formal living quarters, a large private residence, and grounds with gardens. It overlooks the high city walls (see below) that front San Juan Bay. La Fortaleza is owned by the Commonwealth of Puerto Rico.

Castillo San Felipe del Morro

Generally known simply as El Morro ("The Promontory"), this historic fortification is strategically located on a 140-foot headland overlooking the entrance to San Juan Bay, designed to defend San Juan from attack by sea. Begun in 1539 and not completed until 1787, it was one of the largest fortifications built by Spain in the Caribbean. It was named in honor of Spain's King Philip. The massive six-level fortification included a tower, bastions (projecting portions of the fort), drawbridge, moat, three cisterns holding more than 200,000 gallons of rainwater, 18- to 25-foot-thick stone walls, and a main battery of 37 cannons. El Morro's last military engagement occurred in 1898 when it was subjected to a naval bombardment and defeat by the United States in the Spanish-American War; modern warfare fueled by the Industrial Revolution had rendered the fortification outdated. Shortly after, the Treaty of Paris was signed in which Spain ceded the islands of Puerto Rico, Cuba, Guam, and the Philippines to the United States, which rose to become a major world power. El Morro and many other Spanish government buildings in Old San Juan then became part of the large US Army post, Fort Brooke, which served as an active military base during the two World Wars. In 1949 San Juan National Historic Site was established, and El Morro was transferred to the US Department of the Interior in 1961. Since then, much of the original landscape of the fort has been

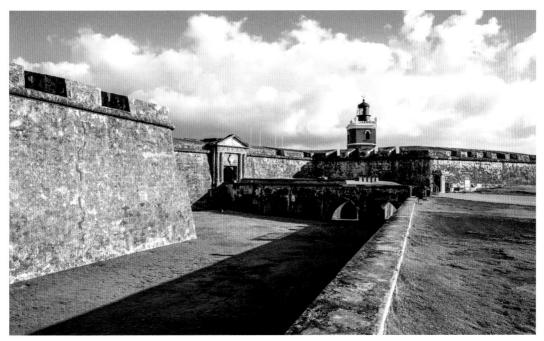

Generally known simply as El Morro ("The Promontory"), Castillo San Felipe del Morro is strategically located on a 140-foot headland overlooking the entrance to San Juan Bay.

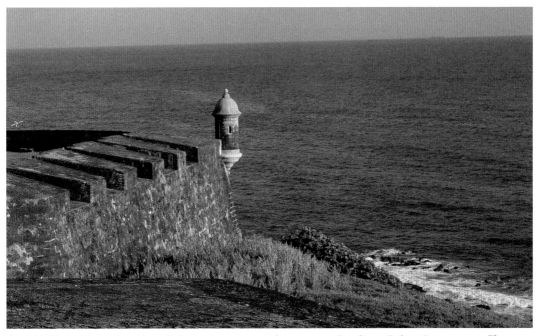

A series of distinctive bastions (also called sentry boxes or *garitas*) were mounted on fort walls for military purposes. These architectural features are now considered a symbol of San Juan.

restored, and it is now one of Puerto Rico's main tourist attractions.

Castillo San Cristóbal

While Castillo San Felipe del Morro protected San Juan from attack by sea, Castillo San Cristóbal guarded the city from attack by land. Construction began in 1634 and was completed in 1790. This lovely historic site with extensive coastal views comprises 27 acres and offers visitors delightful walking opportunities while they learn about the history of the fortification. This is the largest fortification built by the Spanish in the New World, and the site of the first shots fired in the Spanish-American war of 1898. The extensive fortification on three levels includes irregular and triangular bastions (in the French-influenced Vauban-style fortress); a dry moat; tunnels to protect soldiers from enemy fire and to allow safe passage of troops, weapons, and supplies; a large main plaza; casements (bombproof rooms with gun ports for cannons); officers' quarters; barracks; kitchen; latrine; gunpowder magazines; and cisterns that could hold 800,000 gallons of rainwater. Historians consider the fortification to be a masterpiece of 18th-century military engineering and innovation.

Fuerte San Juan de la Cruz

This small fort was constructed on a small rocky island called El Cañuelo (local people often call the fort "El Cañuelo") located on a peninsula that guards the western side of the entrance to San Juan Bay. Together with Castillo San Felipe del Morro on the eastern entrance to the Bay, cannon fire from these defensive locations set up an intimidating crossfire to enemy ships attempting to enter the harbor. The fort also protected the mouth of the Bayamón River, which was used to access the interior of the island of Puerto Rico. The original fort, constructed in the late 1500s, was made of wood, but it was burned in a Dutch attack in 1625. The current square-shaped fort was built of massive sandstone walls between 1630 and 1660. However, substantial improvements in the firepower at Castillo San Felipe del Morro diminished the importance of El Cañuelo. The fort is open to the public on limited occasions; although the interior is generally closed, visitors can walk around its exterior and enjoy the coastal views in the process.

City Wall of San Juan

An ambitious masonry defensive wall was constructed around the City of San Juan between the 16th and 20th centuries, and most of this system of walls and related defensive structures still exist. The wall was approximately three miles long and included a series of bastions (distinctive structures mounted on the wall for military purposes, and sometimes called sentry boxes or *garitas)*; these architectural features are now considered a symbol of the city. The wall linked the fortifications of La Fortaleza, Castillo San Cristobal, and Castillo San Felipe de Morro. San Juan is the only remaining walled city under US jurisdiction, though the southeastern portion of the wall was badly damaged in a 1867 earthquake and was ultimately removed to make way for expansion of the city. The wall included five gates that allowed residents and soldiers to enter and exit the city. The San Juan Gate still stands today in the western section of the wall and is part of the World Heritage Site.

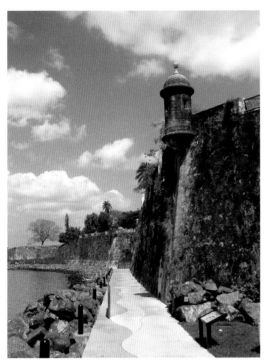

Paseo del Morro is a public walkway that borders the outer edge of Old San Juan's historic Castillo San Felipe del Morro.

LOGISTICS

All of the five major visitor attractions are open to visitors, although only the exterior of Fuerte San Juan de la Cruz may be visited. Visitors are permitted to enter the governor's mansion at La Fortaleza on guided walks conducted only when the government isn't in session. Four of the attractions described in the preceding section are located in the historic section of San Juan within walking distance of one another, but Fuerte San Juan de la Cruz is located outside the city and requires a drive to reach it. While visiting these important sites, be sure to enjoy the beautiful natural setting of the fortifications, including lovely San Juan Bay, and the historic and lively old city of San Juan that features historic homes, churches, and other buildings, museums, plazas, and commercial businesses. A range of visitor facilities and services, including accommodations and restaurants, are readily available in the city and surrounding areas. It's wise to check the official websites of La Fortaleza (fortaleza .pr.gov) and San Juan National Historic Site (nps.gov/saju) before visiting.

MAMMOTH CAVE NATIONAL PARK

In central Kentucky lies Mammoth Cave National Park, a place that more than lives up to its ambitious name; this is the largest known cave system in the world (by a longshot!). With more than 425 miles of passageways, the cave system is longer than the world's second- and third-longest caves combined, and geologists think there may be as many as 600 additional miles of caves yet to be discovered. Of course this says nothing of the park's more than 50,000 acres of aboveground terrain featuring rivers, forests, bluffs, sinkholes, and ridgetops. The size and diversity of the cave and its environs earned the park inscription on the World Heritage List in 1981.

Key ingredients of caves include limestone, sandstone, and groundwater, and all of these are found in abundance at Mammoth Cave. Approximately 325 million years ago, a vast inland sea covered much of the central United States; over millions of years, calcium carbonate deposits from marine life as well as precipitating calcite from seawater fell to the seafloor, creating a thick limestone layer. When these seas disappeared, rainwater infiltrated the soil and absorbed carbon dioxide to form a weak carbonic acid. This slightly acidic groundwater dissolved the soft limestone to form underground streams that, in turn, carved massive systems of subsurface passageways. In the case of Mammoth Cave, an ancient river deposited a layer of relatively impervious sandstone over much of the limestone. Consequently, a large portion of Mammoth Cave is dry and isn't as highly decorated with classic cave formations such as stalagmites and stalactites. However, vertical cracks in the sandstone allowed water to seep into parts of the cave to form elaborate draperies, stalactites, rimstone dams, and other features.

Extensive forests cover much of the aboveground portion of the park and include beech, tulip tree, sugar maples, white and black oaks, three species of hickory, hemlock, yellow birch, magnolia, and holly. The Green River and its major tributary, the Nolin River, provide water and riparian habitat that help support a diverse array of wildlife; these rivers are among the most biodiverse in the nation. Mammals include deer, bobcats, coyotes, and foxes. Birds and waterfowl include wood ducks, kingfishers, and great blue herons. Mammoth Cave supports several species of bats, as well as one species each of cave salamander, eyeless cave fish, and cave shrimp.

Evidence suggests that Native Americans explored and used Mammoth Cave at least 4,000 years ago. Archaeologists' findings include cane torches used for illumination and other artifacts, as well as a number of mummified bodies. The use of the gypsum gathered in the cave by these people is unknown. Local legend suggests the cave

A ranger-led tour group stops in the Star Chamber on the popular Violet City Lantern Tour of Mammoth Cave.

was "rediscovered" by John Houchins around the turn of the 19th century. Reportedly, he shot and wounded a black bear that he then followed into the cave. After that, the cave's history includes its use as a church, a tuberculosis sanitarium, and a source of saltpeter (to make gunpowder) in the War of 1812; ultimately, tourism became the cave's primary use. In 1838 Stephen Bishop, a slave belonging to the property's owner, started successfully leading cave tours, and he's credited with systematically exploring the cave and mapping many of its passages. A

movement to establish the cave as a national park began in the early 20th century. However, unlike national parks on the vast public lands of the western United States, all the land was privately owned and had to be purchased, much of it by means of eminent domain. Nearly 600 farms were obtained, creating significant animosity among local residents, a source of bitterness even today. Watch for the evidence of these homesteads, including level homesites, stone and brick chimneys, small cemeteries, and "wolf trees" (large trees that offered valuable shade to

farm homes). Congress established Mammoth Cave National Park in 1941 on more than 45,000 acres of land; the park has since grown to 53,000 acres. This surface land is vital to protecting the internal "plumbing" of the vast Mammoth Cave system.

VISITOR CENTER

Located near the geographic center of the park, the Mammoth Cave Visitor Center is the park's hub and the place for visitors to orient themselves to what lies both above and below the surface of the park. The building includes educational displays and access to National Park Service rangers and volunteers. All cave tours begin here; periodic ranger-led programs are offered as well. The building

includes an emphasis on sustainability, earning Gold-level certification in the national Leadership for Energy and Environmental Design (LEED) program.

VISITOR ATTRACTIONS

Of course the primary attraction of the park is its world-renowned cave complex, the largest in the world. National Park Service rangers offer more than a dozen tours that vary in the features that are included and the length and difficulty of the walking and climbing; there's something for nearly everyone. But don't forget the extensive aboveground terrain that's vital to the formation and protection of the park's caves and offers a rich and diverse natural landscape, wildlife

The Rotunda is the first large room seen if entering Mammoth Cave from the Historic Entrance.

viewing, camping opportunities, and a network of conventional trails for hiking, biking, and equestrian use. The park's scenic roads offer leisurely drives as another option for enjoying and appreciating the area, and the park's two rivers offer boating and fishing. Mammoth Cave is an International Dark Sky Park that offers exceptional night-sky viewing and a distinctive nocturnal environment for wildlife.

DRIVING TOURS

Two scenic roads bisect the park on a north–south axis and meet roughly in the center of the park near the visitor center. Mammoth Cave Parkway enters the park from the southeast corner and travels about five miles to the visitor center and associated complex of visitor facilities and services. This is a pleasant two-lane road of about five miles that includes several attractions, including Diamond Caverns (a privately owned complex of caves just outside the park), Sloan's Crossing Pond Trail, Doyle Valley Scenic Overlook, and Hercules and Coach No. 2, two train cars that were part of the historic Mammoth Cave Railroad. Green River Ferry Road enters the park from the north and travels about five miles to where it intersects Mammoth Cave Parkway. The highlight of the road is the crossing of the Green River on its namesake ferry, developed in 1934. The ferryboat uses a system of cables to carry cars, hikers, and bikers over the short but historic crossing.

Many visitors enjoy the short ferry ride across the Green River on their way to the park's visitor center.

WALKING/HIKING THE PARK

The park can be walked/hiked above- and belowground, and both should be pursued. Belowground, find long passageways that have been shaped by flowing water, some with decorative cave formations. Aboveground, there are nearly 80 miles of trails that traverse the park's varied terrain and include native forests, hollows, and streams that highlight much of the park's interesting natural and cultural history. The Green River divides the surface lands of the park into north and south sections, with the southern half supporting most of the developed portion of the park and the northern half offering a more expansive backcountry.

Cave Tours

All visitors should take at least one of the excellent cave tours offered by National Park Service rangers. Most of these tours require a ticket and there's a small associated fee. It's wise to reserve tickets; see the park's website (noted below) for an up-to-date description of how to do this. There are more than a dozen tours to choose from, and the Grand Avenue Tour is a good choice; it's one of the longest in both distance and time—about four miles and four hours—and a little challenging in places (nearly 400 feet of elevation gain). This tour includes several of the shorter tours, making it an efficient way to see much of the diversity of the many

The park also includes the land above the cave complex; this protects the geologic processes that formed the caves and offers a network of aboveground hiking trails.

miles of underground passages. Other good options include the Violet City Lantern Tour (conducted exclusively by lantern to simulate early exploration of the cave) and the Wild Cave Tour, a very demanding six-hour spelunking experience.

Visitor Center Complex Trails

The visitor center complex offers a number of attractions that can be reached on foot. The Historic Entrance to the caves is the largest natural opening into the Mammoth Cave system and was used by Native Americans, miners, and early cave explorers; it can be reached on a short walk from the visitor center. The Old Guide's Cemetery is also a short walk from the visitor center. A longer walk leads to the Green River and along the Green River Bluffs Trail.

River Styx Spring Trail/Green River Bluffs Trail/ Heritage Trail

The southern half of the park offers an appealing network of short and moderate above-ground trails that show off many features of the park's landscape. Favorites are the three visitor center complex trails noted above, which can easily be combined. For example, the River Styx Spring Trail is a little more than a mile (round-trip) and offers pleasant walking through a mature forest featuring giant beech, sycamore, and maple trees. The trail leads past the historic natural entrance to the cave and then down to the banks of the Green River. A short spur offers a close-up view of River Styx Spring where it emerges from the cave and flows into the river. The natural cane reeds you see in the forest were gathered by Native Americans and used to

light their way into the cave thousands of years ago. You can retrace your steps to the trailhead or, better yet, pick up the Green River Bluffs Trail that leads a little over a mile through highlands along the Green River and through a peaceful hardwood forest with numerous limestone outcrops. The trail includes some gentle uphill walking and offers striking views of the Green River; the trail ends at the Headquarters Picnic Area, which is adjacent to the visitor center parking lot. Finally, consider walking the half-mile Heritage Trail loop. Enjoy the quiet forest and note the small level area that is evidence of an old homesite. The highlight of the trail is the Old Guide's Cemetery, where the enslaved early cave explorer and guide Stephen Bishop is buried.

Cedar Sink Trail

Though this trail is in the southern half of the park, it sits on the west side, away from the developed area. Sinkholes are vital components of Mammoth Cave, places where the underground erosion of the cave has collapsed the surface area, creating great depressions. Here, water runs into and/or out of the cave. The Cedar Sink Trail, a 1.6-mile lollipop route, includes several of the park's largest and most impressive sinkholes. It's also a magical place for spring and early-summer wildflowers. The well-maintained trail is generally easy walking, though it ventures down into (and out of) two large sinkholes with the help of several sets of steel staircases. Here you can see for yourself how the surface water flows into and out of the cave. Most of the trail passes through mature, lush-seeming forest, alive with birdcalls.

The park includes a campground in an attractive forest setting.

Sal Hollow Trail/
Buffalo Creek Trail

These two trails in the northern half of the park offer a less-developed and quieter network of trails that are open to hiking and equestrian use. The Sal Hollow and Buffalo Creek Trails (sorry, there are no bison in the park) are both accessed by the Maple Spring Trailhead but lead in different directions. The former is 8.1 miles (one way) and the latter is 4.4 miles (one way), and both have a lot to offer, including a long but easy and pleasant stroll. With only a little cleverness, a portion of these trails can be hiked in tandem by connecting them with a short section of the Turnhole Bend Trail, making a 5.5 mile loop. The loop includes classic upland forest with big trees, abandoned farms, small sinkholes, old gravel roads, and lots of spring wildflowers. Want more? Several backcountry campsites can be used to create a grand backpacking adventure.

SPECIAL PROGRAMS

Cave tours are led by park rangers, and these tours are the core of the National Park Service's interpretive programs. However, there are other, aboveground programs and special events as well, including hikes that address many aspects of the park's natural and cultural history. The NPS Junior Ranger Program is a popular choice for children (and adults!).

LOGISTICS

The park is open year-round, and cave tours are offered every day except Christmas. Spring can be wet, summers hot and humid, and winters cold. However, the park's caves stay a constant 54 degrees Fahrenheit. The park includes three campgrounds, a rustic lodge and cabins with food service and a gift shop, and a camp store and post office. Backcountry camping is available at designated sites and along floodplains, although a permit is required. Reservations for cave tours are advisable; check the park website (nps.gov/maca) for up-to-date information. A short bus ride may be needed to reach the beginning of some cave tours.

MESA VERDE NATIONAL PARK

For many centuries, Native Americans lived atop and among the mesas of southwest Colorado. Though Mesa Verde National Park celebrates this extended occupation of the region, it focuses primarily on the approximately 750-year period (550 to 1300 CE) that it was home to what is generally called the Ancestral Pueblo people. For most of that time, these people lived in simple pit houses and pueblos, farming and hunting in the surrounding area. But they eventually changed their way of life, building new homes—striking cliff dwellings—in the natural alcoves just under the rims of the mesas. Most of these cliff dwellings were small, with fewer than 10 rooms, but some were huge, multistoried, and complex, comprising as many as 100 rooms. Following this period, most residents of the area migrated to what is now Arizona and New Mexico near the end of the 13th century (some migrated to Texas after the Pueblo Revolt of 1680). Regardless, they left behind a treasure trove of cultural objects that offer fascinating insights into their life and culture, and this, along with the oral traditions of contemporary Native Americans, suggest much about the life and times of the people who lived in what is now Mesa Verde National Park.

Established in 1906, Mesa Verde was the first national park created to preserve and celebrate cultural rather than natural resources (though Indigenous people generally consider themselves part of the natural environment), and it marked the beginning of what is now a very substantial component of the National Park System that preserves and interprets human civilization and society, including the interaction between people and their environment. There are nearly 5,000 ancestral sites in the park, including about 600 cliff dwellings, and the importance of the park is manifested in its inscription in 1978 as America's first World Heritage Site.

Even though the natural environment is not the original focus of the park, it's still interesting and strongly related to Ancestral Pueblo culture. "Mesa Verde" is Spanish for "green table," offering a clue to the area's mesa-top environment. But there's not just one mesa—generally defined as a high, flat plateau—but several that are divided by steep canyons. (Some geographers suggest that the mesas are more technically cuestas.) Composed mostly of sedimentary rock—sandstones and shale—that was deposited by ancient seas and wetlands, Mesa Verde is part of the massive Colorado Plateau that was substantially uplifted by tectonic forces; subsequent streams carved the plateau into several distinct mesas. The land slopes slightly to the south, which contributed to formation of the large natural alcoves that house many of the larger cliff dwellings (groundwater flows south and erodes these alcoves). The park's largest cliff dwellings are found on Chapin Mesa and Wetherill Mesa. Elevations in the park generally range from 6,000 to 8,500

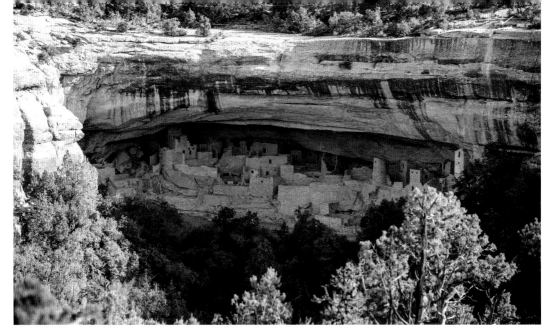

Cliff Palace, the largest and most famous cliff dwelling in the park, can be toured on a ranger-guided hike.

feet. Sagebrush dominates lower elevations, and piñon-juniper forest (the "pygmy forest" of the Southwest) covers much of the rest of the park. Natural wildfires in recent years (and throughout history) have heavily burned large areas of this forest. Higher elevations support Gambel oaks and occasional Douglas firs. Observant visitors may see mule deer and coyotes; bobcats, mountain lions, and bears are present but rarely seen.

The natural environment played an important role in Ancestral Pueblo culture. Soil provided for agricultural development; seep springs offered water for drinking and agriculture; forests supplied wood for building and cooking fires; native plants and wildlife were vital sources of food and medicine; and natural alcoves provided for the culture's characteristic and distinctive cliff dwellings. But evidence suggests there may be another important way in which the natural environment had a direct effect on

Ancestral Pueblo culture. One theory about why these people migrated away from Mesa Verde is that high population growth, a prolonged drought, and growing scarcity of resources (trees, animals, fertile soil) may have forced them to move. Further study of the relationship between these Native Americans and their environment may offer vital lessons to contemporary society.

Evidence suggests that the Mesa Verde area was visited by nomadic Paleo-Indians as early as 10,000 years ago. However, the mesa-top villages and cliff dwellings built by Ancestral Pueblo people didn't emerge until the first century CE, probably about the year 750, with the increased practice of agriculture. Pit houses gave way to increasingly large mesa-top pueblos, often in small to large village complexes, and the people adopted increasingly sophisticated agricultural practices, including dry-land crops of corn, beans, and squash that supplemented other foods

such as deer, bighorn sheep, small game, turkeys, potatoes, and wild plants such as rice grass and berries. Small reservoirs were constructed to capture rainwater and snowmelt, and turkeys were domesticated.

Adoption of cliff dwellings in the last century of Ancestral Pueblo presence at Mesa Verde featured blocks of sandstone plastered with adobe mortar, often multiple kivas (ceremonial and living spaces), and sometimes towers. Artful white pottery with black designs was fashioned into pots, bowls, cups, pitchers, and other objects.

It's likely that some trappers and prospectors were shown the remains of the cliff dwellings and associated cultural items in the late 19th century by Ute people, who then occupied the Mesa Verde area as part of their reservation. Photographer William Henry Jackson visited the area in 1874, and his photographs were widely viewed. The Wetherills,

local ranchers, explored the mesas and helped guide Frederick Chapin, a writer and photographer, through the area in 1889 and 1890. Chapin's 1892 book, *The Land of the Cliff-Dwellers*, focused more attention on the area. Gustaf Nordenskiöld, a Swedish scientist, conducted the first systematic survey of the area, publishing his book *The Cliff Dwellers of the Mesa Verde* in 1893. However, he removed many important cultural items and shipped them to Sweden; these artifacts now reside in the National Museum of Finland.

Loss of cultural artifacts and the damage done searching for them raised concern about maintaining the integrity of the area. After visiting Mesa Verde in the early 1880s, journalist Virginia McClurg worked to protect the area, including forming the Colorado Cliff Dwellers Association. Her colleague, Lucy Peabody, lobbied Congress for protection of the area. In an expression of

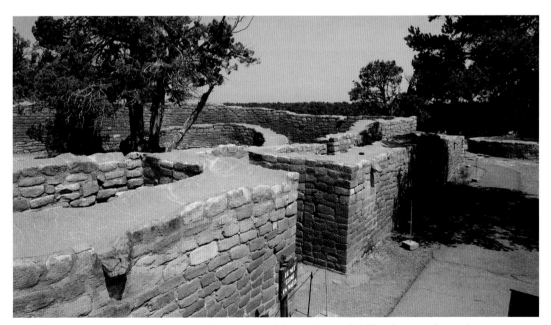

Many of the archaeological sites in the park are found on top of the area's mesas; Sun Temple is a good example.

concern over looting and vandalism of Native American items throughout the Southwest, Congress passed an important law in 1906, generally called the Antiquities Act, that allows the president to create national monuments by executive order, providing protection of historic, cultural, and scientific resources. This law has been used many times to create protected areas (usually called "national monuments"), and Congress often eventually establishes these places as national parks, affording them a greater degree of protection. This process continues today. Just a few weeks after passing the Antiquities Act, Congress established Mesa Verde National Park.

VISITOR CENTERS

The state-of-the-art LEED-certified Mesa Verde Visitor and Research Center near the park entrance should be the first stop for all visitors. This modern and striking building features a variety of exhibits that orient and educate visitors about the sophisticated natural and cultural history of the area. Other exhibits include information about the modern descendants of the Ancestral Pueblo people, original sculptures and other art that offer a variety of perspectives on Mesa Verde's people and landscape, and environmental design features of the building. Rangers help visitors plan their visits, and a small shop carries educational materials, maps, guidebooks, and gift items. The building also houses a state-of-the-art research and storage facility for the park's archives and museum collection of more than three million cultural objects.

Though not a conventional visitor center, the Mesa Verde Museum, farther into the park, is the oldest in the National Park System. The building is constructed of Cliff House Sandstone (the same type of stone used by Ancestral Pueblo people to construct nearby Spruce Tree House and other cliff dwellings) in an architectural style known as Modified Pueblo Revival. The museum displays and interprets cultural items—ceramics, mugs, jewelry, and sandals—excavated in the park. The museum is located on Chapin Mesa, about 20 miles from the park entrance.

DRIVING TOURS

Mesa Verde's roads offer an important way to see and appreciate the park. The park's main road leads directly off CO 160, where the park's visitor center and museum are found. This drive is about 15 miles to the Far View Area, but it's a slow, winding, two-lane road, so allow plenty of time. There are some nice attractions along the road, including the Mancos Valley, Montezuma Valley, Park Point, and geologic overlooks. The road rises steadily, giving visitors a sense of the climb that was required to reach the park's Chapin and Wetherill Mesa tops, the locations of most of the park's cliff dwellings and other features. Here the road splits, one branch leading to Chapin Mesa and one to Wetherill Mesa. Both roads require drivers to move slowly, offer wonderous views, and lead to the park's iconic cliff dwellings as well as mesa-top sites such as Fairview and Badger House Community and along the Mesa Verde Top Loop Drive.

WALKING PARK TRAILS

Nearly all visitors to Mesa Verde do some walking, as visiting the larger cliff dwellings can only be done on foot, sometimes with challenges such as uneven terrain and

ladders. Most of the park is closed to hiking due to the fragility of the area's ancestral sites. Nevertheless, there are several walks that offer important insights into the area's history and prehistory as well as grand views of the park's scenic mesas, canyons, and surrounding lands.

Cliff Palace, Balcony House, Spruce Tree House, Long House, and Step House

These are the grandest and most iconic cliff dwellings in the park, and all demand what many visitors might consider a substantive walk, varying from under a mile to more than two miles. Three of them—Cliff Palace, Balcony House, and Long House—require a ticket for entrance and include a ranger-guided walk. The tours last an hour, and all require navigating some steep and uneven surfaces, using ladders, and even crawling through a narrow tunnel in one case. But this is all part of the adventure and suggests the ways in which the residents of these magnificent dwellings entered, exited, and moved around them. Balcony House and Long House have a deserved reputation for being the most challenging. The cost of tickets is nominal and should be purchased up to two weeks in advance at recreation.gov. Check the park's website (noted below) for up-to-date information on purchasing tickets and to see what's open and closed for the season. Spruce Tree House is also impressive, and you don't need a ticket. NPS rangers are stationed at the site to answer questions and watch over this precious cultural resource.

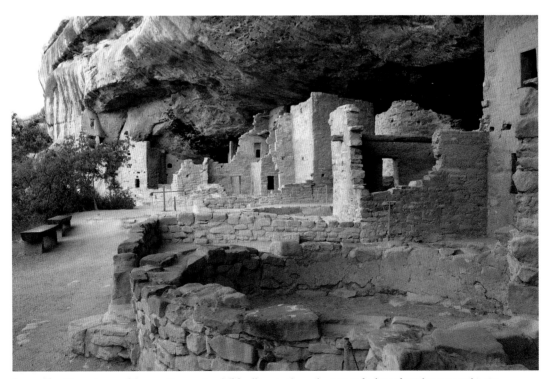

Spruce Tree House is one of the most impressive cliff dwellings in the park; visitors don't need a ticket to tour this site.

Petroglyph Point Trail

In addition to the walking tours noted above, a favorite hike at Mesa Verde is the Petroglyph Point Trail. The 2.4-mile loop begins and ends near the Mesa Verde Museum. The trail leads to the park's most impressive rock art panel, featuring the stylized symbols—dozens of them over a 12-foot-wide area—recorded by the Ancestral Pueblo people. Contemporary Hopi believe some of the symbols tell the story of the emergence of their ancestral people from the earth, their subsequent history, and perhaps their future. These images were chipped into the rock and are highlighted by the contrast between the dark desert varnish on the surface of the rock (a dark coating on exposed rock surfaces found in many arid locations) and the lighter color of the sandstone underneath. Reaching this impressive rock art panel requires an adventurous hike up and down what is sometimes a highly crafted trail of steep, narrow steps, all located under the edge of the mesa. However, the return half of the hike is along the top of the relatively flat mesa top and offers wonderful views of the Mesa Verde landscape where the Ancestral Pueblo people hunted and gathered, grew crops, and carried on their day-to-day lives.

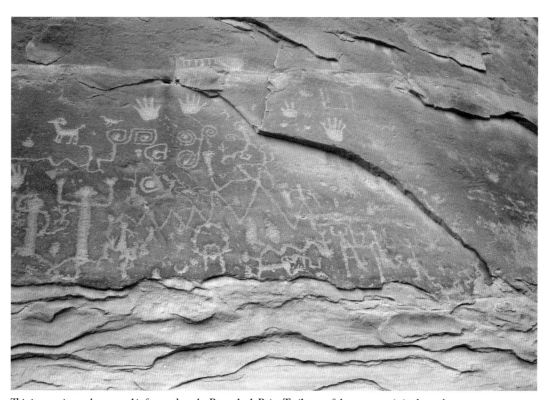

This impressive rock art panel is featured on the Petroglyph Point Trail, one of the most scenic in the park.

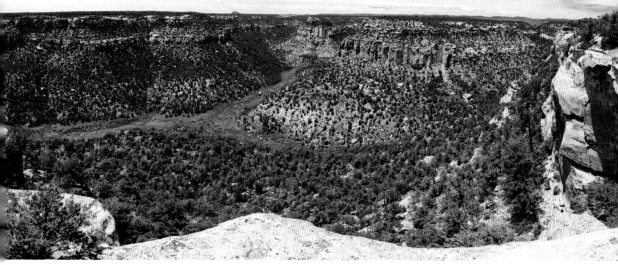

Views of Spruce and Navajo Canyons can be seen from the Petroglyph Point Trail.

Soda Canyon Overlook Trail

This is a short (about 1.2 miles) lollipop trail off Cliff Palace Loop Road that gently undulates through a classic piñon-juniper forest as it makes its way to a series of three overlooks, two of which are the only places from which you can see Balcony House other than on the ranger-guided tour. Binoculars will be helpful, and the views are best in the morning when the sun lights up the cliff dwelling. The middle overlook is of large and impressive Soda Canyon and the prototypical landscape of Mesa Verde. Look for the natural alcoves just under the edges of the canyons, the types of alcoves where iconic cliff dwellings were constructed. Soda Canyon is named for the white calcium carbonate deposits below the rim of the canyon, the mineral that remains from seeps and springs vital to the native people.

Badger House Community Trail

Most Mesa Verde visitors confine themselves to the Chapin Mesa area and for good reason—this is where so many of the park's most iconic cliff dwellings are found. But the park also has a quieter side that's just as impressive: Wetherill Mesa. Maybe it's the narrow, winding road to the mesa that filters out many visitors. But there are impressive cliff dwellings (e.g., Long House, the second largest in the park) along with a detailed story of the history of the Ancient Pueblo people as told along the 2.5-mile Badger House Community Trail. This relatively flat trail along the mesa top passes four important dwelling sites—collectively known as Badger House Community—that trace 600 years of prehistory.

SPECIAL PROGRAMS

National Park Service policy requires the presence of a ranger at most of the major ancestral sites; the NPS offers ranger-guided tours (which require a ticket) or the presence of a ranger while visitors conduct their

own self-guided tours (with lots information panels, brochures, etc.). This helps ensure the protection of these areas and offers visitors ready access to knowledgeable park rangers. In addition to these interpretive programs, rangers conduct nightly programs during the summer on a variety of topics at the park's Morefield Campground. The NPS's Junior Ranger Program is popular with children (and adults!).

The NPS generally offers a series of "special hikes" guided by rangers or other experts, and these are wonderful opportunities to see sites that are not open on a regular basis or to tour some of the cliff dwellings at unusual times, such as sunrise. These opportunities are posted on the park's website and must be reserved.

LOGISTICS

Making your way around Mesa Verde requires driving some long, narrow roads that lead into the park and onto large Chapin and Wetherill Mesas. Shortly after you enter the park, find the relatively new and impressive Mesa Verde Visitor and Research Center; stop here to learn more about the park and plan your visit. There is a large campground (Morefield) in the park that includes some RV sites and electrical hookups, as well as Far View Lodge. Additional visitor facilities and services are available outside the park, primarily in Cortez and Mancos. The park is open year-round, but winter can be cold and snowy, and many of the major cliff dwellings, roads, and other attractions are closed. Summer can be hot, so spring and fall are ideal times to visit. For the most up-to-date information, see the park's official website: nps.gov/meve.

MONTICELLO AND THE UNIVERSITY OF VIRGINIA IN CHARLOTTESVILLE

Thomas Jefferson would be on nearly every American's list of most distinguished US citizens; his accomplishments and contributions include wide recognition as one of the nation's Founding Fathers, author of the Declaration of Independence, third president of the United States, founder of the University of Virginia, and talented philosopher, scientist, and historian. Less widely appreciated are his interests and achievements in architecture as reflected in design of his home at Monticello (near Charlottesville, Virginia) and the historic core of the University of Virginia in Charlottesville campus.

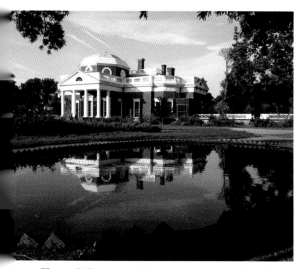

Thomas Jefferson is widely recognized as a founder of the United States, but he was also an accomplished architect who designed his Virginia home, Monticello.

But there are strong connections among these architectural efforts and his underlying interests in classical antiquity and philosophy; how these ideas might help shape and represent the American ideals of freedom, self-determination, and democracy; and how these concepts might best be manifested in American agriculture and education.

Jefferson's ideas about buildings and their relationship to the new nation were informed by his intense study of classical European architecture, both through reading and the five years he spent in France as US Minister Plenipotentiary to the Court of Versailles. He was particularly influenced by classical architecture, its representation in the Pantheon of Rome (though he didn't see the building in person), and the classical lines adopted by Italian architect Andrea Palladio. When he returned to the United States, he began his work to shape American cultural expressions in these classical European traditions but also mold into them into the distinctive physical and cultural context of the fledgling American nation. Monticello and the University of Virginia's historical core—which Jefferson called his idealistic "Academical Village"—are the ultimate expressions of his ideology. Both places were inscribed as a serial World Heritage Site in 1987.

VISITOR CENTER

The David M. Rubenstein Visitor Center and Smith Education Center serve as the public entrance to Monticello. The visitor center is where visitors purchase tickets to enter the grounds and tour Jefferson's home and surrounding property and includes parking, several exhibits, a kids discovery room, and a powerful introductory film. The visitor center also houses a shop and the Monticello Farm Table Cafe. From the visitor center, visitors can take a shuttle bus to Monticello or walk to the home via an approximately half-mile trail. Visitors can also meet Jefferson (as played by a professional actor-interpreter) on most days. A variety of tours of the home, grounds, garden, cemetery, and other attractions are available. The University of Virginia doesn't have a formal visitor center but offers daily tours of the campus that are conducted by trained students.

VISITOR ATTRACTIONS

The two attractions of this World Heritage Site are Monticello and the historic Academical Village of the University of Virginia. Although the two sites are not directly adjacent, it's just a few miles' drive from one to the other.

Monticello

Jefferson inherited approximately 2,500 acres of land outside Charlottesville, Virginia, in the Piedmont region of the state, when he was 14 years old. He fashioned the land into a large plantation that, with other purchases, reached a total of 5,000 acres. The plantation

A variety of tours of Monticello are conducted, including several of the home's interior rooms.

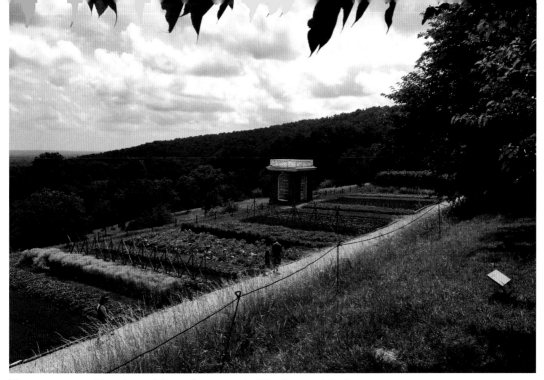

The extensive vegetable gardens at Monticello grew much of the plantation's food.

grew tobacco and other mixed crops but later shifted from tobacco to wheat in response to changing markets and Jefferson's progressive interests in agriculture. He designed and supervised construction of his home, Monticello, a plantation house, beginning in 1769 and lasting for 40 years as he designed, redesigned, and remodeled the building throughout much of his adult life. The home was sited on a substantial rise that afforded striking views of the surrounding mountains; the name of the home is Italian, meaning "little mountain." Design of the home was heavily influenced by the classical architecture of Europe, particularly the design principles of Italian Renaissance architect Andrea Palladio, and was substantially different from any other contemporary American home. The

original building included eight rooms and featured a two-story portico.

However, after his return from Europe, Jefferson transformed the structure beginning in 1796 into a 21-room home of approximately 11,000 square feet that was constructed in the fashionable neoclassical design he experienced in France, though he added his own innovations in adapting the building to its American context. Notably, the new design included an octagonal dome above the west front of the building instead of the original second-story portico. The building is known for its refined proportions and decor, its graceful siting into the surrounding landscape, and its expression as a quintessential neoclassical work of art. Jefferson was an avid horticulturalist, and

he designed and supervised construction of the home's extensive gardens that were a source of food, a horticultural laboratory, and a lovely feature of the property. The main house was flanked by small outlying pavilions. Just to the south of the house was Mulberry Row, a lane that included a row of outbuildings (dairy, washhouse, storehouses, nail factory, joinery, gardens for produce and flowers) and quarters for slaves (in the form of log cabins). At Jefferson's direction, he was buried on the grounds in what is now Monticello Cemetery. Monticello is owned and operated by the nonprofit Thomas Jefferson Foundation at Monticello.

University of Virginia Academical Village

Jefferson strongly believed in the power of education and its importance to the future of America. Consequently, he founded the University of Virginia in 1819 in Charlottesville, just a few miles from his home. This was the first nonsectarian university in the nation, and he intended it to educate the leaders of the new nation in public service and practical matters, and to be his legacy to his beloved Virginia and the nation. The core of the university was (and still is) the ideal "Academical Village" he designed and constructed. The centerpiece of the campus is the Rotunda, originally housing the library and several lecture rooms, and it is the physical and intellectual heart of the campus. The design of the Rotunda is based on the Pantheon of ancient Rome. The large lawn in front of the building has served as a model of open green areas that characterize the centers of most modern American universities.

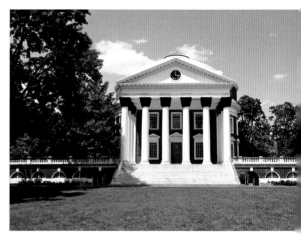

The Rotunda was the centerpiece of Jefferson's ideal "Academical Village" at the historic University of Virginia.

Although the Rotunda was heavily damaged by fire, it was restored in 1899.

The Academical Village is a terraced green space surrounded by trees and residential and academic buildings and gardens; the Rotunda sits at the north end of the lawn. The design of the Academical Village is based on Jefferson's vision of a holistic learning environment that extends beyond the classroom. The long buildings that face the lawn are rooms for students and are separated by 10 two-story pavilion buildings, each with a unique classical facade, that serve as faculty housing and, originally, classroom space. This conceptual design follows Jefferson's vision of students and faculty living and learning together, with the Rotunda library the hub of the community. The Academical Village still serves as the core of the much larger and more modern university campus. In 1976 the American Institute of Architects recognized the historic campus as an outstanding achievement in American architecture. The university is owned by the Commonwealth of Virginia.

JEFFERSON AND THE TRAGEDY OF SLAVERY

Recent scholarship, activism, and updated curatorial work at both Monticello and the University of Virginia have focused on the role of slavery at Monticello and the university, and this history has marred Jefferson's remarkable accomplishments and legacy. The Thomas Jefferson Foundation began work in 1993 to document the role of slavery at Monticello. Like most Southern plantations, enslaved workers were instrumental in many phases of plantation work, including construction of buildings, domestic work in and around the residence, manufacturing work at the plantation, and in agricultural production. Jefferson enslaved more than 600 people over the lifetime of his construction and occupation of Monticello. Moreover, Sally Hemings, an enslaved woman, had a sexual relationship with Jefferson for 38 years when Jefferson was a widower; she bore six of their children, four of whom survived to adulthood. Archaeological evidence suggests that she may have even occupied a small room near Jefferson's bedroom. This history has led to important changes and additions to the public education programs based on the shameful profiteering of the plantation on slavery and the mistreatment of so many enslaved people.

These revelations have affected the University of Virginia as well, but in this case much of the research was conducted by students, in particular undergraduate student Catherine O'Neale, who prepared a 2006 thesis titled "Slaves, Freedpeople, and the University of Virginia." Follow-up research discovered that the university used more than 100 enslaved persons to help build some of the institution's original buildings and care for the grounds. Moreover, some faculty and students brought their family's slaves with them to campus to help with household tasks and upkeep of the buildings and grounds. This scholarship led to a program of activism on campus to revise the school's history and to begin to atone for the long period of enslaving people by Jefferson, the university's founder, and the university as well. Since then, the university has designed and erected its Memorial to Enslaved Laborers on campus, just east of the Rotunda. The memorial features a broken shackle (referencing the "Ring Shout," a dance practiced by enslaved people celebrating spiritual liberation) and a granite wall with inscriptions of the names of enslaved people associated with the university. A student-led tour of the campus called "Slave to Scholar" is also conducted.

Today, it seems inconceivable that Jefferson would have participated in the practice of slavery given his groundbreaking work to advance the causes of self-government and individual freedom, and especially perverse that the author of the Declaration of Independence could have enslaved people for his personal and professional gain. But Jefferson himself wrote about the university: "For here we are not afraid to follow the truth wherever it may lead." The university and management of Monticello are trying to live up to Jefferson's advice.

LOGISTICS

The University of Virginia is located in Charlottesville, a lively town of about 50,000 residents, about a 2.5-hour drive southwest of Washington, DC; Monticello is just a few miles from the campus. The tours of

Monticello is featured on the back of the US "Jefferson nickel."

Monticello noted above are popular and should be reserved well in advance, if possible; see Monticello's official website (monticello.org) for details and costs. The University of Virginia offers free daily tours of campus, including the historic Academical Village; see the university's official website (virginia.edu) for details. A full range of visitor facilities and services is available in Charlottesville and surrounding communities.

MONUMENTAL EARTHWORKS OF POVERTY POINT

At about the same time as the New Kingdom of Egypt was ruled by its most famous pharaohs and queens—Tutankhamun, Nefertiti, and Ramses II—an ancient community of Native Americans began constructing a series of exceptionally large earthworks in what is now northeast Louisiana. Over the next 600 years, these people built a series of very large earthen mounds, curved ridges, and a great plaza that became a residential complex, a ceremonial site, and the center of a vast exchange network. It's estimated that this construction project required movement of 53 million cubic feet of soil, carried by workers in woven baskets and hide bags; each load would have weighed approximately 50 pounds, and there were no wheeled carts or draft animals to help. The site chosen for this construction provided easy access to the vast Mississippi River Valley and its namesake river and hardwood forests along its perimeter. The name "Poverty Point" is taken from a 19th-century plantation that was located on a portion of the property. The distinctive social-environmental system that developed in association with the earthworks is called the Poverty Point Culture. There is evidence that the powerful culture emanating from the site shaped the lives of villages and communities throughout the Lower Mississippi

Valley, parts of the Gulf Coast, and even some parts of the lower Midwest.

The design of the site is unusual in that it consisted of a group of conventional mounds and a large plaza but also included a series of six nested concentric, semielliptical (C-shaped) ridges that encircled the plaza on three sides, divided into sections by at least four aisles. The diameter of the outermost ridge measures three-quarters of a mile. The site was situated on the high ground of Macon Ridge, which forms the western edge of the Mississippi River floodplain. Bayou Maçon, a part of the Mississippi River tributary system, is located in the floodplain directly east of Macon Ridge. The site is also unusual in that the people who constructed it are considered by anthropologists to be a pre-agricultural society of hunters, fishers, and gatherers—a type of culture that was traditionally thought to be nomadic, to lack a consistent supply of nutrients, and to lack a hierarchical organizational structure conducive to successfully building such a massive engineering project. The diet of the residents at Poverty Point was varied and included fish, alligators, turtles, frogs, waterfowl, aquatic plants and tubers, deer, small mammals, nuts, fruits, and seeds. The unusually rich and diverse range of wild foods available near

It can be a long climb to the top of the mounds, some of which approach 100 feet tall.

the site gave residents regular and plentiful supplies of food without agriculture, which allowed year-round use of the site and supported earthworks construction.

Excavations conducted at the site document that it was constructed and occupied between 1700 and 1100 BCE and then gradually declined. Research suggests that dwelling units (with walls formed by a woven structure of cane and sticks covered in mud) were located on the ridges and that most residents were temporary pilgrims to the site. There also may have been as many as a couple hundred permanent residents at any one time. The site was ultimately abandoned around 1100 BCE, perhaps due to climate change and large-scale flooding in the Mississippi Valley. Excavations also suggest that the people who constructed the earthworks may have had a sophisticated knowledge of earthen construction, mixing soil types in ways that allowed the structures to persist over centuries without the advantage of mechanical compaction and despite the abundant rainfall and subsequent erosion characteristic of the region. The central plaza included large circles (from 25 feet to more than 200 feet in diameter) of timbers set on end; their purpose is not yet known.

Though pottery isn't found in abundance, it's present in both imported and locally made varieties. The most common artifacts found at the site are what have become known as Poverty Point Objects. These are small hand-formed balls of the local soil that were heated in a fire and used for cooking. The only natural resource that was not available on-site was stone, so a vast exchange network served to obtain this and other goods. The network extended up to 1,000 miles and was aided by travel on surrounding rivers. Many tons of rocks and minerals were imported to the site and used for projectile points; tools such as knives, scrapers, adzes, and axes; cooking vessels; grinding stones; beads; pendants; and other objects.

As one of America's most important archaeological sites, Poverty Point has received much recognition and protection, including designation as a state historic site, a US national monument, and a US National Historic Landmark. Most recently, it was inscribed as a World Heritage Site in 2014. The 402-acre property is managed by the Louisiana Office of State Parks.

VISITOR CENTER

The Poverty Point National Monument Visitor Center serves as an excellent introduction to the site. A museum orients visitors to the area and includes educational exhibits, artifacts from the site, an information desk, and videos. Ranger-guided tram tours are offered from Wednesday to Sunday, weather permitting. Guided hikes, flint knapping, prehistoric pottery, and other interpretive programs are offered regularly. Atlatl and pump drill demonstrations are offered daily. An archaeological laboratory, research dormitory, and tutorial facility are also located at the park.

VISITOR ATTRACTIONS

Although the primary visitor attractions of this World Heritage Site are its namesake monumental earthworks, there are a few others as well. Take the time to see and appreciate the grand and mysterious landscape sculpted by ancient people more than 3,000 years ago.

Plaza

This nearly 43-acre plaza enclosed by the innermost concentric ridge appears to be natural, but archaeological excavations have found that the original landscape has been extensively modified into its nearly

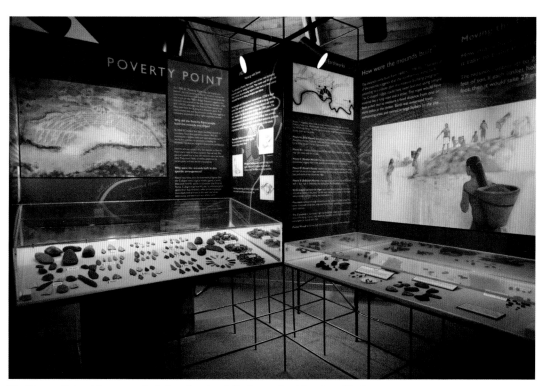

The Poverty Point visitor center includes educational displays and artifacts found in the area.

flat form. Naturally occurring gullies were filled and soil was added to the site to raise the surface area three feet or more. Further research has found that the plaza included multiple large circles of 25 to 200 feet in diameter, defined by large wooden posts and other buried features.

Mound A

The larger mounds at the site have been simply labeled by archaeologists with letters. Mound A was constructed sometime after 1350 BCE and is the largest at the site, standing 72 feet high and roughly 705 by 660 feet at its base; the mound is located west of the ridges and is roughly T-shaped. The mound was probably constructed quickly, perhaps in as little as a few months, because there's no evidence of weathering of the soil during construction. The original vegetation of the mound's footprint was burned immediately prior to construction. The mound is built of approximately 8.4 million cubic feet of fill, making it the second-largest earthen mound (by volume) in eastern North America, second to Monks Mound at Cahokia Mounds State Historic Site (and World Heritage Site) described earlier in this book. A large borrow pit is present north of Mound A.

Mound B

Mound B was the first mound built at the site, around 1650 BCE. Constructed in phases, it is 21 feet high and the base diameter of its roughly conical form is 180 feet. The mound is located north and west of the site's six concentric ridges. Excavations have found impressions of woven baskets and animal-hide bags left in the bottom of the sixth stage of construction. These impressions give archaeologists evidence of the shape, size, and materials used to haul soil during construction of the mounds.

Mound C

Mound C is located inside the plaza near the edge of Macon Ridge. This large loaf-shaped mound is about 260 feet long, 80 feet wide (though this is truncated along the eastern edge due to erosion), and 6.5 feet tall (from the current surface of the ground). Multiple radiocarbon dates are consistent with the Poverty Point period, but there is not enough information to know if it was one of the earlier or later mounds constructed at the site. Its internal construction is unlike other mounds on-site. A depression that divides the mound may be evidence of a wagon road constructed in the 19th century.

Mound D

This mound is rectangular in shape with a flat summit; it's about 100 feet by 130 feet, is 6.5 feet tall, and is located on one of the site's concentric ridges. Research has found later Coles Creek culture ceramics at the mound, and luminescence dating confirms that the mound was constructed about 2,000 years after the Poverty Point culture. More recent evidence of the use of the mound is the historic cemetery found on the top of the mound, related to the Poverty Point Plantation.

Mound E

This is a rectangular, flat-topped mound with rounded corners and a ramp extending from the northeast corner; it stands over 13 feet high and is 360 feet by 295 feet at its base. Excavations suggest it was constructed in

Much of the site has returned to hardwood forests, but the location of the earthworks is still obvious.

phases, and small flakes of nonlocal chert have been found inside the mound. Like the other large mounds, there is little evidence of use except for social or ceremonial purposes. Recent radiocarbon dates place its construction sometime after 1500 BCE. The mound is located south of Mound A.

Mound F

This mound was discovered in 2013 and is located outside and to the northeast of the concentric ridges; it stands about 5 feet tall and is 80 feet by 100 feet at its base. Radiocarbon dating suggests this was the last mound constructed at the site.

Lower Jackson and Motley Mounds

Two other mounds still exist in the area surrounding the site. Approximately 1.8 miles south of Poverty Point is Lower Jackson Mound, an 8-foot-tall conical mound with a 150 feet diameter at its base. Radiocarbon dating shows that this mound was constructed during the Middle Archaic Period, around 3700 BCE; this predates the Poverty Point earthworks by about 2,000 years. Motley Mound is about 1.2 miles north of Poverty Point and stands 52 feet high and measures 560 feet by 410 feet at its base, but its age or relationship to Poverty Point is unknown.

The Poverty Point site included several timber circles—some larger than 200 feet in diameter and now marked with PVC pipe—but their purpose is not yet known.

The Jackson Place Mound Complex (dated from 700 to 1100 CE) was located only a few hundred yards south of Poverty Point but was mostly leveled by farmers in the late 1960s.

DRIVING TOUR

A short driving tour winds through the site and is a good option for seeing some of the major earthworks. The tour includes stops at eleven points of interest; be sure to ask for the self-guided driving tour brochure at the visitor center. Ranger-guided tram tours are also available Wednesday through Sunday.

HIKING TRAIL

Walking through the site is the best way to more fully appreciate it, and a 2.6-mile self-guided walking trail has been developed for this purpose. There are 20 educational stops along the trail, and the trail is gently graded (with the exception of the climb to Stop 3 and to the top of Mound A). Ask for a copy of the *Hiking Trail Guide* at the visitor center (where the trail begins). Much of the site is open to the sun, so be sure to wear a hat in summer and take plenty of drinking water.

LOGISTICS

The site is located near the town of Epps, Louisiana, and is open daily with the exception of Thanksgiving, Christmas, and New Year's Day. Poverty Point World Heritage Site is managed by the Louisiana Office of State Parks. There is a nominal entrance fee, but seniors (age 62 and older) and children under 3 years old are free. For the most up-to-date information, see the site's official website (povertypoint.us): There are picnic areas on-site, but no accommodations or campsites. Poverty Point Reservoir State Park to the south has cabins, campsites, RV sites, and the Black Bear Lodge for overnight stays.

OLYMPIC NATIONAL PARK

Olympic National Park. Could there be a better name for this regal place? (In Greek mythology, Mount Olympus was the home of the 12 Olympians, the major Greek gods.) Square in the middle of America's nearly million-acre Olympic National Park rises Mount Olympus, nearly 8,000 feet high and cloaked in the glaciers that helped shape the mountains and much of the rest of this park. Follow these glaciers and their melt-water downstream toward the Pacific Ocean through subalpine meadows of wildflowers to find the park's emerald valleys that hold some of the world's most impressive and beautiful old-growth rain forests of Sitka spruce, western hemlock, bigleaf maples, and western red cedars. Some trees are more than 300 feet tall and 70 feet around, and every-thing is covered in moss and lichens. Just a little farther west, walk along the park's more than 60 miles of wild Pacific Ocean coast-line with its beaches, sea stacks, tide pools, and driftwood. All this is just a few hours' drive from the Seattle metropolitan area. It's no wonder the park was inscribed as a World Heritage Site in 1981.

The underlying geology of the park is complex but is a mix of several of the

The Olympic Mountains rise in the middle of this nearly million-acre national park.

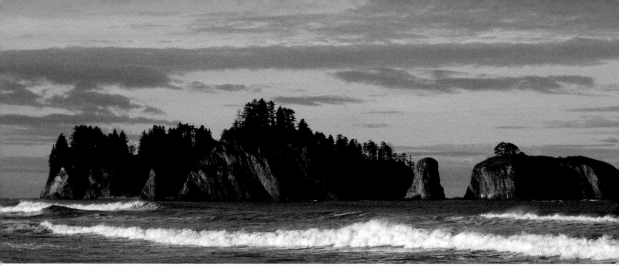

The park includes more than 60 miles of wild Pacific Ocean coastline, with its beaches, sea stacks, tide pools, and driftwood.

conventional forces and processes that have shaped much of North America. Cracks in the floor of the Pacific Ocean west of the present-day park emitted magma that eventually formed a deep sea range of volcanoes, or seamounts, composed primarily of basalt. Later, the tectonic plate underlying these volcanoes (the relatively small Juan de Fuca Plate) moved east and collided with the much larger tectonic plate underlying the northwest portion of the continent. As these plates collided, the seamounts were pushed up to form the core of the present-day Olympic Mountains. Subsequently, water and glaciation eroded the landscape, forming the system of U-shaped valleys that radiate off the mountains.

Over deep time, luxuriant vegetation, including the ecologically significant rain forests that currently grow on the west side of the park, covered most of the area. The Hoh Rain Forest is an excellent example. This land receives more than 12 feet of rain annually and has a rich understory of ferns as well as a large population of epiphytes

(plants that derive their moisture and nutrients from the air and rain and usually grow on another plant, especially trees). Higher elevations receive less rain and are covered by forests of western hemlock and subalpine meadows. The highest elevations in the park are above tree line, and vegetation is sparse and low-growing. The wide variation in the park's habitats supports many species of iconic wildlife, including Roosevelt elk, cougars, black bears, bobcats, black-tailed deer, beavers, and marmots. Marine mammals include sea lions, seals, sea otters, porpoises, and gray whales. Notable birds include bald eagles, red-tailed hawks, ospreys, and northern spotted owls.

A large Native American presence on the Olympic Peninsula has been traced back to about 12,000 years (contemporary tribes describe their history as reaching back to "time immemorial") and was focused on hunting and fishing, particularly salmon and marine mammals. Sadly, diseases introduced by European immigrants decimated most of the tribes that inhabited the area.

The present-day Olympic Peninsula includes several small Indian reservations. Olympic National Park maintains government-to-government relations with eight federally recognized tribes: Port Gamble, S'Klallam, Jamestown S'Klallam, Lower Elwah Klallam, Makah, Quileute, Hoh, and the Quinault Indian Nation. Explorer Juan de Fuca recorded seeing the peninsula in 1592, but because of its isolation and ruggedness, serious exploration of the area was substantially delayed. In the late 19th century, logging became a primary economic activity, but clear-cutting proved devastating and drew growing opposition. President Theodore Roosevelt established Mount Olympus National Monument to help protect the area in 1907, and an additional level of protection was provided with establishment of Olympic National Park in 1938.

VISITOR CENTERS

Visitor centers are important parts of visiting national parks, places to learn about the parks and help in planning park visits. Olympic National Park has three: Olympic National Park Visitor Center/Wilderness Information Center (in Port Angeles), Hoh Rain Forest Visitor Center, and Kalaloch Ranger Station (technically a seasonal visitor contact station). Take advantage of these facilities to get more out your visit, learn park rules and regulations, and help stay safe in the park.

VISITOR ATTRACTIONS

The park's many and substantive visitor attractions can be thought of in two basic categories: places and activities. The NPS typically divides the park into ten regions, all offering distinctive natural and cultural resources and associated visitor attractions. The Elwha Valley in the north-central area of the park is the park's largest watershed, includes the lovely Elwha River surrounded by mountains, and is the traditional home of the Lower Elwha Klallam Tribe. The wild Elwha River supported remarkably abundant salmon and trout, but that changed dramatically in the early 1900s when two dams were constructed, blocking fish migration. More recently, this environmental story has come full circle with removal of the dams in 2012 and 2014, marking the biggest environmental restoration project in the history of the National Park System. Come visit this region and join in the celebration.

The Hoh Rain Forest is on the west side of the park, where the Hoh River flows off the slopes of Mount Olympus. The area's annual average of 140 inches of precipitation a year has given rise to one of the most remarkable rain forests in North America, a place all visitors should experience. Hurricane Ridge, another prominent region of the park, offers easy access to the park's

A bull elk finds favorable habitat in the park's famous Hoh Rain Forest.

impressive mountains. The region's great hiking trails, vast views, and location near the gateway town of Port Angeles make it especially popular with visitors. The Kalaloch/Ruby Beach region is on the southwest coast of the Olympic Peninsula and is easily accessible off US 101. Attractions include pristine wild beaches, marine mammals, and birding.

The Lake Crescent region is easily accessible from Port Angeles, the largest town on the Olympic Peninsula. Lake Crescent is a large, deep, glacially carved body of water in the foothills of the park and offers boating, hiking, and scenic beauty. The Ozette region is directly on the Pacific coast in the isolated northern area of the park. The landscape is diverse, including wild beaches, old-growth forests, a large lake, marine mammals, and hiking. The Mora/Rialto Beach region south of Ozette is more easily accessible and features similar attractions.

The Quinault region is found in the more remote southern portion of the park; this valley offers access to alpine meadows, mountain peaks, lovely lakes, and temperate rain forests. The Staircase region in the southeastern corner of the park is also remote and requires travel over an unpaved road; the area offers distinctive, cathedral-like forests of Douglas fir. The Sol Duc Valley, in the more accessible northern area of the park, features old-growth forests, subalpine lakes, mountain peaks, the Sol Doc River, the popular hike to Sol Doc Falls (see the description below), and migrating salmon in the fall.

These remarkably diverse regions support a wide variety of recreation opportunities, including hiking, boating, fishing, camping, snow play, and scenic driving.

DRIVING TOURS

Olympic National Park is unusual in that no roads cross the park, and this contributes to protecting the ecological integrity of the area. However, there are many scenic drives around the perimeter of the park and beautiful spur roads that access many regions of the park. US 101 is the historic highway that travels most of the west coast of the United States through California, Oregon, and Washington. The northernmost section of the road is a grand 205-mile route that encircles most of Olympic National Park. Sections of the road pass directly through the Lake Crescent and Kalaloch/Ruby Beach regions of the park, and attractive spur roads access the park's other regions. This large network of roads offers many days of delightful and adventurous scenic driving. The park offers a free app-based audio tour; see the park website (noted below) for details.

One of the most scenic and popular spur roads into the park is Hurricane Ridge Road, which starts in the town of Port Angeles and runs approximately 17 miles deep into the heart of the park. The road is steep, full of curves, and includes several short tunnels, but it is paved and accessible to conventional passenger cars. The road leads through deep forests up to the 5,000-foot Hurricane Ridge area that features dramatic open meadows with 360-degree views of surrounding mountains, valleys, and the sea. Several short hiking trails are available from the summit area (see below).

HIKING PARK TRAILS

This is a large and highly diverse park, and it has a trail system to match: nearly 600 miles

An extensive trail system offers access to the diverse regions of the park.

of maintained trails. Hike through the rain forests, along high ridgelines, around mountain meadows, and along the Pacific Ocean coast. Many trails can be walked as day hikes, but consider a backpacking trip as well (a permit is required); nearly all the park is designated wilderness. The following hikes will give you a good sense of this glorious park.

Hurricane Ridge

Hurricane Ridge is a large elevated area that's served by the 17-mile steep and winding Hurricane Ridge Road and is the most heavily visited area in the park. Here you'll find a network of short trails that feature the most outstanding views in the park (including the Olympic Mountains and glacier-capped Mount Olympus, the Strait of Juan de Fuca, Vancouver Island, and Victoria, British Columbia); lush spring meadows filled with wildflowers; subalpine forests; and wildlife such as mule deer and mountain goats. Depending on the time you have available, pick one of more of these short trails, including Big Meadow Loop, Cirque Rim Trail, High Ridge Loop, and Sunrise Point Spur Trail. Most of these trails are less than a mile or so, and some are interconnected with others, allowing you to fashion your own route. Check with rangers at the Hurricane Ridge Visitor Center for advice and a map of the area, and consider joining one of the ranger-led hikes. There are many ways to enjoy walking dramatic Hurricane Ridge.

Hoh Rain Forest

The extensive and luxuriant rain forests on the west side of the park are a dominant feature of Olympic. The Hoh Rain Forest is perhaps the best example and is readily accessible to hikers. The abundance of precipitation supports a large old-growth forest of Sitka spruce, western red cedar, western hemlock, Douglas fir, and bigleaf maple; some of these trees are more than 300 feet tall and 25 feet in circumference. A lush understory of younger trees, tall shrubs, and ferns carpets the area. Dramatic spikemoss hangs from the branches of many trees. Look for older trees that stand on massive stilted roots, evidence that these trees sprouted on fallen "nurse logs" that have since rotted away. Two short nature trails start from the visitor center that serves this area. The Spruce Nature Trail (a 1.3-mile loop) and the Hall of Mosses Nature Trail (a 0.8-mile loop) wander through the forest and feature a series of interpretive signs. You may see Roosevelt elk that inhabit this area. If you'd like a longer hike, consider the 17-mile Hoh River Trail that follows the Hoh River and then climbs steeply to Glacier Meadows on Mount Olympus; the trail makes an excellent backpacking trip.

Rialto Beach

The more than 60 miles of wild Pacific Ocean coastline are a signature feature of the park and demand at least one epic hike. A favorite begins at Rialto Beach and travels north along the rocky coast for about two miles to Hole-in-the-Wall, a massive sea arch. Along the way, you'll see dramatic sea stacks, large accumulations of driftwood, pristine beaches, extensive tide pools (the best are just north of Hole-in-the-Wall), and lots of wildlife, including seabirds, eagles, and many marine mammals such as whales, sea lions, and sea otters. Walk this route only at low tide.

Sol Duc Falls

The Sol Duc Valley in the northwest section of the park is a diverse area with old-growth forests, subalpine lakes, snowy peaks, and lots of wildlife. The valley is defined by the beautiful Sol Duc River, its name a Quileute term meaning "sparkling water." The trail to Sol Duc Falls, one of the most popular attractions in the park, is an easy out-and-back walk of 1.6 miles (round-trip) beneath a dense cover of forest and along the joyfully cascading river. You'll hear Sol Duc Falls long before you see it—a nearly 50-foot drop into a narrow rocky gorge; depending on the flow of the river, the falls is made up of several streams or channels. Find great views and memorable photos of the falls from both upstream and downstream.

A young family enjoys a hike in the Sol Duc region of the park.

SPECIAL PROGRAMS

The National Park Service is famous for its outstanding program of ranger-led interpretive programs, teaching visitors about the natural and cultural history of the parks. (The word "interpretation" refers to the translation of technical material into more easily understandable language.) These programs, including nature walks and campfire talks, are held throughout the summer season at popular destinations and campgrounds throughout the park. Check the "calendar" tab on the park's website (noted below) or the park's free newspaper for the current schedule.

LOGISTICS

Olympic is a large park that dominates Washington's Olympic Peninsula, south and west of the Seattle metropolitan area. Large wilderness areas of the adjacent Olympic National Forest surround the park and make it feel larger still. The park is open year-round, but winter can be severe in the upper elevations and rainy in the lower elevations; the primary visitor season is June through September. The park is encircled by US 101, with many side roads that lead into the mountainous and coastal regions of the park. There are several lodging options in the park, including historic hotels, rustic cabins, and modern motels such as Kalaloch Lodge, Lake Crescent Lodge, Log Cabin Resort, and Sol Doc Hot Springs Resort. A full range of commercial accommodations is found in surrounding towns. There are 15 campgrounds in the park with nearly 1,000 campsites. Backpacking is allowed in the park's large Daniel J. Evans Wilderness, but a permit is required. See the park's official website (nps.gov/olym) for the most up-to-date information.

PAPAHĀNAUMOKUĀKEA

Papahānaumokuākea is a place of superlatives, a vast ocean reserve in the north-central Pacific Ocean roughly 150 miles northwest of the inhabited Hawaiian Archipelago. Covering nearly 600,000 square miles (nearly as large as the state of Alaska), this is one of the most expansive marine protected areas in the world and the largest conservation area in the United States. In fact, it's substantially larger than all the units of the US National Park System combined. This long, linear, and isolated reserve is centered on a string of small, low-lying islands and coral atolls that runs for 1,200 miles and includes a generous portion of the surrounding and wild Pacific Ocean. This enormous expanse is one of the world's last and best examples of a largely pristine and naturally functioning marine ecosystem; some observers call it a remnant of the "ancient Pacific."

Papahānaumokuākea is a sacred place as well, important to Kānaka ʻŌiwi (native Hawaiians) for its history and cultural meaning. Papahānaumoku is a mother figure personified by the earth, and Wākea is a father figure represented in the sky; their union

This beckoning ocean view suggests the nearly 600,000-square-mile expanse of Papahānaumokuākea, one of the largest marine protected areas in the world.

describes the birthing of the islands of the Hawaiian Archipelago. Papahānaumokuākea (pronounced Pa-pa-hah-now-mo-koo-ah-keh-ah) was the first World Heritage Site in the United States to be inscribed (in 2010) for both its natural and cultural significance.

Consideration of natural history often begins with the underlying geology of a site, and that's especially appropriate at Papahānaumokuākea. This World Heritage Site is an internationally prominent example of island hot-spot volcanism, resulting in a progressive line of islands. For millions of years, an undersea volcano beneath the Pacific tectonic plate has been expelling magma, forming seamounts (underwater mountains) as the magma cooled. Islands are created when these seamounts rise above the surface of the ocean. As the Pacific Plate moved in a northwest direction, a chain of islands was created, forming many seamounts and small islands that are a part of Papahānaumokuākea. These islands were shaped and ultimately reduced in size by erosion and subsidence (the gradual caving in or sinking of an area of land). The larger Hawaiian Islands to the east are a later, related, grander-scale example of island hot-spot volcanism, a process that continues today. Native Hawaiian oral traditions and ancestral data repositories record all these major biological events in the Hawaiian worldview and provide the longest longitudinal expertise of Hawai'i.

Papahānaumokuākea is a diverse collection of aquatic and terrestrial features and related habitats. Prominent features including the pelagic (open-ocean) and deep-water portions of the surrounding Pacific Ocean; small eroded islands; atoll islands

Gallinules forage while swimming, walking on land, or climbing through marsh vegetation.

(ring-shaped reefs); islands, or chains of islands formed of coral, many of which are the "footprints" of former high volcanic islands); seamounts; pinnacles (high rock formations); undersea banks and shoals; shallow lagoons; sand dunes; dry grasslands and scrublands; and a hypersaline lake (especially high salt content).

These features have given rise to a great diversity of plant and animal species, currently estimated at about 7,000, but it's likely that many more have yet to be documented; these species include coral, terrestrial vegetation, fish, birds, and marine mammals. Many plants and animals—estimated at 25 percent—are endemic, meaning they occur naturally nowhere else and are highly dependent on maintaining the specialized habitats at Papahānaumokuākea. Many species are considered threatened or endangered, including green and hawksbill sea turtles; Hawaiian monk seals; the Laysan duck and albatross, Nihoa finches, and millerbirds; six species of endangered plants such as the fan palm; and many species of arthropods. Because of the area's isolation, size, and high degree of protection, its reef ecosystems are still dominated

Papahānaumokuākea features extensive systems of coral reefs.

by top predators such as schools of sharks, a feature that is now missing from most other island environments due to adverse human activity. An estimated 5.5 million seabirds nest in the area each year, and 14 million reside here seasonally.

Papahānaumokuākea represents an 'Ōiwi (native Hawaiian) place protected as a sacred space in Hawaiian traditions. It's believed that Papahānaumokuākea is the place where life originates and to where the spirits return after death. Similar to other Indigenous cultures, native Hawaiian culture is inextricably connected to the health of the environment. The health of Papahānaumokuākea is vital to native Hawaiian culture and communities that perpetuate their ancestral knowledge systems, values, and practices to this day. Ancient Polynesians sailed these waters and occupied these islands in their exploration and settlement of this vast region, leading to settlement of the current Hawaiian Islands. These people developed a sophisticated philosophy and cosmology based on kinship between people and the natural world. Two islands within Papahānaumokuākea, Nihoa

and Mokumanamana, contain archaeological remains from pre-European settlement. These sites include shrines and stone figures that resemble those of Tahiti and the Marquesas Islands and offer evidence of a great migration across the Pacific Ocean and its islands that began around 3000 BCE.

The cultural significance of Papahānaumokuākea extends to more recent history as well. The 19th-century Pacific-based American whaling industry affected this area. Whaling vessels renewed their provisions and recruited new whalers in Honolulu ports; native Hawaiians accounted for nearly 20 percent of the crew of this expansive whaling fleet. In the 1930s the US Navy constructed a large naval base, naval air station,

Paddleboards are one option for exploring the waters and shores of Papahānaumokuākea.

and submarine base on the island of Kuaihelani (Midway) in response to threats from Imperial Japan. Kuaihelani was of vital strategic importance during World War II and was the site of the historic Battle of Midway. This region of the Pacific includes dozens of shipwrecks and lost naval aircraft.

Papahānaumokuākea is comprised of several administrative areas, including Papahānaumokuākea Marine National Monument, Northwestern Hawaiian Islands Coral Reef Ecosystem Reserve, Midway Atoll National Wildlife Refuge, Battle of Midway National Memorial, Hawaii State Seabird Sanctuary, and the Northwestern Hawaiian Islands State Marine Refuge. Papahānaumokuākea Marine National Monument is the all-encompassing administrative area, and is cooperatively managed by the US Fish and Wildlife Service, the National Oceanic and Atmospheric Administration, and the State of Hawaii Department of Land and Natural Resources, and the Office of Hawaiian Affairs.

VISITOR ATTRACTIONS

World Heritage Sites, like most conservation areas, are managed to both protect these areas and make them available for visitor enjoyment and appreciation. However, there is often an inherent conflict between these two foundational objectives: Too much or inappropriate visitor use can lead to unacceptable degradation of natural and cultural resources. Because of the isolation of Papahānaumokuākea and its rare and fragile natural and cultural environments, management emphasis is placed primarily on preservation. Consequently, public

A diver enjoys a close-up view of a stocky hawkfish.

access is severely limited, with the primary exception of traditional native Hawaiian practices within the area.

Papahānaumokuākea Marine National Monument maintains a visitor center—Mokupapapa Discovery Center—in Hilo, Hawaiʻi, that interprets the natural and cultural history of the Northwestern Hawaiian Islands and their surrounding marine environment. Public access to Midway Atoll National Wildlife Refuge and Battle of Midway National Memorial was allowed at one time but has been discontinued due to shortages in staffing and operational capacity. Despite the lack of direct visitor access, a variety of virtual learning opportunities are available. For example, the Papahānaumokuākea Marine National Monument website (papahanaumokuakea.gov/visit/welcome.html) offers and describes a range of virtual learning opportunities, including a map of the area where users can click on each island and atoll to find educational materials and photos, suggested areas to visit that share Papahānaumokuākea features, teaching and educational materials, a list of books and movies that address the area, and much more.

REDWOOD NATIONAL AND STATE PARKS

Like most national parks, Redwood National and State Parks (Redwood) in northern California promises a lot and delivers even more. Of course it protects its namesake, the iconic old-growth redwood trees, the tallest living things on Earth. Some of these giants have been growing here for more than 2,000 years and can reach heights of 375 feet or more. Once covering 2,000,000 acres of coastal California and Oregon, indiscriminate logging, mostly in the latter half of the 19th century, reduced the old-growth redwood forest to less than 100,000 acres, nearly half of which is now included in Redwood. But the surrounding land and sea protect the natural and cultural context of the redwoods, and visitors are fortunate to be able to find these and associated components of the historic redwood forests in the park as well. Redwood includes 37 miles of precious undeveloped coastline; the low-lying Coast Range of mountains; indigenous plant and animal life (including habitat for several threatened species); wild and scenic rivers (including the Smith River, the only free-flowing river remaining in California); coastal grasslands; an area of sand dunes; and the culture of the original inhabitants, who have lived here for thousands of years and for whom the area is still home.

Management of the park is a fresh breath of administrative air, a cooperative venture between the National Park Service (NPS) at the federal level and the California State Parks Department at the state level. Officially known as Redwood National and State Parks, the area includes three state parks—Del Norte Coast, Jedediah Smith, and Prairie Creek Redwoods—and the federal national park. In recognition of its international significance, Redwood was inscribed as a World Heritage Site in 1980.

The park and its environs are geologically active, part of the massive "Ring of Fire" in the basin of the Pacific Ocean. But the star of the natural world at Redwood is its namesake tree. The scientific name of redwoods is *Sequoia sempervirens*; the first word notes the genus (in this case, honoring the famous Indian chief) and the latter the species (in this case, meaning "long-lived"). Redwoods are closely related to the giant sequoias found in Sequoia/Kings Canyon and Yosemite National Parks (see the chapter on Yosemite National Park later in this book). Redwoods grow taller than sequoias, but the latter have a greater mass (at least in the main stem of the tree), and redwoods can live up to 2,000 years or more, although the average is less than 1,000 years. Redwoods grow only near the coastline of northern California and southern Oregon, not too close to the sea because they can be injured by salt spray, but close enough to be bathed by the fog common to the area in summer; this fog is absorbed by the leaves/needles and provides the moisture needed to survive the

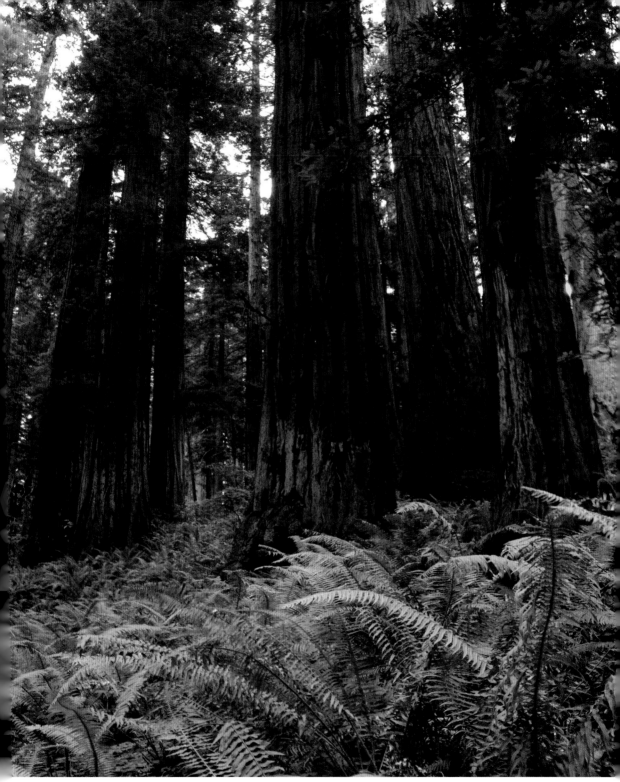

This park protects many of the remaining old-growth redwoods that have been living here for more than 2,000 years; these remarkable trees can reach heights approaching 400 feet.

area's hot, dry summers. The trees have bark up to a foot thick that protects them from insects, disease, and the area's historic ground fires. Periodic ground fires clear the forest floor of competing species, and Indigenous people commonly used fires to enhance opportunities for travel, hunting, gathering, and ceremony. Redwoods are an ancient species, having evolved in the Age of Dinosaurs.

Old-growth redwood forests are especially biologically rich, and when other features of the park are added in, including its range of elevations from below sea level (the park extends a quarter mile out from the shoreline) to 3,200 feet, the park is important to many species of plants and animals. Other important forest trees include Douglas fir, Sitka spruce, red alder, Pacific madrone, and bigleaf maple. Understories of laurel, rhododendron, and ferns are common. Notable land mammals include black bears, mountain lions, Roosevelt elk, black-tail deer, and bobcats. Marine species include gray whales, seals, sea lions, dolphins, and porpoises. Birds include pelicans, bald eagles, ospreys, and endangered northern spotted owls and marbled murrelets. California condors were recently reintroduced to the park after nearly 100 years of absence. Rivers provide habitat for salmon and steelhead.

Small diverse groups of Native Americans have lived along the coast for thousands of years, hunting, fishing, and gathering for subsistence and using fallen redwood trees for houses and boats. Their lives were deeply and spiritually intertwined with the land in which they lived and interacted, and they maintained a balanced approach to using and stewarding the land so that it would

always provide nourishment and protection for their families and community. These tribal communities continue to live, gather, practice ceremony, and hunt in the area, and park managers consult with tribal members on park management actions.

In the 1800s the area experienced several economic boom periods—first for trapping, then for gold, and finally for logging the extensive groves of ancient redwoods. Logging continued into the 20th century, powered by the tools of the Industrial Revolution, including trains and bulldozers, and the lumber was used for buildings in San Francisco and other areas.

In the early 20th century, conservationists became alarmed at the rapid disappearance of the redwoods and formed a group called "Save the Redwoods League." In the 1920s the group successfully lobbied the State of California to set aside the three state parks that are such integral parts of the present-day system of protected areas. Over the years, this group, along with the Sierra Club, National Geographic Society, and others, raised money to purchase land that was ultimately included in the park, and this process continues today. Some of this land has been logged but is now being reclaimed, a process that will take centuries. The groups also worked for decades to establish a national park to protect the area and finally succeeded in 1968. In 1994 the NPS joined with California State Parks to form Redwood National and State Parks to take a coordinated approach to park management. The present-day park has grown to include a 40-mile stretch of northern California comprising nearly 132,000 acres.

VISITOR ATTRACTIONS

Of course the stars of the show at Redwood are the pristine groves of ancient redwoods, trees that have been growing here for centuries. Enjoy scenic drives through miles of these forests, and take the time to walk through one (or more) of the oldest groves (see descriptions below). But there's so much more—miles of wild Pacific Ocean coastline; California's Coast Range of mountains; wild and scenic rivers that flow into the Pacific Ocean; iconic wildlife, including marine mammals; and prairie grasslands. And there are so many ways to enjoy and appreciate the park: learning about it at its visitor centers and interpretive programs, driving its scenic roads, hiking park trails, camping, wildlife viewing, kayaking, and more.

VISITOR CENTERS

A robust five visitor centers are located throughout the park; from north to south, these are the Hiouchi Visitor Center, Jedediah Smith Campground Visitor Center, Crescent City Information Center, Prairie Creek Visitor Center, and Thomas H. Kuchel Visitor Center. Most offer educational exhibits on the park's natural and cultural history, park rangers and/or volunteers to answer questions and offer trip planning advice, ranger-led programs (including the

A herd of Roosevelt elk finds good habitat in the park.

NPS's ever-popular Junior Ranger Program), and small retail outlets.

DRIVING TOURS

The park offers lots of scenic driving. Historic US 101, the road that runs along the west coast of the United States, travels about 60 miles through much of the park, and long stretches of this route are strikingly beautiful. Be prepared to stop often for scenic views, trailheads, and other attractions. There are several shorter scenic drives off US 101. Howland Hill Road, a 10-mile drive on an unpaved road from Crescent City to the junction with US 199 near Hiouchi, offers up-close views of old-growth redwoods in Jedediah Smith Redwoods State Park. Enderts Beach Road leads just over two miles from US 101 just south of Crescent City to the beach, where you'll find stunning coastal views and (maybe) elk and whales (see the Enderts Beach hike description below). Requa Road leaves US 101 just north of Klamath and leads to Klamath River Overlook, where you'll find great views and whale- and bird-watching. Newton B. Drury Scenic Parkway is a dramatic 10-mile drive through the heart of the old-growth redwood forest in Prairie Creek Redwoods State Park; this may be one of the finest scenic drives in the national park system. Cal-Barrel Road is off the Newton B. Drury Parkway—look

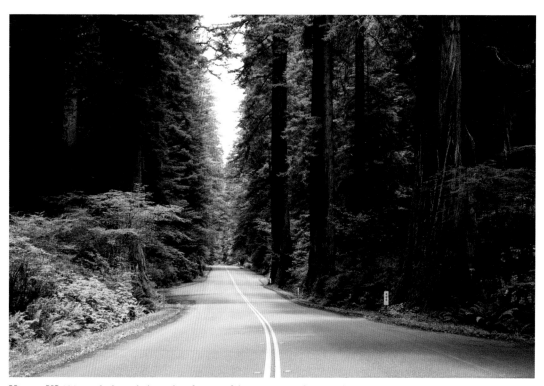

Historic US 101 travels through the park and is one of the most scenic drives in the country.

closely for the signed turnoff. This narrow, winding 1.5-mile road showcases exceptionally large coastal redwoods. Davison Road is an approximately seven-mile road that exits US 101 2.5 miles north of Orick; the road features meadows grazed by Roosevelt elk, access to the California Coastal Trail, and magical Fern Canyon Trail (see descriptions of these trails below). Bald Hills Road exits US 101 one mile north of Orick and travels 17 miles to Lyons Ranch Trailhead. The road passes through redwood forests and accesses the iconic Lady Bird Johnson and Tall Trees groves of redwoods (see descriptions below), Redwood Creek Overlook, and historic Dolason Prairie and Lyons Ranch. With the exception of US 101, all of these roads are minor, often twisting, and unpaved in some places; they're generally inappropriate for large vehicles (such as campers), and local conditions should be checked at park visitor centers. Access to the Tall Trees Grove and Fern Canyon require park permits; see the park's official website (noted below) for details.

HIKING PARK TRAILS

Walking is the best way to see, experience, and appreciate national and state parks, and this may be especially true at Redwood. Only by walking through these ancient groves of trees can you fully sense the seemingly impossible size of the trees and the centuries it takes to establish these old-growth forests. Redwood includes more than 200 miles of trails, some through the most iconic old-growth redwood groves but others along the Pacific coast and the streams that empty into the ocean. The following hikes are recommended.

The Ancient Redwood Groves: Tall Trees Trail, Lady Bird Johnson Grove Trail, Stout Memorial Grove Trail, Simpson-Reed Trail, Boy Scout Trail, Grove of the Titans

Though there are many huge redwood trees scattered through the park, a few of the largest and most majestic old-growth groves of redwoods are easily accessible on relatively short, well-maintained trails. These are the heart of the park. Choose one or, better yet, walk several, maybe even all of them; each seems more impressive than the last, and that's saying something. The Tall Trees Grove has the longest trail (about 3.5 miles) and is thought by some to be the

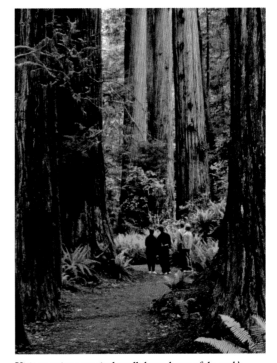

Visitors enjoy a magical stroll through one of the park's groves of old-growth redwoods carpeted with ferns.

most magnificent, but maybe that's because it's the only one that requires a permit from the NPS to enter. Trails through the other groves are considerably shorter. Ferns and other greenery carpet all the groves, and interpretive signs posted along the trails enhance the quality of each walk.

Fern Canyon Trail

Fern Canyon is the story of environmental tragedy to triumph. This magical canyon follows the bed of Home Creek but was drastically reshaped by destructive hydraulic mining during the 19th-century California gold rush. This damage created an unnaturally steep-sided canyon with 40-foot walls that have since been naturally revegetated with ferns, mosses, and other rain forest plants. In fact, the canyon walls—nearly every square inch of them—are covered in this greenery, and the effect is enchanting. From the end of Davison Road, walk up the canyon about a half mile and then climb out of the canyon on a series of steps, returning to the trailhead along the canyon rim for a hike of about a mile. The trail through Fern Canyon is connected to a network of other trails in this area, offering opportunities for much longer hikes. *Note:* A permit is needed to drive to and park at the trailhead servicing Fern Canyon; check the park's website for details.

Enderts Beach

As impressive as the redwoods are, you should find time to walk at least one of the park's remarkable Pacific Ocean beaches; scenic Enderts Beach is a good choice. A walk of just under a mile along the abandoned old Coast Highway brings you down to a crescent-shaped wild beach known for its waves, rocky shoreline, long walks, driftwood, and fascinating tide pools. Check the NPS website for ranger-guided walks here if you prefer to go with a group.

Redwood Creek Trail/ Hiouchi Trail

These trails follow two of the most important streams in the park. Redwood Creek Trail is one of the most popular in the park, though it's typically hiked only to a turnaround point about 1.5 miles from the trailhead, the point of the first major crossing of the creek on a footbridge. (This and other bridges along the trail are only in place in the summer months, and fording the creek in high water can be dangerous.) This first section of the trail is flat and well maintained and is a delightful walk along the river and beside the rain forest composed of spruce, Douglas fir, maples, alders, and occasional redwoods. A resident elk herd adds to the excitement. The full length of the trail travels about eight miles to the Tall Trees Grove noted above; it is best walked as a short backpacking trip, with camping opportunities along the usually wide creek bed (a permit is needed for this and other backpacking trips). The Hiouchi Trail is an out-and-back trail of 4.2 miles (round-trip) through expanses of redwoods and along the south bank of the Smith River (named for 19th-century explorer Jedediah Smith). The Smith is the only undammed river system in California. The river's waters are a striking jade green, derived from upstream deposits of serpentine; "Hiouchi" is a Native American word for "blue-green waters." The trail ends at the magnificent Stout Memorial Grove noted above.

The park includes 37 miles of wild California coastline.

Coastal Trail

The park's epic long-distance trail traces its magical, largely undeveloped coastline almost continuously for 35 miles, and all of it can be walked, either in its entirety or in sections. The trail is part of the legendary 1,200-mile California Coastal Trail. Highlights of the trail include old-growth redwoods and Sitka spruce, migrating gray whales, secluded beaches, massive piles of driftwood, tide pools, Roosevelt elk, open prairies, offshore sea stacks, thousands of seabirds, and sweeping ocean vistas. Five backcountry camps are within an easy day's walk of one another. Tide tables and the ability to read them are essential to safely navigate the trail.

SPECIAL PROGRAMS

A suite of ranger-led interpretive programs is offered in a number of locations. Examples include nature walks, campfire talks, guided kayak tours, and tide pool walks. See the "calendar" tab on the NPS website for dates and locations of programs. The NPS Junior Ranger Program is offered at many locations throughout the park.

LOGISTICS

The park is open year-round, but winter tends to be rainy and summers can be hot and foggy; spring and fall are the best times to visit. There are no commercial lodgings in the park, but four basic cabins are available at Prairie Creek Redwoods State Park and four more at Jedediah Smith Redwoods State Park. A full range of accommodations can be found in surrounding towns. There are four developed campgrounds in the park (Jedediah Smith, Mill Creek, Elk Prairie, and Gold Bluffs Beach), all managed by the California Department of Parks and Recreation. Backcountry camping is allowed at seven camping areas, but a permit is required. For the most up-to-date information on the park, see its official website: nps.gov/redw.

SAN ANTONIO MISSIONS

In the 18th century, Spain established a series of missions in the south and east of what is now the US state of Texas, part of Spain's efforts to colonize, evangelize, and defend the northern frontier of New Spain (what is now Mexico). Typically, the missions included churches, but they were more than that. They were communities of Franciscan missionaries and local Indigenous people (generally called Coahuiltecan people by the Spanish), who had lived in small, diverse bands in the region for thousands of years. These communities often included military troops and associated facilities. The missions were expected to convert Indigenous people to Catholicism and instruct them in cultural practices with the ultimate goal of becoming citizens of the Spanish Crown. Although the missions included in San Antonio Missions World Heritage Site were established independently, they were located along the

The interior of San Juan Church; the mission's chapel and bell tower are still in use.

San Antonio River in south Texas near one another and shared defensive and agricultural activities. (Some of these missions were originally located in east Texas but relocated to the San Antonio region.) Missions typically included a church, a convento, residences, a granary, workshops, perimeter walls, farmlands and grazing areas, as well as extensive water control and irrigation systems called acequias. Four of the mission churches continue their religious practices today and are open for public services, baptisms, weddings, and funerals.

This serial World Heritage Site, inscribed in 2015, includes five detached mission complexes and some outlying properties. Four are part of San Antonio Missions National Historical Park, established in 1978 and managed by the National Park Service. The churches are owned and operated by the Archdiocese of San Antonio. The fifth mission (Mission Valero, popularly called the Alamo) is owned and managed by the State of Texas. An advisory committee helps provide a coordinated approach to protection and management of the World Heritage Site.

Over their three centuries, the missions have helped create a blended culture and society that is a fusion of Spanish and Indigenous influences, manifested in the current architecture, language, art, clothing, and food of this region. Many contemporary families that now live in these regions of south Texas and northern Mexico proudly trace their ancestry to these Native Americans, Spanish settlers,

and the missions that integrated them into a new and distinctive culture. The World Heritage Site also includes important elements of the natural environment, particularly the lovely San Antonio River, the precious water it carries, and the riparian habitat it supports.

VISITOR CENTER

San Antonio Missions National Historical Park's visitor center is located at Mission San José (described below). The center includes exhibits, a film (*Genie de Razon*; *People of Reason*), and a park store and is staffed by park rangers and volunteers. Purchases at the park store help support park programs and projects. Just outside the visitor center is a plaque recognizing the park's designation as part of the San Antonio Missions World Heritage Site.

VISITOR ATTRACTIONS

This World Heritage Site is composed of five mission complexes and associated outlying properties. These missions are the primary visitor attractions and are described below from north to south.

Mission San Antonio de Valero (the Alamo)

Most Americans are generally aware of the Alamo, the site of the iconic 1836 military battle between Texan and Mexican troops. The Texas fighters were vastly outnumbered and nearly all died; among the dead were folk heroes Davy Crockett and James Bowie. The determination of Texas to win its independence from Mexico was ultimately successful when the state won its revolution, became

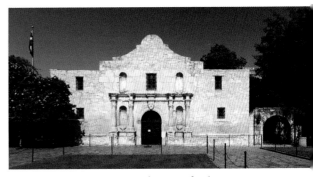

The Alamo is an important manifestation of early missionary history and an inspiring symbol of liberty for Texans and, more broadly, the United States.

an independent republic, and was ultimately annexed into the United States in 1845 as the 28th state.

But well before this period of history, what is now known as the Alamo was an early Spanish mission much like the other four missions that compose San Antonio Missions World Heritage Site. The beginnings of a mission—a temporary mud, brush, and straw structure near the headwaters of the San Antonio River—was established by the new governor of Spanish Texas, Martín de Alarcón, in 1718 and called Mission San Antonio de Valero. The structure was destroyed in 1724 by a hurricane and was later relocated to what is now the city of San Antonio. By 1744 the new mission complex had expanded to cover three acres and included a stone residence for priests, an adobe barracks building that housed more than 300 Native American converts, and a textile workshop; the planned church was never completed. In the 19th century, the name of the mission was changed to the "Alamo," perhaps referencing the nearby grove of cottonwood trees (*álamo* in Spanish) or perhaps named after another place of

the same name. But shortly after the battle of the Alamo in 1836, retreating Mexican forces tore down many of the Alamo walls and set fires throughout the complex; few buildings remained.

Since that time, the history of the Alamo has been checkered and its ownership in doubt, but during the Great Depression the federal government constructed a replica wall around the Alamo and a museum and razed several nonhistorical buildings. The Alamo was designated a National Historic Landmark in 1960, and was transferred to public ownership and management by the State of Texas in 2015. Today the Alamo is an important manifestation of its early missionary history and an inspiring symbol of liberty for Texans and, more broadly, the United States. Located in downtown San Antonio (sometimes called "the Alamo City") near the city's famous River Walk (see below), Alamo Plaza attracts millions of visitors each year, offering guided tours of the Alamo church (see below for details), interactive history lessons, a film, historical artifacts, an archaeology exhibit, the Statues of Heros, a stroll through lovely Alamo Gardens, and more.

Mission Concepción

As the oldest unrestored stone church in the United States, this site's architecture maintains a high degree of integrity. Brightly painted exterior frescos and geometric designs have faded over the centuries, but some interior rooms include both original and restored paintings. Mission Nuestra Señora de la Purísima Concepción de los Hainais was established in 1716 in east Texas by the Domingo Ramón–St. Denis expedition to convert local Indigenous people to

Catholicism. However, it was relocated to San Antonio in 1731 and renamed Nuestra Señora de la Purísima Concepción de Acuna in 1731. The mission site consists of a sanctuary, nave, convento, and granary.

Mission San José

Popularly known as the "Queen of the Missions," Mission San José was established in 1720 and is the largest of the five missions; it was originally called Misión San José y San Miguel de Aguayuo. The mission was constructed of local limestone covered in brightly colored frescoed white lime plaster and was extensively restored in the 1930s and again in 2011. Noted architectural and ornamental features include flying buttresses, carvings, quatrefoil patterns, and the famed "Rose Window." At its height, it provided sanctuary and a community to more than 300 Indigenous neophytes. The mission includes a campo santo (sacred burial ground) for baptized residents and citizens of New Spain; note the two grave markers in a small campo santo in the front of the church in the mission. The site includes the

The church at Mission San José, the largest of the World Heritage Site's five missions

park's visitor center; a self-guided tour brochure is available on the park's website.

Mission San Juan Capistrano

Established in 1716 in east Texas as Misión San Jose de los Nazonis, the mission was moved to San Antonio in 1731 and renamed Mission San Juan Capistrano (now popularly called Mission San Juan). Mission San Juan is known for its rich farmlands, and this productive agriculture enabled the mission to be more fully sustainable than most and even helped supply produce to the larger region. Gardens and orchards outside the mission walls produced melons, pumpkins, grapes, and peppers. Further afield, Indigenous neophytes grew traditional maize (corn) and beans, as well as sweet potatoes and sugar corn in irrigated fields. Rancho de Pataguilla was located 20 miles southeast of the mission and supported 3,500 sheep and nearly as many cattle in 1762. To celebrate this agricultural heritage, the park has partnered with the San Antonio Food Bank to operate a living demonstration farm fed by a traditional *acequia* (an irrigation canal) at the mission. The mission's chapel and bell tower are still in use, and a Romanesque archway graces the entrance gate. The short self-guided Yanaguana Trail leads to a nearby lovely stretch of San Antonio River.

Mission Espada

The park's southernmost mission is Misión San Francisco de la Espada (popularly known as Mission Espada). Originally established in 1690 as San Francisco de los Tejas near the present-day town of Weches, Texas, it relocated to San Antonio in 1731 and features the best-preserved portion of the region's original irrigation system, which brought water from the San Antonio River to farm fields. The irrigation system includes a dam and the Espada Aqueduct, constructed in 1745. A fire in 1826 destroyed most of the mission's buildings, but the chapel, granary, and two of the compound's surrounding walls remain. Near Espada, on the Mission Reach Trail, visitors find the large Arbol de Vida (Tree of Life) that tells the stories of local citizens; note the unusual church door and stone archway, a favorite place for a photo. Indigenous residents of Mission Espada were taught farming practices, blacksmithing, weaving, masonry, and carpentry—vocational skills that contributed to the growth of San Antonio and are still evident today. A working loom is on view at the mission. A self-guided walking tour of Mission Espada is available, and guided tours of the larger grounds are offered periodically. Rancho de las Cabras, located about 30 miles south of Mission Espada, was established by the residents of the mission as an agricultural enterprise and is one of the first ranches in Texas. The ranch is part of San Antonio Missions National Historical Park and San Antonio Missions World Heritage Site, but is accessible only by a guided tour conducted

Espada Dam is part of the historic and extensive irrigation system that served Mission Espada.

The church at Mission Espada; this is the southernmost of the World Heritage Site's string of five missions.

by National Park Service rangers; contact the park for details.

San Antonio River Walk/Mission Reach Ecosystem Restoration and Recreation Project

The San Antonio River Walk (Paseo del Rio) is a world-renowned 15-mile walking path along the San Antonio River through the city of San Antonio. Slightly below street level, this serene walk through a large urban ecosystem offers access to a variety of attractions, including the city's downtown, King William Historic District, the Pearl Brewery District, the River Walk Public Art Garden, museums, and shops and restaurants. The Alamo is a short stroll from the River Walk. The River Walk is open to pedestrians, and boat tours ply the water. In 2013 the Mission Reach Ecosystem Restoration and Recreation Project was completed; this additional 15 miles of walking paths extends the River Walk south to include the other four missions of the World Heritage Site. The missions are located approximately 2.5 miles apart. Generally called the Mission Reach, the trail can be hiked or biked as it winds along the San Antonio River through historic neighborhoods and farmlands.

LOGISTICS

The five missions comprising the World Heritage Site, and the associated irrigation systems, are located on the south of the city of San Antonio. There's no fee to access, enjoy, and appreciate all of these sites, although a timed ticket for the tour of the Alamo Church is required (reservations can be made at the website noted below). Most of the World Heritage Site is managed by the US National Park Service; the Alamo is managed by the State of Texas in partnership with the City of San Antonio. It's always wise to check the official websites of these organizations, and the following two are recommended: nps.gov/saan and thealamo.org. These areas can be visited year-round, but summers can be very hot; if visiting then, be sure to wear sun protection and drink lots of water. All the missions include educational and interpretive materials and programs; sites managed by the NPS offer the Junior Ranger Program. Audio tours of all five missions can be downloaded from the City of San Antonio World Heritage Office website: sanantonio.gov/WorldHeritage. The NPS website (https://www.nps.gov/saan/learn/historyculture/we-re-still-here-san-antonio-mission-descendant-stories.htm) offers first-person oral histories of some of the descendants of the mission sites.

STATUE OF LIBERTY

In the terms of the world of art, the Statue of Liberty is a "colossal sculpture," reminiscent of those of antiquity. The statue is composed of thinly pounded sheets of copper affixed to a steel framework to achieve its impressive dimensions. Its height from the ground level of the pedestal on which it stands to the tip of the raised torch is just over 305 feet. The length of the index finger is just over eight feet and its circumference at the second joint is 3.5 feet. The statue weighs an impressive 204 tons. But the colossal character of the statue can just as easily be applied to its cultural significance. This gift to the people of the United States from the people of France in 1886 celebrated the centennial of American independence and is an emblem of democracy and freedom throughout the world. Its dramatic placement at the mouth of New York Harbor on Liberty Island, greeting the millions of immigrants arriving in the United States, is a powerful symbol of our nation's most foundational ideals.

The statue and its placement on Liberty Island was a collaboration of intellectuals, artists, architects, and engineers, most famously French philosopher Édouard de Laboulaye, French sculptor Frédéric Bartholdi, French engineer Gustave Eiffel, American architect Richard Morris Hunt, and National Park Service (NPS) landscape architect Norman Newton.

Known as the "Father of the Statue of Liberty," Laboulaye proposed the idea of a monument for the United States in 1865.

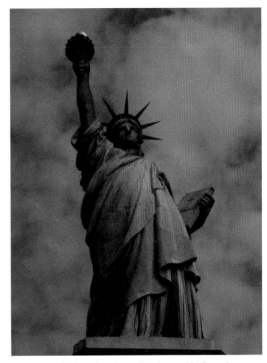

Known as a "colossal sculpture" in the world of art, the Statue of Liberty weighs an impressive 204 tons.

He was an expert on the US Constitution, advanced the idea of the "common law of free peoples" based on principles of the Enlightenment, was an ardent supporter of President Abraham Lincoln and the abolitionist cause of the Civil War, and a strong advocate for the return of democracy to France and an end to the repressive monarchy. In 1865 Laboulaye proposed the idea of a monument to freedom in the United States, as well as a celebration of the friendship between France and the United States so apparent in the American Revolutionary War. He worked

with his friend and colleague Bartholdi to craft such a monument, and titled the sculpture *Liberty Enlightening the World*.

Bartholdi traveled to the United States in search of large commissions. He found a suitable site for the statue, Liberty Island (then known as Bedloe's Island) in New York Harbor, but received only encouragement from leading Americans of the day rather than the funding he sought. He returned to France to work with Laboulaye and begin the design and construction process. The statue's torch and arm were displayed in Philadelphia and New York and the head and shoulders in Paris, creating public support for the project. The statue was ultimately funded by the French and the pedestal on which it stands by Americans.

French architect and designer Gustave Eiffel (later of Eiffel Tower fame) designed the internal structure of the sculpture (succeeding Eugène Viollet-le-Duc, who died in 1879). Eiffel designed an innovative structural approach, using a flexible skeletal system that proved an important adaptation to the wind and weather of New York Harbor.

The statue was designed to stand on a large pedestal, and that was planned by American architect Richard Morris Hunt. Hunt, the first American to attend the École des Beaux-Arts in Paris, designed a massive pedestal of granite mined in the United States.

Norman Newton was an American landscape architect who worked for the NPS in the 1930s. He crafted a master plan for Bedloe's Island (which became Liberty Island in 1956) that ultimately removed army buildings and created lawns and promenades that offered a more suitable context to celebrate

Liberty Island in New York Harbor offers a parklike setting for the Statue of Liberty.

the statue as well as an attractive parklike setting for visitors.

In 1876 French artisans and craftsmen began constructing the statue in Paris under Bartholdi's direction. It was completed in 1884 then disassembled for shipment to the United States aboard a French Navy ship, arriving in New York in 1885 to great fanfare. The pedestal was completed in 1886, and the statue was erected that year using steam-driven cranes and derricks. The statue stands within a star-shaped outer structure that was part of the island's previous army fort. The statue was publicly unveiled on October 28, 1886; a million Americans gathered in New York to celebrate.

The statue's Liberty Island home has a much longer history, beginning with its occupation by Native Americans who gathered oysters in the surrounding waters and hunted and gathered across the island. Dutch explorers led by Henry Hudson in the early 1600s called the three islands in New York Harbor the Oyster Islands. In 1664 the English took possession of the region, renaming it New York, and what is now Liberty Island

was sold to Isaac Bedloe and eventually became known as Bedloe's Island. The island was transferred to the State of New York in 1796 and then to the US government in the early 1800s. It was used by the US Army until 1837 and eventually designated as the location for the statue.

While the statue is often cited and widely recognized for its strong references to the promise of liberty and freedom in the United States (indeed, the broken shackle and chain at the right foot of the statue is powerfully suggestive, as is the Declaration of Independence carried in her left hand), it must also be considered within the historic limitations on these ideals that have been experienced by some groups in society, most notably Black Americans. Indeed, freedom for Blacks and other racial/ethnic minorities remains an unfulfilled promise even today. Consequently, attitudes toward the statue by Black Americans and others are often ambivalent. Careful observers note that early 20th-century African American intellectual and writer W. E. B. Du Bois wrote in his autobiography that when he returned to the United States by ship from Europe, he was unable to imagine the sense of hope so many European immigrants felt as they entered New York Harbor.

VISITOR ATTRACTIONS

The Statue of Liberty is the centerpiece of Statue of Liberty National Monument, established in 1924. The monument was transferred to the NPS in 1937, beginning its modern era, and was inscribed as a World Heritage Site in 1984. The monument includes Liberty Island and nearby

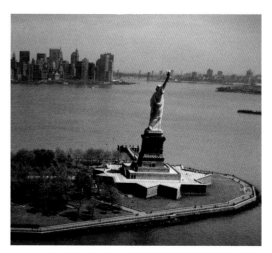

The dramatic placement of the Statue of Liberty at the mouth of New York Harbor, greeting millions of immigrants arriving in America, is a powerful symbol of our nation's most foundational ideals.

Ellis Island, offering a variety of attractions for visitors from around the world.

Statue of Liberty

Of course the statue itself is the primary attraction and can be appreciated in many ways. It can be seen from the shores of Lower Manhattan, and boat tours of New York Harbor offer impressive views. But most visitors will probably want to experience the statue more directly, and this is possible by taking a ferry from either the City of New York's Battery Park or from Liberty State Park in New Jersey. Once on Liberty Island, visitors can walk much of the approximately 13-acre island, enjoy close-up views of the statue, and appreciate the scale of the statue and the pedestal it stands upon. Visitors can tour the pedestal and the statue (climbing stairways inside the statue that lead up to the crown), though reservations are needed; both are highlights of visiting the monument. Visiting the crown requires a climb of 162

steps on a tightly confined spiral staircase; the pedestal and the crown offer panoramic views of New York City and the surrounding lands and seascape.

Statue of Liberty Museum

Visitors to Liberty Island are treated to the world-class Statue of Liberty Museum, a state-of-the-art facility with dramatic views of the statue and inspiring exhibits, including the Immersive Theater, featuring a breathtaking, virtual fly-through of the statue's interior; the Engagement Gallery, featuring multimedia displays of the warehouse where Bartholdi built the statue; and Inspiration Gallery, where visitors can add their portrait

to the *Becoming Liberty* collage. The museum also includes historical artifacts related to the statue, including its original torch from 1876. Make some time on your visit for this 21st-century museum experience.

Ellis Island National Museum of Immigration

Statue of Liberty National Monument includes Ellis Island, a sister of Liberty Island, and the Ellis Island National Museum of Immigration. This museum tells the gripping story of the 12 million immigrants who dared leave their homes in Europe and elsewhere to find the American dream for themselves and their families, passing through the now

The original torch of the Statue of Liberty is displayed in the museum.

quiet halls of Ellis Island Immigration Center from 1892 to 1954. There's a strong relationship between the statue and Ellis Island's history with immigration—a relationship that's powerfully illustrated in Emma Lazarus's famous 1883 poem "The New Colossus," which references America's magnetic history of immigration in the iconic lines "Give me your tired, your poor, your huddled masses yearning to breathe free." The poem is inscribed on a plaque mounted on the statue's pedestal. Ellis Island is widely known for its collection of immigration records and includes the Bob Hope Memorial Library, honoring this famous American entertainer and patriot who was himself an immigrant processed at Ellis Island in 1908.

SPECIAL PROGRAMS

Like most sites managed by the NPS, ranger-guided tours are available. Programs start at Liberty Island's flagpole throughout the day and last approximately half an hour. These programs are free, and no reservations are necessary. Topics addressed include why and how the statue was made, important people in the statue's design and construction, the history of Liberty Island, and the international symbolism of the statue. Self-guided audio tours are available for both Liberty and Ellis Islands.

LOGISTICS

Given the advisability of reservations for visiting the statue's pedestal and crown, it's wise to plan your visit well ahead of time, including purchasing a ticket for one of the ferries that serve the islands; see the park's official website (nps.gov/stli) for the latest information. The monument is open year-round with the exception of Thanksgiving and Christmas Days. Be advised that all visitors to Liberty Island are required to undergo airport-like security screening upon arrival. If you find it difficult or impossible to visit in person, watch the engaging Virtual Tour produced by the NPS, available at nps.gov /hdp/exhibits/stli/stli_tour.html.

TAOS PUEBLO

Straddling a small tributary of the Rio Grande in northern New Mexico, two stunning multistory reddish-brown adobe buildings are stark evidence of a Native American community that has occupied this site for what the Taos Pueblo people describe as "time immemorial." This is the oldest continuously inhabited site in the United States and substantially predates the "discovery" of America by Columbus in the 15th century. Taos Pueblo is the remarkable physical manifestation of the Ancestral Puebloan people of Arizona, New Mexico, and the broader Southwest, and is located two miles north of the present-day city of Taos. The beauty and historical and cultural significance of the iconic Taos Pueblo earned its inscription as a World Heritage Site in 1992.

The Taos Pueblo settlement site includes a walled village that encloses the two multi-story adobe buildings, seven kivas (underground ceremonial chambers), the ruins of a previous pueblo, four middens (unexcavated mounds of trash and other debris), a track for traditional foot races, the remains of the first missionary church built in the 1600s, the present-day San Geronimo Catholic Church, and burial sites inside and outside the walled compound. The two large pueblo structures are called Whomah (the north structure) and Whoaqwima (the south structure) in the Taos Pueblo (Tiwa) language. The place—the village—is called Tuah-Tah, also referred to as "The place of the Red Willows." The settlement is sited at about 7,000 feet in elevation and sits near the base of the Taos Mountains,

The two pueblos at this World Heritage Site straddle Red Willow Creek, and members of the community are sometimes called the Red Willow people.

a portion of the Sangre de Cristo Range of the Rocky Mountains that rise to more than 13,000 feet. Though the settlement site is limited to approximately 47 acres, it sits within the more extended area of Taos Pueblo lands that include 48,000 acres of the Blue Lake Wilderness Area and other lands in the Taos Valley, for a total of approximately 111,000 acres. This area includes Sacred Blue Lake, the source of the stream that flows through the settlement. The stream is a source of physical and spiritual nourishment for its people and their food crops and is variously referred to as the Rio Pueblo de Taos, Rio Pueblo, and by Taos Pueblo people as Tuah-Tah Bah Nah, the "River of Taos Pueblo." Members of the Taos Pueblo community refer to themselves as Tuah-Tah Dainah, translated as the "People of Taos Pueblo." Another name for the place, translated from the Tiwa language, is "The place of the Red Willows," and members of the Taos Pueblo community sometimes call themselves the Red Willow people.

Taos Pueblo is a quintessential example of the traditional architecture of the pre-Hispanic period of the Americas that is unique to the Southwest. The site's importance is magnified by the continuous presence of the Taos Pueblo people, who have made their home here over the centuries and who continue to carry on their culture in a thriving contemporary community. Traditional building styles and construction processes and materials are used, enhancing the site's authenticity. The multistory, tiered, and stepped-back structure of the pueblos is especially distinctive, reaching five stories in places. Adobe—a mix of soil, water, and straw, materials readily available on site and especially well-suited to the arid climate—is the primary building material; the wet adobe is either poured into frames or formed into sun-dried bricks. Buildings are typically flat-roofed, with the roofs supported by vigas—large logs gathered from the forests of the surrounding mountains, with smaller wooden pole structural members. Roofs are covered with a layer of earth, and the roofs of the lower buildings serve as structural support for the floors of the higher stories of the pueblo. The lower walls of the pueblos are more than two feet thick to support the upper stories. There were typically few windows in the walls, and the "doors" of the rooms were located on the roofs, primarily for cultural but also for defensive purposes; entry was by a system of ladders.

The pueblo structures include many small rooms, and homes in the pueblos were typically two rooms, one for living and sleeping and the other for cooking, eating, and storage; there was little or no furniture. Passageways connected some of the homes. Interior walls are coated with thin washes of white earth to keep them clean and bright; exterior walls are coated annually with a layer of adobe plaster. Ancient lifestyles have given way to some modern adaptations; most homes are now furnished with tables, chairs, and beds, and more contemporary doors and windows have been added. However, electricity, running water, and indoor plumbing are not permitted within the village wall by the community's self-governing system; this is to maintain the village in a traditional condition for cultural purposes. Much of the appearance and use of the pueblo village remains unchanged.

The prehistory of Indigenous Americans in the Taos Valley is complex and primarily

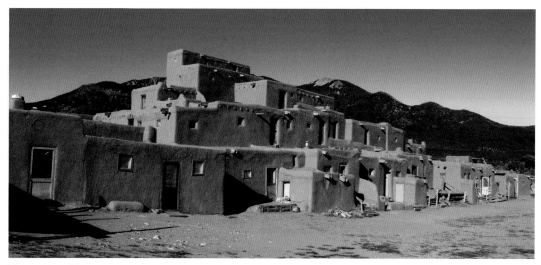

The pueblos at Taos are considered to be one of the oldest continuously inhabited communities in the United States.

based on limited archaeological evidence and oral histories and culture. The people who inhabit Taos Pueblo (and other Pueblo villages) may be descended from various pre-Columbian groups who migrated into the area or were attracted to the region by the precious water of the Rio Grande and its tributaries. For the Taos Pueblo people, this was their destination. Archaeological evidence suggests that the earliest known human occupation of the area was around 900 CE. The first pueblo at or near the present-day site was likely constructed around 1325; little of it remains today. Archaeologists call this Cornfield Taos, and it's a sacred site. The existing Taos Pueblo was constructed slightly to the west of the original structure, probably around 1400. This prehistoric record is shaped largely by limited archaeological evidence, and the Taos Pueblo people base their prehistorical presence more appropriately as "time immemorial."

From its earliest days, Taos Pueblo was a center of trade and communications among Indigenous people in the region, including those along the Rio Grande and on the southern plains. Taos Pueblo hosted an annual trade fair in the fall at the conclusion of the harvest season. The pueblo was first visited by the Spanish in 1540, when members of the Francisco Vásquez de Coronado expedition were searching for the fabled Seven Cities of Gold. The adobe of the pueblo contained small bits of the mineral mica, and its shiny surface initially caused great excitement among members of the expedition. After Spanish contact, trade eventually extended to New Spain and then Mexico via the Chihuahua Trail.

Because the pueblo was one of the first communities in the Southwest visited by Spanish explorers, it played an important role in cultural exchanges between these groups and the ultimate struggles between them that occurred from the 16th through the 18th centuries. Although residents of the pueblo adopted some of the Spanish culture, including the teachings of the Catholic Church, there was some resistance followed

by conflict. The Spanish constructed a mission at the pueblo in 1598 and built the first Catholic Church, San Geronimo de Taos, around 1620. But rising tensions led to the killing of the resident priest and destruction of the church around 1660. The church was rebuilt, but the regional Pueblo Revolt of 1680 led to destruction of the church and the killing of two more priests.

New Mexico became a US territory in 1847. But Taos Pueblo had been under the jurisdiction of two previous governments, Spain and then Mexico, and the Taos Pueblo people objected to being placed under the jurisdiction of another "foreign" government, the United States of America. Local Mexicans who were also opposed to the new US government turned to Taos Pueblo to lead a resistance movement. This revolt of 1847 led to the killing of US Territorial Governor George Bent and subsequent reprisal by US Cavalry forces. The final engagement took place at Taos Pueblo and resulted in destruction of the San Geronimo Mission, the ruins of which still stand. A new church was erected around 1850.

In 1906, shortly before New Mexico became the nation's 47th state, thousands of acres of Taos Pueblo land, including the sacred Blue Lake, were taken by the US government for inclusion in the US National Forest System. Blue Lake and its surrounding lands are an important area that supports the living culture and traditions of the Taos Pueblo people. After a prolonged political struggle, this area was returned to the pueblo in 1970. Only Taos Pueblo people are now allowed on these lands.

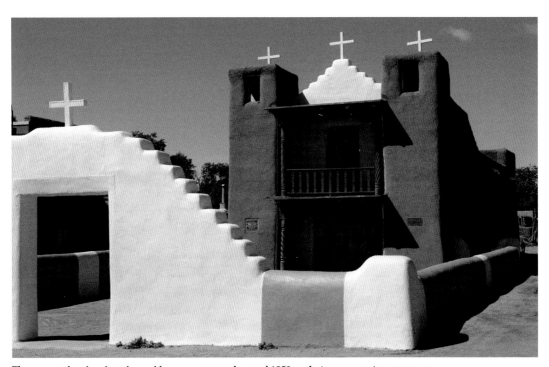

The present-day church at the pueblo was constructed around 1850, replacing two previous structures.

Taos Pueblo is a remarkably authentic example of the distinctive culture of the ancient Ancestral Puebloan people who inhabited the American Southwest well before the Spanish explorers arrived. This authenticity is reflected in the physical presence of the pueblos and associated structures, as well as the lifestyle and cultural traditions of the people. But in some interesting ways, it also reflects the Spanish presence in the region beginning in the 16th century, influences that have lasted to the present day. Examples include Catholic churches and their teachings, language, building styles and techniques, and food. More recent influences include those of conventional European-American settlers, soldiers, and government, particularly after New Mexico became a US territory and then a state. In these ways, Taos Pueblo represents a broad-based society with multicultural influences that reflect the distinctive heritage of the American Southwest. Prime examples include the close proximity of the pueblo's Catholic church and pueblo kivas, the burials of native and Spanish people in and near the pueblo, and the pueblo's special governmental status as a limited sovereign nation within the United States. But Taos Pueblo has maintained its distinctive community and way of life, adopting the new teachings, techniques, foods, and implements of other cultures to improve their lifestyle while maintaining their older cultural way of life.

Today the village of Taos Pueblo is inhabited by about 150 people on a year-round basis; other members live in homes near their agricultural fields part of the year as was the tribal practice in past times. Many cultural and social community activities take place in the village throughout the year when tribal members congregate in their village

The site's cemetery includes the ruins of the original church (in the background).

houses. Traditional government consists of a Tribal Council, a Governor's Office, and a War Chief's Office; these groups provide general oversight of the facilities, programs, and services of the community and its lands and natural resources. Though rooms and homes within the pueblo are owned by individual members of the tribe, the larger structures within which they are located are owned by the community as a whole.

The tribal nation is fundamentally patriarchal, as manifested by exclusive male membership on the Tribal Council, in tribal government, and in many cultural responsibilities and activities. Women, however, have important cultural responsibilities of their own and in support of the men's duties. In contemporary times, women hold important positions in support of tribal government. There is a traditional rivalry between the people of the north and south sides of the stream, and the culturally important foot races are an expression of this rivalry. Today the vast majority of tribal members are baptized as Catholics, but traditional Indian religious rites are also practiced, and the acceptance of both religious belief systems is evident in the presence of both kivas and the Catholic church at the pueblo. The intertwining of these belief systems is evident in the scheduling of certain culturally-related activities in conjunction with the Catholic calendar. The population of people currently living on tribal land is estimated to be several thousand; some practice agriculture, some are traditional or contemporary artisans, and others are employed at the pueblo and in the nearby town of Taos and beyond. Tourism has become an important component of the pueblo's economy, and many people visit Taos Pueblo each year; several arts and crafts shops are located within the pueblo.

Some contemporary observers have noted that the pueblo may exemplify vital elements of an environmentally sustainable community. Its buildings are constructed of locally sourced materials, and the adobe structures have important insulating properties that help keep them cool in summer and warm in winter. The community relies on a local water source, and residents use agricultural practices that supply at least some of their food. A vast ancient and contemporary irrigation system delivers water to farm fields. In the early years, residents generated all their food through hunting, gathering, and farming. Important elements and places of the natural environment are held in special protective status—even adopted into their spiritual beliefs and practices—because they offer vital resources for spiritual beliefs and practices. Sacred Blue Lake and its surrounding mountain lands, designated as the Blue Lake Wilderness Area to be "forever wild," are examples. Perhaps Taos Pueblo has important environmental lessons for contemporary American culture.

VISITING TAOS PUEBLO

The people of Taos Pueblo graciously welcome visitors when the village is open. However, the pueblo is a living culturally-based community and not simply a tourist attraction or archaeological site; it's the homeplace of a traditional Indian community, a sovereign American Indian tribe. The tribal government recognizes, understands, and respects the desire of the public to visit Taos Pueblo and therefore keeps the pueblo open for visits when possible.

However, the pueblo is the site of important cultural and private activities, such as funerals, that require closure of the village, sometimes without advance notice.

Taos Pueblo is open most of the year, Thursday through Monday, from 9:00 a.m. to 4:00 p.m. However, there are several cultural activity days and periods during the year when the pueblo is closed to the public. Check the dates of these closures on the official website (taospueblo.com), and note the schedule of fees charged to access the pueblo. Guided tours are offered by residents and last approximately a half hour; because tour guides are volunteers, gratuities are appreciated. The Taos Pueblo language (Tiwa), English, and some Spanish are spoken by many residents.

Visitors are guests in the pueblo and shops of community members, so the following reasonable rules apply:

1. Please abide by "Restricted Area" signs; these areas are designated to protect the privacy of residents and the sites of native religious practices.
2. Don't enter doors or homes except those that are clearly marked as businesses. The homes used as a place of business are clearly marked as such.
3. Photography is generally allowed, but commercial photography requires written permission. Community members should not be photographed without their consent. No photography is allowed in San Geronimo Chapel, and no photography is allowed of religious ceremonies.
4. Visitors interested in sketching or painting must apply for approval.

5. Please respect the cemetery and the ruins of the old church; an adobe wall surrounds this area and is a boundary that shouldn't be crossed.
6. Don't enter the river; it's the pueblo's sole source of drinking water.
7. Please respect this home as though it were yours.

Community artists maintain businesses in some of the pueblo rooms (these are clearly marked), and visitors are welcome to enter; direct interaction between visitors and artists is encouraged.

Taos Pueblo is located about two miles north of the town of Taos, New Mexico; the street address is 120 Veterans Highway. There are no lodgings and very limited commercial food services are available at the pueblo, but a full range of facilities and services is offered in and around the town of Taos. Camping is available on surrounding public lands and in nearby commercial campgrounds

Several Native American artists maintain businesses in the pueblo; visitors are welcome to purchase items and speak with the artisans.

THE 20TH-CENTURY ARCHITECTURE OF FRANK LLOYD WRIGHT

Ask an American to name a famous architect and chances are the answer will be Frank Lloyd Wright. And the American Institute of Architects agrees, recognizing him as "the greatest American architect." In fact, Wright might be considered "America's architect," since his highly refined professional philosophy reflected much of the American landscape and culture. However, Wright's influence extended well beyond the United States, including Europe and his beloved Japan. Wright's accomplishments are celebrated in this serial World Heritage Site that includes eight iconic buildings scattered across six states. These buildings express Wright's innovative architectural vision, including his solutions to society's rapidly evolving needs for housing and places of worship, work, leisure, and education.

Wright was born in 1867 and raised in rural Wisconsin, where he studied civil engineering at the University of Wisconsin. But his passion for architecture led him to an apprenticeship with the noted architects of what was known as the Chicago School of Architecture, ultimately working closely with Louis Sullivan, who became his mentor. Later he created his home and studio, Taliesin, in Spring Green, Wisconsin, designing private homes and public buildings. He spent time in Japan, leaving an impressive architectural heritage; his most important building was the Imperial Hotel, and he influenced many young Japanese architects. He had a short presence in Southern California, where he designed private residences, including Hollyhock House. Later in life, he spent time in Arizona, where he designed his winter home and studio, Taliesin West. He designed more than 1,000 structures during his long and productive life, including private residences and public buildings such as offices, churches, schools, skyscrapers, hotels, and museums. He also successfully wrote and lectured widely in America and Europe about architecture, focusing on his innovative—sometimes even revolutionary—philosophies. His personal life was tumultuous and sometimes tragic.

Wright's philosophical approach to architecture was well developed, rich, and evolving; he wrote: "There is no architecture without a philosophy." His professional philosophy was infused with elements of nature, democracy, new and unexpected use of materials, aesthetic integrity, and the power of architecture to inform and improve life. His architectural style is often described as "American" and "organic," reflecting the American landscape and culture and blurring the boundaries between interior and exterior, structure and environment.

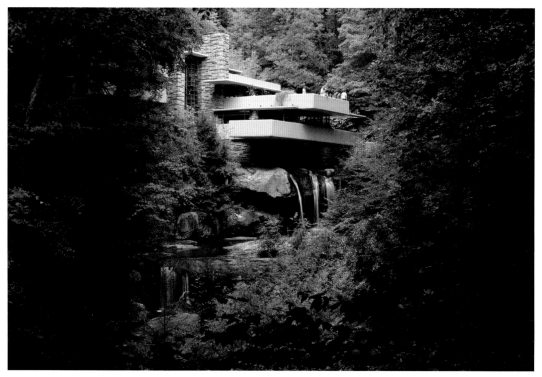

Constructed in 1939, Fallingwater may be Wright's most famous building. The American Institute of Architects called it "the best all-time work of American architecture."

His early career is manifested in the "Prairie" homes he built in the American Midwest, strongly influenced by the expansive horizontal, low-lying landscape. Prairie homes typically have only one or two stories (though there are exceptions) and are characterized by an open floor plan, low-pitched roofs with broad overhanging eaves, strong horizontal lines, ribbons of windows (often casements), a prominent central chimney, built-in stylized cabinetry, coordinated design elements (often based on forms of local plants), and use of brick, stucco, and wood. The buildings present a unified whole, as though their varied parts belong together. Large expanses of glass in windows and doors were placed to unify the interior and exterior landscape. Art glass was often used for decoration. Wright was one of the first architects to design and install custom electric light fittings, including some of the first electric floor lamps.

Later in his career he pioneered the concept of what he called the Usonian home ("Usonian" is a word coined in the early 1900s for the United States of North America) and the associated Broadacre City, sometimes called Usonia (there is a housing development outside New York City called Usonia). This was a new vision of the emerging American suburb that called for small-scale single-family homes that were affordable for the growing number of households without domestic help. These dwellings had

progressively open floor plans (more "spaces" instead of rooms), allowing monitoring of children and guests. These ideas, including slab-on-grade foundations and simplified construction techniques that facilitated more mechanization and efficiency in building, affected suburban design that was adopted by many postwar developers.

In 1932 Wright (and wife Olgivanna) established the Taliesin Fellowship in which students would come to Taliesin and Taliesin West to study and work under Wright. A total of 625 people joined the Fellowship in Wright's lifetime, expanding the influence of his work. Wright's ideas were also influential in European architectural and critical circles in the early 20th century and contributed to the European Modern Movement.

VISITOR ATTRACTIONS

The centerpieces of this serial World Heritage Site are the eight Wright buildings that are found in six states that span much of the nation. These buildings were designed and constructed in the first half of the 20th century; range widely in location, function, scale, and setting; and dramatically illustrate the architect's philosophy of organic architecture and how it evolved. There are consummate examples of Prairie and Usonian houses, a place of worship, a grand museum, and complexes of Wright's own home, studio, and educational facilities. Although all these buildings were specifically designed to meet the needs of their owners, they also illustrate the foundational professional principles of the architect. Most of the properties have remained relatively unchanged since their construction. All buildings are open to the public, though special arrangements are needed in some cases; this is noted under "Logistics" below. The eight buildings are presented as follows in chronological order.

Unity Temple (constructed 1906–1909)

Completed in 1909 in Oak Park, Illinois, this is the earliest of the eight Wright buildings included in the World Heritage Site, the only church (and one of just two public buildings), and the only public building of the Prairie period. The size and scope of the building is limited by a small suburban site and a limited budget. Perhaps its most distinguishing feature is the innovative use of a relatively new building material, unpainted reinforced concrete, in a nonindustrial application—an example of the ways in which Wright pioneered such nontraditional materials in 20th-century architecture. The concrete was exposed to the viewer and created a light-filled space adorned with the colors of nature. Some architects consider Unity Temple, with its abstract cubic form, the world's first "modern building." Interior spaces use natural lighting to soften the building's appearance. Today the building's auditorium/worship space is still used for religious services, performances, public assembly, and as a meeting hall.

Frederick C. Robie House (constructed 1910)

Completed in 1910 in Chicago, this single-family home may be the consummate expression of Wright's Prairie architectural style. Here you'll find many of the original ideas and associated design elements that

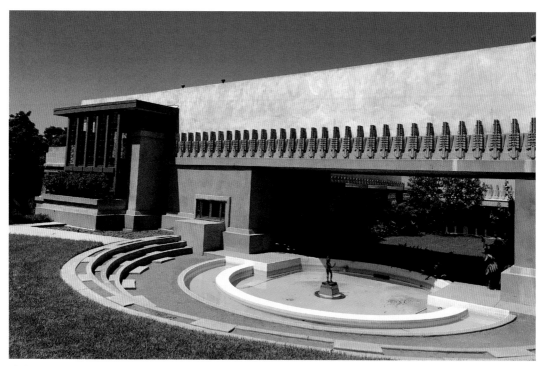

Hollyhock House is an example of Wright's design initiative in Southern California in the early 20th century; this gave rise to what became known as California Modernism.

characterize his professional philosophy, in particular his conception of architecture as an integrated whole: site and structure, interior and exterior, furniture and ornament. The structure's dominant horizontal plain—roofline, bricks and mortar, broad balconies and terraces—ties the building to the landscape on which it's sited. The large open-plan character of the interior space is revolutionary for the time. Other characteristic design elements include doors and windows that feature abstract organic shapes and that allow the sun, air, views, and other components of the landscape to be become one with the home. Many of Wright's later buildings, including Fallingwater and the Guggenheim Museum, include elements of this distinctive Prairie style. In 1991 the Robie House was honored by the American Institute of Architects as one of the ten most significant structures of the 20th century.

Taliesin (constructed 1911–1959)

Construction of this complex building was begun in Spring Green, Wisconsin, in 1911 as Wright's long-term home and studio. He continued to tinker with the building for the rest of his life, and it is his most expansive exploration of his organic architectural philosophy. He constructed the large building on the brow of a ridge with the vision that the structure be "of the hill, not on it." Wright made extensive use of local materials and carefully designed pleasing vistas of surrounding hills and farms, all emphasizing the connection between the built and natural

environments. This was further emphasized by the entrances to many rooms via their corners thereby featuring long sight lines that extend through the interior and on to the landscape beyond. "Taliesin" is a Welsh word meaning "shining brow."

Hollyhock House (constructed 1918–1921)

This house is an important symbol of Wright's early 20th-century foray into Southern California and contributed to the birth of what became known as California Modernism. The monumental building was designed as a home, but also an arts complex that included a theater, cinema, studios for artists, and housing for actors and directors, all of which were reflections of the budding Hollywood movie industry. All spaces open into a central patio, making it "half house and half garden," seamlessly integrating the indoors with outdoor gardens and living spaces. The structure included multilevel rooftop terraces linked together with bridges and stairways. Design elements include references to Spanish California and pre-Columbian Mexico and abstractions of native hollyhock flowers.

Fallingwater (constructed 1936–1939)

Fallingwater, constructed in Mill Run, Pennsylvania, may be Wright's most famous building. In fact, the American Institute of Architects has called Fallingwater "the best all-time work of American architecture." It was designed as a private home on a woodland site that includes a prominent 30-foot waterfall. Epitomizing Wright's philosophy of organic architecture, the building was not designed to offer views of the waterfall, but for residents to "live with the waterfall . . . as an integral part of [their] lives." Consequently, the house is cantilevered over the falls with three floating terraces of rock and reinforced concrete, seemingly part of the waterfall itself. Extensive use of concrete, steel, and glass reflect Wright's pioneering use of modern materials in contemporary architecture. Fallingwater is a masterful union of architecture and nature.

Herbert and Katherine Jacobs House (constructed 1936–1937)

Constructed in Madison, Wisconsin, the Jacobs House is the first full manifestation of Wright's innovative Usonian philosophy. Influenced by the Great Depression and the emerging modern need for modest family housing, the Jacobs House became a model for today's detached, single-family, affordable suburban home. Working with a budget of $5,000, Wright created an open design plan of functional spaces and large windows and doors with views of and direct access to a small landscaped neighborhood lot. The building employs basic geometric forms and is constructed of simple, inexpensive materials of brick, wood, and concrete. The American Institute of Architects named the Jacobs House one of the 20 most important residential designs of the 20th century.

Taliesin West (begun in 1938)

This complex of buildings, was designed and constructed to be Wright's winter home, studio, and architectural fellowship center, and was occupied by Wright the last 20 years of his life. The location is in Scottsdale, Arizona, at the foot of the McDowell Mountains. The building reflects Wright's continued interest

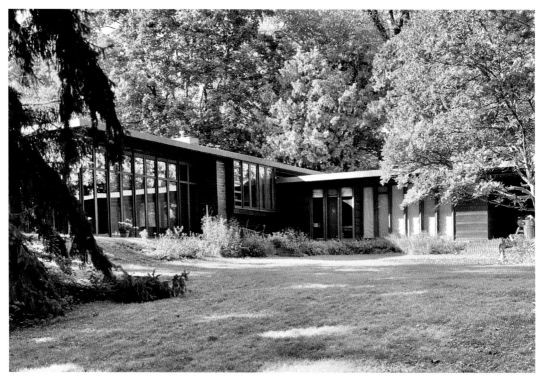
Constructed in the 1930s, the Herbert and Katherine Jacobs House is a manifestation of Wright's innovative "Usonian" philosophy designed to meet the emerging modern need for modest family housing.

in new building materials; for example, his use of "desert rubble stone" masonry was a mix of local small boulders and stones consolidated with concrete. The structure included overlapping indoor and outdoor spaces, a triangular garden of native plants, and a triangular pool. The use of native materials throughout the complex is both timeless and modern. Wright incorporated design and construction approaches developed in Taliesin West into other Southwestern commissions.

Solomon R. Guggenheim Museum (constructed 1956–1959)

Working with the Guggenheim Foundation, Wright reconceived the modern art museum as a building that is a work of art itself. Constructed in New York City, Wright sited the building directly across from Central Park and incorporated the sculptural and sinuous forms of nature into the structure's distinctive form and signature spiral ramp. In this way the building is starkly contrasted with the neighboring traditional boxy buildings. The interior space features a skylit dome. The building was explicitly designed to showcase Solomon Guggenheim's collection of abstract art; visitors took an elevator to the top level and appreciated the artworks while slowly walking down the central spiral ramp. The structure is an internationally recognized icon of modern architecture, though it has undergone some modifications and an

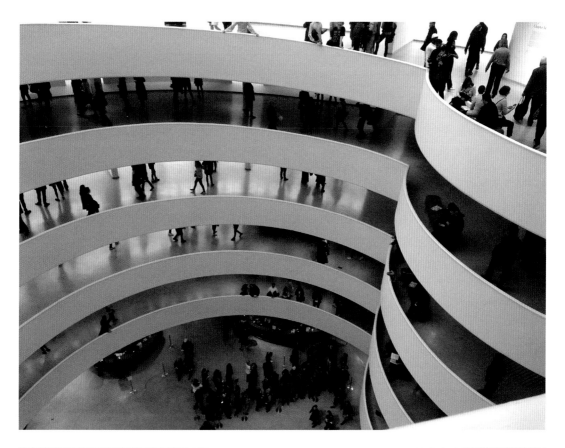

Wright reconceived the modern art museum as a building that is a work of art itself.

addition. The Guggenheim set the standard for modern museums that reflect the art they house and is among the most popular attractions in New York City.

LOGISTICS

All eight of the properties included in the World Heritage Site are open to the public, though some are more widely accessible than others. Unity Temple is owned by UTP, LLC, and is available for public tours through the Frank Lloyd Wright Trust. The Robie House is owned by the University of Chicago but operated by the Frank Lloyd Wright Trust; it's open for public tours. Taliesin is owned by the Frank Lloyd Wright Foundation; tours are offered by Taliesin Preservation. It's open year-round, and offers several types of tours. Hollyhock House is owned by the City of Los Angeles and operated by the Department of Cultural Affairs; it's open for tours and also contains exhibition space.

Fallingwater is owned by the Western Pennsylvania Conservancy; it's open year-round and is available for tours. The Jacobs House is privately owned and is available for public tours by appointment. Taliesin West is owned by the Frank Lloyd Wright Foundation; the site is open year-round for public tours. The Guggenheim Museum is owned by the Guggenheim Foundation and is open year-round as a public art museum.

The 20th-Century Architecture of Frank Lloyd Wright was inscribed as a World Heritage Site in 2019. The management coordination entity is the Frank Lloyd Wright World Heritage Council, established in 2012 via a memorandum of agreement between the Frank Lloyd Wright Building Conservancy and the owners and/or representatives of the owners of the eight component properties. Readers can learn much more about Wright and his architecture at the Frank Lloyd Wright Conservancy's website: savewright.org/WorldHeritage.

WATERTON-GLACIER INTERNATIONAL PEACE PARK

Waterton Lakes National Park (Waterton) and Glacier National Park (Glacier) are two early and important examples of conservation at the national level. Waterton was established in 1895 as the fourth of Canada's national parks and is managed by Parks Canada; Glacier was established in 1910 as the tenth national park in the United States and is managed by the US National Park Service. Separated only by the border between these two nations, the parks are directly adjacent and share responsibility for protection and management of the vital natural and cultural resources of this Rocky Mountain region.

This common objective drew these parks—and nations—into a more formal cooperative approach when Waterton-Glacier International Peace Park was established in 1932, the first such international park in the world. This peace park is the result of a grassroots initiative proposed by the Rotary Clubs of Alberta, Canada, and the US State of Montana, in 1931. The proposal was ratified by the national governments of both countries the following year. Since then, many international peace parks have been created around the world to take a cooperative approach to large landscape-scale conservation and to celebrate and promote international peace

and goodwill, a process sometimes called "ecological diplomacy." Waterton and Glacier have developed cooperative approaches to park management that include conservation of migratory wildlife, wildfires, search and rescue, and other aspects of park administration. The significance of the area's natural and cultural resources and the multinational approach embodied in the international peace park were recognized in 1995 when the area was inscribed as a World Heritage Site, and this international approach is strengthened through the objectives and provisions of the World Heritage Convention.

GLACIER

Glacier National Park is achingly beautiful and ecologically significant, making it one of the most popular US national parks. The name "Glacier" suggests the vital geological role of glaciers in its natural history, now and well back into deep prehistory. The geology of Glacier is complex. Most of the rocks are sedimentary, deposited in shallow seas over a very long period of time. However, this land is part of the great Rocky Mountains that have been uplifted, folded, and faulted, substantially rearranging the initial flat layers of stone.

Deep forests, high mountain lakes, and glacially-carved mountains are found in abundance in Glacier National Park.

The continent's most recent ice age, some 10,000 years ago, resulted in an extensive system of glaciers that flowed over the park's landscape, leaving their obvious marks, and the park's namesake glaciers have been a powerful geologic force. These effects are manifested in the park's remaining glaciers; the wide U-shaped valleys they carved; lakes that formed in these wide valleys; cirques (bowl-shaped areas near the tops of mountains where glaciers have plucked away portions of the mountain); tarns (bodies of water left by melting glaciers); moraines (rocks and associated materials carried by glaciers and deposited on its edges and terminus); and arêtes (sharp-edged ridges where glaciers have eroded both sides of a mountain) that characterize many of

the taller peaks. Today the park is also a poster child for the effects of climate change, with only a couple dozen or so glaciers remaining from the estimated 80 when the park was established in the early 1900s. Scientists predict the park's glaciers will continue to diminish over the next decade.

Nearly all the flora and fauna that existed in the park when it was established can still be found here. The park's varied elevations and aspects offer a wide variety of habitats, including dry plains, rivers and lakes, extensive subalpine forests, and alpine tundra. The result is more than 1,110 species of plants, including wildflowers that bloom from spring through summer. Distinctive species include bear grass and glacier lilies. Iconic

wildlife include grizzly and black bears, mountain goats, bighorn sheep, moose, elk, mule and white-tailed deer, bobcats, coyotes, mountain lions, wolverines, and lynx. Nearly 300 species of birds have been recorded.

In the late 1800s, American conservationist George Bird Grinnell, co-founder of the Audubon Society, traveled to northern Montana to an area he would later christen the "Crown of the Continent." Here he found expansive old-growth forests, the high peaks of the Continental Divide, a large number of active glaciers, a series of turquoise alpine lakes, and a diverse collection of native wildlife. Over the next two decades, he worked to protect this area as a national park, succeeding in 1910 when more than a million acres were designated as Glacier National Park.

Though Crown of the Continent is the name bestowed on Glacier by Grinnell, the native Blackfeet Indians called it "Backbone of the World," suggesting its natural and cultural significance. But many Native American and First Nations tribes, such as the Salish (Seli'š), Kootenai (Ksanka in United States/

Mountain goats are often considered the iconic symbol of Glacier National Park; this young one (called a kid) is just learning to scamper across the park's rocky cliffs.

Ktunaxa in Canada) and the Pend d'Oreille or Kalispel (Qlispe'), along with tribes of the Blackfoot Confederacy, composed of the Siksika, Blood (Kainai), and Northern and Southern Piegan (Piikani), found shelter and hunting grounds in the lands now designated as Waterton-Glacier International Peace Park and World Heritage Site. The Blackfeet ceded 800,000 acres of land to the US government with the understanding that they would retain subsistence rights while the government would be allowed mining rights. But provisions for subsistence hunting were ultimately discontinued once the national park was established. Gathering rights have remained in place, although access to places needed to exercise these rights have varied over the years. Today the Blackfeet maintain a reservation on the eastern side of the park; the Flathead Indian Reservation is south and west of the park.

The 1800s witnessed attempts at economic development of the area, including fur trapping and prospecting, but none were very successful until the Great Northern Railway completed track near the park in 1891 and ultimately built a series of hotels and chalets to attract and house visitors. Tourism has been the business of the park ever since.

WATERTON

Waterton Lakes National Park is just over the Canadian border from Glacier in southern Alberta, and it shares much of Glacier's natural history. However, Waterton may be even more ecologically diverse (at least on a per-acre basis), considering the park's relatively small size of 125,000 acres. To the east of the park lie vast prairie lands and foothills

that add a substantial element of natural history to the park beyond the large areas of higher elevation forests, glacially-sculpted mountains, and alpine lakes. Consequentially, the park includes a staggering array of plants and animals. For example, more than 60 species of mammals inhabit the park, including wolverines, bighorn sheep, white-tailed deer, mule deer, mountain goats, elk, moose, foxes, gray wolves, bison, coyotes, beavers, river otters, cougars, lynx, bobcats, grizzly bears, and black bears. The park also includes more than 1,000 species of vascular plants. The park was established in 1895 and is a popular unit of the Canadian National Park System.

The park takes its name from lovely Waterton Lake; shared by the two nations, the lake honors English naturalist and conservationist Charles Waterton. The park lies within the traditional and sacred Siksikaitsitapi (Blackfoot) territory, and Parks Canada and First Nations partners work closely together to help ensure that the park reflects this human history and its traditions, culture, and connection to Paahtomahksikimi (the Sacred Lake within the Mountains). The US National Park Service and Parks Canada maintain government-to-government relations with Confederated Salish and Kootenai Tribes (including Kootenai (Ksanka), Pend d'Oreille (Kalispel or Qlispe'), and Salish (Seli's) Tribes in the United States) and the Ktunaxa Nation in Canada along with the Blackfoot Confederacy, composed of the Blackfeet (Amskapi Piikani) Nation in the

Blakiston Falls is a popular attraction in Waterton Lakes National Park.

United States and the Blood (Kainai), Siksika, and northern Piikani (Aapátohsipikáni) Nations in Canada.

People of European descent began to explore the Waterton area in the second half of the 20th century and include Lt. Thomas Blakiston, John George "Kootenai" Brown, and William Pearce, who were primarily interested in economic development, including railroad routes and minerals, particularly oil. The first oil well was drilled in 1902 but was not economically productive; the site is now preserved in the park as a National Historic Site of Canada. The grand Prince of Wales Hotel was constructed in the park in 1926–27 on the shores of Upper Waterton Lake by the Great Northern Railway of the United States; the hotel was designated a National Historic Site of Canada in 1992.

VISITOR CENTERS

When visiting parks that are new to you, it's always smart to start at visitor centers; these facilities are designed to inform visitors about the parks and help with trip planning. Glacier offers three visitor centers scattered around the park; Waterton features a new, state-of-the-art facility.

Glacier

St. Mary Visitor Center is located on the east side of the park, adjacent to the St. Mary entrance on the Going-to-the-Sun Road near the village of St. Mary. Apgar Visitor Center is located on the west side of the park, approximately two miles north of the west entrance to the park near the village of West Glacier. Logan Pass Visitor Center is located near the center of the park at iconic

Logan Pass on the park's Going-to-the-Sun Road (see below). All of these facilities offer trip planning information, interactive educational exhibits, small bookstores, restrooms, and water fountains/filling stations. St. Mary and Apgar offer ranger-led activities. Logan Pass has trailheads for the popular Highline and Hidden Lake Trails.

Waterton

Waterton features the state-of-the-art Waterton Lakes Visitor Centre, an environmentally friendly facility that earned LEED (Leadership in Energy and Environmental Design) Silver certification; the visitor center is located in the heart of the park at Waterton townsite. Constructed of responsibly sourced materials, the facility uses high-efficiency, low-flow plumbing, collects rainwater for use in the building, and reduces the need for electric lighting with natural daylight. Much of the site is restored with native and adaptive vegetation. Park staff help educate visitors about the area and plan visits. Designed as a place of cultural meeting, the visitor center highlights Blackfoot culture with songs, stories, and translations woven throughout the exhibits; the Blackfoot Cultural Centre is located a block south of the visitor center.

DRIVING TOURS

Glacier

Going-to-the-Sun Road

This iconic road, one of the most celebrated in the US National Park System, stretches more than 50 miles through the heart of the park, connecting the park's east and west entrances. This scenic drive treats visitors to

what may be the most spectacular scenery in the Rocky Mountains, including glacier-carved peaks, turquoise alpine lakes, great swaths of mature forests, and some of the park's most popular trailheads. Sometimes simply called the Sun Road, it was constructed in the late 1920s and early 1930s. One of the park's most popular attractions, it shouldn't be missed. It's been widely recognized as a National Historic Place, National Historic Landmark, and Historic Civil Engineering Landmark. The highest point along the road is iconic Logan Pass at 6,646 feet, where wild mountain goats can often be seen. A narrated driving tour of the road can be downloaded from the iTunes store.

Many Glacier Area

The lovely drive to the complex of visitor attractions known as Many Glacier is another good option for enjoying and appreciating this iconic national park. Drive north on US 89 from the St. Mary park entrance for about nine miles and enjoy the great views of Lower Saint Mary Lake to the west. Then turn left and drive about 12 miles to the Many Glacier area, enjoying the views of Lake Sherburne. At Many Glacier, find a rich collection of some of the park's finest features, including stunning glacial lakes, majestic mountains, some of the finest wildlife viewing in the park, several of the park's best hiking trails (see the description of the Grinnell Glacier Trail below), and the historic and striking Many Glacier Hotel.

Camas Road and North Fork Road to Polebridge

Polebridge and the North Fork are less-visited portions of the park, and these two roads offer a great way to spend a day in the park. From West Glacier, Montana, drive into Glacier National Park and turn left onto Camas Road. This scenic road takes visitors through the park around Huckleberry Mountain. You will then exit the park and come to a junction with the North Fork Road. (*Caution:* This is an unpaved road and can be rough.) Turn right to head north toward Polebridge; this 13-mile drive follows the North Fork of the Flathead River and offers lovely views into Glacier National Park. Another seven miles of rough, dirt road into the park brings you to Bowman Lake. Note that there is no cell phone coverage in this area. The park website recommends a four-wheel-drive/high-clearance vehicle and the ability to change a tire, as flat tires are common. Vehicles over 21 feet and/or trailers are not permitted on any roads in the North Fork area, with the exception of private horse trailers accessing the Bowman horse corral.

Looking Glass Highway to Two Medicine

Looking Glass Highway (MT 49) is a short stretch of road between the villages of East Glacier and St. Mary. From St. Mary, head south on US 89 for about 19 miles then bear right onto MT 49. This route winds through mountains and hills just outside Glacier National Park and provides beautiful views into the Two Medicine Valley. Eight miles from the junction of US 89 and MT 49 you'll reach the Two Medicine entrance to Glacier National Park. The Two Medicine Valley has a campground, small camp store, boat tour, and lots of hiking trails. From the junction you may continue on MT 49 another 4 miles to reach Glacier Park Lodge in East Glacier.

US 2, East Glacier to West Glacier

US 2 follows the southern border of Glacier National Park and the Middle Fork of the Flathead River, offering many views into Glacier National Park as well as views of the picturesque river. You'll cross the Continental Divide after traveling 12 miles from East Glacier. In another 14 miles you'll reach the Goat Lick Overlook in the small town of Essex; this is a natural mineral lick that attracts mountain goats from miles around. An underpass was built to funnel mountain goats into a tunnel, allowing safe passage across the highway. The next 30 miles of the drive to West Glacier are especially dramatic, offering many scenic turnouts.

Waterton

Entrance Parkway

The Entrance Parkway travels five miles from the park gate to Waterton townsite and provides scenic views overlooking the Waterton Valley. The road begins on the park's prairie lands and follows the chain of Waterton Lakes past the Prince of Wales Hotel National Historic Site to the Waterton townsite. It's one of the best roads in the park for viewing wildlife. (A multiuse pathway called the Kootenai Brown Trail runs alongside the Entrance Parkway from the park gate to the townsite.)

Red Rock Parkway

The Red Rock Parkway travels approximately 10 miles up the Blakiston Valley through rolling grasslands and ends at Red Rock Canyon (named for the several thick sedimentary beds of red argillite rock). The road offers dramatic views of Mount Blakiston—at 9,645 feet, the park's highest peak. Following the road is an ideal way to experience Waterton's classic intersection between prairie and mountain landscapes. Be sure to stop at the scenic pull-offs, many of which have interpretive displays. At the end of the parkway, an inviting self-guided trail loops around Red Rock Canyon. In June the wildflowers are prolific along the road, and it's a great place for wildlife viewing. The parkway is narrow and may not be suitable for larger motor homes.

Chief Mountain Highway

Opened in 1936, the Chief Mountain Highway affords exhilarating vistas of the Waterton and Blakiston Valleys. The road is the primary route between Waterton and Glacier. The highway climbs from the grasslands near Maskinonge Lake to a viewpoint (Chief Mountain Lookout) that offers a magnificent panorama of the Waterton and Blakiston Valleys. Along the way to Chief Mountain (the international border), the highway passes through wetlands and the site of the Sofa Mountain Wildfire. Drivers can continue across the international border (you'll need your passport) to the community of St. Mary, on the boundary of Glacier National Park. Chief Mountain Highway has wide shoulders, making it good for cycling, but be prepared for some substantive climbs. Belly River campground is located along the road.

Bison Paddock Loop Road

Located just inside the park's north boundary, off Highway 6, the Bison Paddock Loop Road provides an opportunity to see plains bison in their natural grassland habitat.

Spring through fall, you can drive the road and see the bison herd that's been maintained in the park since 1952. This short, scenic route passes through fescue grasslands inside the park's summer paddock; the bison are free to roam the enclosure. Bison are wild animals and can be dangerous and unpredictable. When viewing bison from the Bison Paddock Loop Road, drive slowly, always stay inside your vehicle, and take photos from a safe distance. Bison cows are very protective of their young, and it's important to give them plenty of space by staying in your vehicle. Pedestrians, cyclists, and motorcyclists are not permitted on the Bison Paddock Loop Road. A short trail located near the Bison Paddock Loop Road leads to an outstanding view of the valley and mountains. Note the subtle beauty of the rough fescue prairies. Waterton Lakes is the only national park in Canada that protects rough fescue, a grass that is highly nutritious food for Plains bison.

Akamina Parkway

This lovely winding mountain road starts in the Waterton townsite and travels about ten miles along the Cameron Valley, ending at Cameron Lake. Along the way, stop at the First Oil Well in Western Canada National Historic Site. Other attractions along the drive include Crandell Lake, Lineham Falls, Rowe Lakes, Akamina Pass, Cameron Lakeshore, and Carthew-Alderson (Summit Lake). Cameron Lake has a day-use area with interpretive exhibits; a pleasant trail follows the western shore of the lake for about a mile. The Akamina Parkway remains open year-round and provides access to many locations and activities throughout the year.

HIKING PARK TRAILS

Glacier and Waterton are clearly two of the crown jewels of their respective national park systems, and their combined trail systems of over 800 miles offer a great variety of hiking opportunities and the most intimate way to experience and appreciate these parks. The trails are as diverse as the parks, accessing mountains, glaciers, lakes, forests, meadows, prairie grasslands, and wildlife. Here are some good options.

Glacier

St. Mary and Virginia Falls Trail

Glacier is known for many things, including waterfalls, and this relatively short and easy trail to these two gems is a bargain. The trailhead is on the Going-to-the Sun Road at the east end of expansive St. Mary Lake; the hike is 1.2 miles (one way) to St. Mary Falls and 0.6 mile farther to higher Virginia Falls. Both are impressive and popular. You can't miss the fact that part of the trail runs through the remains of a recent wildfire; try to see the stark beauty of this place and appreciate the fact that periodic wildfires are a natural part of this ecosystem (although a long history of forest fire prevention and the cascading effects of climate change are making these fires more intense).

Avalanche Lake Trail

This is another of Glacier's trails that offers a lot for a little effort; though the trail is 6.2 miles (round-trip), the walking is pretty easy and very pleasant. The trailhead is off the Going-to-the-Sun Road just a few miles north of Lake McDonald on the west side of the park. This trailhead is also the trailhead for the Trail of the Cedars, a short (0.7 mile, round-trip)

fully accessible nature trail that passes through large and impressive groves of old-growth red cedar and western hemlock, more closely associated with the rain forests of the Pacific Northwest. Avalanche Creek and Sperry Glacier provide the necessary moisture to support this old-growth forest in Glacier. You must walk a portion of the Trail of Cedars to reach the Avalanche Lake Trail; it's suggested you take the east side of the Trail of Cedars loop, as it's more scenic. The Avalanche Lake Trail begins just after the narrow, fluted gorge created by the rushing water of Avalanche Creek. Avalanche Lake, the prize of this hike, is a couple of miles from the gorge and is rimmed on three sides by steep rock walls that rise

hundreds of feet. A series of long and impressive cascades make their way down the face of these cliffs. Follow the trail along the west side of the lake until you reach its terminus. The creek and lake are named for the massive avalanches that have occurred here over the centuries. Like many of Glacier's more popular trails, trailhead parking doesn't begin to meet peak summer demand; arrive here early in the day.

Grinnell Glacier Trail
Grinnell Glacier is one of many glaciers in the park that are shrinking before our eyes, and it's one of the few that can be approached on a maintained trail, considered one of the

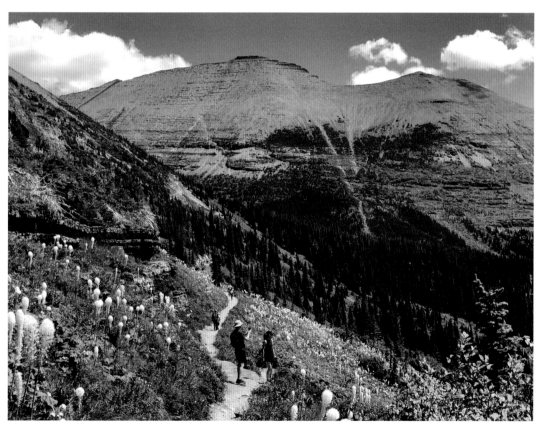
Hikers on the Grinnell Glacier Trail; note the iconic bear grass.

most dramatic in the park. The trail leads out of the Many Glacier area and is a moderately strenuous trip of 11 miles (round-trip) with about 1,600 feet of elevation gain. The trail is varied over its course, first following the shores of Swiftcurrent Lake and Lake Josephine then rising at times, leveling off in delightful alpine meadows and offering striking views, including turquoise Grinnell Lake, a massive headwall, and several striking cascades. The last climb is up and over the large terminal moraine left by Grinnell Glacier and on to the shores of alluring Upper Grinnell Lake. Here you'll have close-up views of Grinnell Glacier with its characteristic fissures and ice caves, another small glacier (The Salamander) that used to be connected to Grinnell, and Gem Icefield, a former glacier that has been reduced by climate change. Don't be tempted to climb or walk on any glacier, as they can be especially dangerous. You may be fortunate to see bighorn sheep at Upper Grinnell Lake and a grizzly bear or two along the trail. *Note:* It's possible to shorten this hike by a few miles by taking a tour boat across Swiftcurrent Lake and then on to the upper end of Lake Josephine (and return that way as well). Check with the concessionaire about their policies and pricing.

Highline Trail/Garden Wall

The Highline Trail is a long-distance, multiday route through the northern part of the park; the Garden Wall is the most iconic section of the trail and is one of the most popular hikes in the park. Though this section is nearly 12 miles one way (don't worry—by being a little creative, you can arrange a shuttle so you don't have to hike the trail in both directions), it's mostly downhill on a well-maintained trail. Most hikers consider it a long day hike, although it could be a two-day backpack trip (which would require a permit). The trail begins in the geographic middle of the park at Logan Pass, where there is a large parking area and visitor center. Much of the trail was carved from the landform known as the Garden Wall, a giant arête that is the Continental Divide. Prepare yourself for unparalleled views and a little bit of exposure to boot (a hand cable has been installed for security on the short ledge-like portion of the trail). Other portions of the trail include high alpine meadows, showy wildflowers (including the park's iconic bear grass), krummholz (high-elevation forest that is severely stunted by cold temperatures and wind), and opportunities to see lots of wildlife, including mountain goats, bighorn sheep, marmots, pikas, and even the occasional grizzly.

At mile 7.6 you reach the Granite Park Chalet, one of a series of backcountry huts constructed by the Great Northern Railroad in the early days of the park; nearly all are now gone (consider making this a two-day hike by staying the night here). At the chalet, you leave the Highline Trail and walk generally west to meet The Loop, the grand switchback on the Going-to-the-Sun Road. This is the key to making this trail an 11.6-mile point-to-point hike rather than a 23.2-mile out-and-back hike. If you have access to two vehicles, leave one at the parking lot at The Loop and drive the other one to Logan Pass (about eight miles) to start your hike. Another option is to park your car at Logan Pass, hike to The Loop, and snag a ride back to Logan Pass on the park's free shuttle bus. A third option is to leave your vehicle at The Loop, take the shuttle bus

to Logan Pass, and start your hike. But be advised that the parking lots at both Logan Pass and The Loop can't accommodate peak demand, so you must park your car early (say, by 7:00 a.m.). Still another option is to park at Logan Pass, walk a few miles of the trail (which many people consider the most dramatic), and return to Logan Pass. There are lots of logistics, but you'll be glad you hiked what is one of the grandest trails in the US National Park System. Of course, you could always hike the full Highline Trail—about a three-day backpacking trip as you head north and exit the park.

Waterton

Linnet Lake Loop Trail

The smaller size of Waterton lends itself to short day hikes, and the Linnet Lake Loop Trail is a good choice, one of the park's "featured" trails. Enjoy this short loop hike on a paved trail of just over a mile that circles this small lake; this is an easy hike. The lake is named for a small bird called a linnet (a small finch). Enjoy the wide variety of colors of the rocks, flowers, and trees along the trail, and look closely for wildlife that inhabit the area. Have your camera handy for the picturesque view of the Prince of Wales Hotel; benches offer opportunities to stop and appreciate the views. The Linnet Lake area is home to a large diversity of plants and animals and is a key travel corridor for the park's wildlife. You can learn a lot about Waterton's natural history through the interpretive displays along this trail. Trailhead parking is on the east side of the Entrance Road, just past the Parks Canada operations area.

Bertha Falls/Lake Trail

This is a moderately challenging hike of 6.4 miles (round-trip) with 1,500 feet of elevation gain. The hike starts with a moderate climb from the Waterton townsite to a scenic viewpoint overlooking Upper Waterton Lake. From here, follow the creek (the trail passes the junction to the Lakeshore Trail) to Lower Bertha Falls. If you choose to continue to Bertha Lake, the next part of the trail ascends several switchbacks leading to views of Upper Bertha Falls. When you arrive at this striking blue-green lake, follow the trail in either direction to enjoy subalpine forests and views of the mountain peaks. Note the contrast between the old-growth forest and the new growth in areas burned by the Kenow Wildfire; fire is one of the ecological processes of change and renewal that are experienced in many parks. Backcountry camping is allowed in this area, but you must have a permit. The trailhead parking lot is on Evergreen Avenue, a short distance south of Cameron Falls.

Crypt Lake Trail

Crypt Lake Trail is a challenging 11-mile (round-trip) hike that includes 2,200 feet of elevation gain. But the trail has a reputation as one of the best hikes in the park and all of Canada. The trailhead is on the east side of Upper Waterton Lake, and most hikers take the 15-minute boat ride across the lake to start and end the hike. The hike features impressive waterfalls, striking mountain views, and a narrow natural passage to reach Crypt Lake, a lovely turquoise alpine lake. The trail clings to steep cliffsides in places, and requires climbing an exposed ladder and squeezing through a tight natural tunnel, but

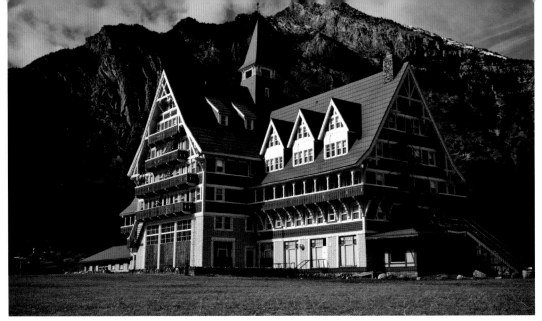
The grand Prince of Wales Hotel was constructed in Waterton Lakes National Park in the 1920s; it was designated a National Historic Site of Canada in 1992.

hikers are rewarded with a chilly dip in icy Crypt Lake (or maybe just a picnic lunch!).

LOGISTICS
This region of the Rocky Mountains gets severe winter weather and lots of snow, so both parks are primarily summer destinations, though the Akamina Parkway in Waterton and portions of the Going-to-the-Sun Road are open year-round. Other parts of the parks are at least partially open in late spring and early fall. Glacier offers seven lodges and motels, including the grand and historic Glacier Park Lodge (just outside the park), Lake McDonald Lodge, and Many Glacier Hotel. It also has two backcountry chalets, Sperry and Granite Park. There are 13 front-country campgrounds; backcountry camping is allowed in many areas, but a permit is required. Seasonal free shuttle bus service is offered along the Going-to-the-Sun Road

in Glacier; it's a great way to cut down on automobile congestion and focus your viewing on the park's scenery. Waterton features the grand and historic Prince of Wales Hotel, an iconic structure located in the historic and charming Waterton townsite. The park also has two frontcountry campgrounds (a third is currently closed due to wildfire damage); camping is allowed in the backcountry of the park, but a permit is required. The presence of grizzly bears in both parks requires special precautions to protect both visitors and bears; please see park displays, visitor centers, and park literature on this and other issues. If you plan to visit both Waterton and Glacier, be sure to pack your passport.

As with all World Heritage Sites, it's a good idea to check the areas' official websites for the most up-to-date information. For Waterton-Glacier International Peace Park, visit the following websites: parks.canada.ca/pn-np/ab/waterton and nps.gov/glac.

YELLOWSTONE NATIONAL PARK

What good fortune that our American predecessors were so foresighted to establish this magnificent national park in 1872! Yellowstone was the first national park in the nation and, indeed, the world—the first time a nation set aside a large area of its land for the benefit of all its people, not just a privileged elite. Conservationist Wallace Stegner famously wrote that the national parks are "America's best idea," a manifestation of our foundational democratic ideals. Yellowstone led to creation of many other national parks but remains the most famous, and for good reason. The park's inscription as a World Heritage Site in 1978—one of the first in the world—is a symbol of its importance to the international community.

And what a powerhouse of a national park! Yellowstone is large, even by national park standards; at 2.2 million acres, it's larger than the states of Rhode Island and Delaware combined. Much of the park sits in the caldera of an ancient and massive supervolcano, the largest on the North American continent; the caldera measures some 30 by 45 miles. Its most recent eruption, approximately 640,000 years ago, is estimated to have been 1,000 times more powerful than the eruption of Mount St. Helens in 1980, emitting an estimated 240 cubic miles of debris. Ash from this explosion has been found at locations across the continent, and the eruption may have affected world weather

patterns. Geologists think that Yellowstone has experienced several massive volcanic eruptions over the past two million years, and these have also deposited vast amounts of lava and ash in the park and beyond. The Grand Canyon of the Yellowstone River is a good place to see the resulting geologic layers that overlie most of the park.

The park's volcanic origin is plainly evident in its many geysers, fumaroles, mud pots, and boiling hot springs, the largest collection of such geothermal features in the world. Old Faithful geyser is the most famous, erupting approximately every 90 minutes. But the park includes many more

Old Faithful geyser is the park's most famous thermal feature; visitors gather many times each day to watch it erupt.

natural attractions, including vast canyons and associated rivers and waterfalls; world-famous megafauna; several mountain ranges that feature 10,000-foot plus peaks; vast subalpine forests and meadows; the largest high-elevation lake in North America; and an extensive petrified forest. This is the national park that all Americans should see; it offers 250 miles of scenic roads and more than 1,000 miles of trails, enabling visitors to appreciate it in so many ways.

Most of the park occupies a high plateau in northwest Wyoming, and it also extends into portions of Montana and Idaho. The average elevation of the plateau is about 8,000 feet. The Continental Divide runs through the southwestern portion of the park. The park's variations in elevation and geography have resulted in a great range of habitats that support highly diverse flora and fauna. Several species of evergreen trees are found in the park, although lodgepole pines compose 80 percent of the park's extensive forests. Quaking aspen and willows are the most common species of deciduous trees. Spring and summer bring diverse wildflowers, and unusual forms of bacteria grow in the park's geyser basins.

Yellowstone supports a variety of exciting wildlife, including grizzly and black bears, wolves, the largest herd of bison in the United States, elk, moose, mule and white-tailed deer, mountain goats, pronghorn, bighorn sheep, mountain lions, wolverines, 18 species of fish (including the famed Yellowstone cutthroat trout), and more than 300 species of birds. Wolves were extirpated from the park in the first half of the 20th century because they preyed on the park's elk (as well as cattle on surrounding private lands) but were successfully reintroduced in the 1990s as a result of increasing ecological and environmental awareness. The howl of wolves, a marker of genuine wilderness, has been reestablished in the park.

Much of the park has experienced periodic wildfires over its long prehistory and more recently, and many species of vegetation have evolved to be fire-dependent. For example, cones of lodgepole pines are triggered to open and disperse their seeds when they're subject to fire. A major fire in 1988

Bison often seek out the warmth of the park's thermal features in winter.

burned more than a third of the park, and this started a lively public discussion on how to manage fires in national parks and other natural areas. Prior to this, public policy was to extinguish wildfires as quickly as possible. However, this approach was ultimately found to be flawed because certain species of vegetation need periodic fires to reproduce; additionally, suppression of natural fires can lead to denser growth of trees and other vegetation and accumulation of great amounts of dead and downed wood that ultimately fuel fires of higher intensity. Now fires are managed in Yellowstone and other national parks in ways that help allow fire to play its natural role. This management regime includes allowing natural fires to burn when they don't endanger people and their property, and even using prescribed fires (intentionally set) in places where they can be safely and appropriately managed.

In addition to its natural history, Yellowstone has a colorful human history, dating back 11,000 years, when Native Americans used the area for hunting and fishing. Indigenous people used volcanic deposits of obsidian to fashion projectile points and cutting tools, many of which have been found and dated. European-American explorers appeared in the 19th century; the first were trappers and colorful mountain men such as John Colter and Jim Bridger. Official government expeditions were mounted in 1870 and 1871, and the findings of these expeditions—in particular the geothermal character of the area and its natural beauty—were instrumental in convincing Congress to withdraw the area from development and establish a national park. Photographs by William Henry Jackson and paintings by

Thomas Moran, both of whom accompanied the 1871 Hayden Geographical Survey to the park, provided visual documentation of the wonders of the Yellowstone territory. Support by the railroad industry, convinced the area would become a great tourist attraction, helped spur establishment of the park. The 1872 act of Congress establishing the park stated that the area would be a public park "for the benefit and enjoyment of the people," and these historic words were etched into the Roosevelt Arch that spans the celebrated northern entrance of the park; President Theodore Roosevelt helped lay the arch's keystone.

However, simply establishing the park and its boundaries was inadequate to protect it, and poaching and illegal logging quickly caused damage. Since there was as yet no National Park Service (NPS), the US Army was called upon to bring order, occupying the park starting in 1886 and building Fort Yellowstone at Mammoth Hot Springs as its headquarters. Many of the original fort buildings are still in use as NPS offices and housing, as well as a visitor center. Be sure to stop by the visitor center for a good example of an early fort building; there's even an engaging historic walking tour. Congress established the NPS in 1916 to manage Yellowstone and the growing list of early national parks.

VISITOR ATTRACTIONS

Given the large size and diversity of the park, its primary visitor attractions might best be described in the context of the park's geography. The Grand Canyon of the Yellowstone River and the adjacent Canyon Village is a complex of visitor attractions and associated

facilities and services in the heart of the park. This large and impressive canyon is roughly 20 miles long and was formed by erosion as the river flowed over progressively softer rock. There are many fine views of the canyon—including dramatic Upper and Lower Falls—along the road and trail systems. The famous painting of this canyon by Thomas Moran was instrumental in convincing Congress to establish the park. Just south of the canyon is the Hayden Valley, with especially good opportunities to view wildlife.

Fishing Bridge, Yellowstone Lake, Bridge Bay, and associated visitor facilities and services are found in the southeast quadrant of the park. As the name suggests, this was a great place for visitors to fish, but declines in the cutthroat trout population caused the NPS to close the bridge to fishing in 1973; however, the bridge remains a good place to watch fish. Volcanic activity in this region several hundred thousand years ago created a large caldera that ultimately became impressive Yellowstone Lake. Hydrothermal processes continue in the region, forming a network of mud pots and fumaroles. Pelican Valley, located just east of this area, offers some of the best wildlife viewing in the park, including grizzly bears, bison, and elk.

Madison and surrounding attractions are located in the western part of the park and include an especially important collection of hydrothermal features. The Fountain Paint Pot and Midway Geyser Basin include all four of the park's major hydrothermal features, including fumaroles, geysers, hot springs, and mud pots. Fountain Paint Pot is a famous example of the latter. Midway Geyser Basin includes the park's most famous hot spring, lovely (and colorful) Grand Prismatic

Spring, as well as Great Fountain and White Dome Geysers. The trailhead to Fairy Falls is also found here. The Madison and Firehole Rivers are other important features of this area. The Madison is a blue-ribbon fly-fishing stream with brown and rainbow trout and mountain whitefish; the Firehole River is world-famous among anglers for its pristine beauty and abundant brown, brook, and rainbow trout.

Mammoth Hot Springs and associated attractions are located in the northwest quadrant of the park and feature the impressive Mammoth Hot Springs Terraces, a large system of hydrothermal sites and travertine terraces that can be viewed on a network of boardwalks. There are also two interesting historic sites. Construction of historic Fort Yellowstone began in 1886 when the US Army began its occupation of the park to protect it from poaching, squatting, and other problems. Much of the fort is still standing and now houses the Albright Visitor Center and NPS employees; ask at the visitor center about a walking tour. The historic Roosevelt Arch is nearby and served as the ceremonial entrance to the park in the early 1900s; it carries the inscription "For the benefit of the people," the democratically inspired wording of the congressional act that established the NPS in 1916. Stop here and do a ceremonial walk through the arch.

Norris Geyser Basin is the largest in the park and is a highly active seismic area, which sometimes adds drama to this large collection of hydrothermal features. Steamboat Geyser, the tallest geyser in the world (300–400 feet), and Echinus Geyser are popular attractions; other thermal features in the area include Artists Paintpots, Beryl Spring,

and Monument Geyser Basin. The Gibbon River is popular for fishing, and Gibbon Falls is lovely. Careful observers will notice a 22-mile swath of lodgepole pines blown down by wind shear in 1984; these trees were killed in the historic wildfires of 1988, and the area is in the process of reestablishing this forest.

The Old Faithful region is located on the southern loop of the Grand Loop Road and includes one the park's largest complexes of visitor attractions and associated facilities and services. World-renowned Old Faithful geyser is the prime attraction because of its size and regular eruption cycle; see it from the nearby boardwalk. Predicted time of the next eruption is posted at the adjacent visitor center and on the NPS app. Old Faithful is part of the Upper Geyser Basin, which includes more than 100 geysers. Other important thermal areas in the Old Faithful region include Biscuit Basin, Black Sand Basin, and Midway Geyser Basin; the latter features iconic Grand Prismatic Spring. The Old Faithful Inn (near Old Faithful geyser) is a mammoth log- and wood-frame hotel constructed in 1903–04 and is a National Historic Landmark; walk through the lobby with its 65-foot ceiling, massive rhyolite fireplace, and stair railings made of contorted lodgepole pine.

The Tower-Roosevelt area is in the northeast quadrant of the park. Popular attractions include dramatic Tower Fall, framed by volcanic pinnacles, the downstream portion of the Grand Canyon of the Yellowstone River, a large concentration of petrified trees, and the wildlife-rich Lamar Valley, where wolves are frequently seen.

The lobby of the Old Faithful Inn; this historic hotel was constructed in the early 20th century and is a good example of the rustic architecture—sometimes called "parkitecture"—employed in the national parks.

The West Thumb and Grant areas, in the southeast portion of the park, share Yellowstone Lake with the Fishing Bridge region to the north. At 136 square miles, Yellowstone Lake dominates much of this region; other lakes in the area include Lewis and Shoshone Lakes. Motorized boats are allowed only on Yellowstone and Lewis Lakes. The West Thumb Geyser Basin on the shores of Yellowstone Lake extends under the lake; several underwater geysers can be seen as slick spots or slight bulges on the lake's surface in

the summer; during winter they are visible as melt holes in the ice-covered surface of the lake. A variety of visitor facilities and services are found in the West Thumb area.

VISITOR CENTERS

The NPS has created a network of ten visitor centers, information stations, and museums scattered around Yellowstone—places to learn about the natural and cultural history of the area and guide visitors to its many attractions.

1. **Albright Visitor Center** (named for the agency's second director) is located near Mammoth Hot Springs in Fort Yellowstone's bachelor officers' quarters for the cavalry troops that protected the park.
2. **Canyon Visitor Education Center** at Canyon Village specializes in geology and Yellowstone's "supervolcano" that shaped so much of the present-day park; the building includes a room-size relief map of the park, real-time earthquake data collected in the park, and a 9,000-pound rotating globe that illustrates volcanic hot spots around the world.
3. **Fishing Bridge Visitor Center and Trailside Museum**, due west of the park's east entrance at the intersection with Grand Loop Road, highlights the ecology of Yellowstone Lake with a special emphasis on park birds; here you'll find great views of Yellowstone Lake. The rustic stone-and-log architecture of the building is a classic example of the "parkitec-

ture" of many buildings throughout the national park system; in fact, this building was a prototype.
4. **Grant Visitor Center** is due north of the park's south entrance and interprets the increasingly important topic of wildfires in the national parks and the West more broadly.
5. **Madison Information Station and Trails Museum** is due east of the park's west entrance, where it connects with the Grand Loop Road. This building, also a prototype of the distinctive parkitecture building style designed to blend into the surrounding natural environment, offers visitors nice views of the Madison River.
6. **Norris Geyser Basin Museum and Information Station** is located at Norris Geyser Basin; the building has been serving the information needs of park visitors since 1930.
7. **Old Faithful Visitor Education Center** is located near iconic Old Faithful geyser on the lower loop of the Grand Loop Road. A full-service facility, it offers views of the geyser, an exhibit hall, and a park store.
8. **West Thumb Information Station** is housed in a small historic building located near Yellowstone Lake; start your walk on the West Thumb Geyser Basin boardwalks here.
9. **West Yellowstone Visitor Information Center** is located in the town of West Yellowstone, just west of the park's west entrance; the facility is staffed by park rangers and chamber of commerce employees.

10. **Museum of the National Park Ranger** is an unusual facility that celebrates and interprets the history of the park ranger profession; it's housed in a historic building and staffed by retired rangers.

SCENIC DRIVES

Yellowstone is an especially big national park, but its elaborate system of 251 miles of roads allow visitors to see much of it by car. A quick glance at a park map shows the "figure eight" network of roads (generally called the Grand Loop Road) that are prominent in the heart of the park, along with the five connecting roads that lead in and out of the park in many directions. Visitors should probably consider the entire system of roads in the park as "scenic drives," but the following offers more-specific direction. Be advised that these drives will (and should) require considerable time because there's so much to see and do, speed limits are slow to help protect wildlife, and drivers often stop to view wildlife (causing frequent "bison jams").

The Lower Loop of the Grand Loop Road is 96 miles and is packed with attractions, including Norris Geyser Basin, Grand Canyon of the Yellowstone, Hayden Valley, Yellowstone Lake, West Thumb Geyser Basin, and the Old Faithful complex of attractions. The road crosses the Continental Divide twice. The Upper Grand Loop is 70 miles and includes Tower Junction (and its impressive Tower Fall), Mammoth Hot

Elk are often seen in large herds throughout much of the park.

Hikers enjoy the park on its vast trail network.

Springs complex (and the park's primary visitor center), and the Norris Geyser Basin. Look for the summit of Mount Washburn, with its distinctive fire tower (the hike to the summit is described below) and the views from Dunraven Pass.

The roads that connect the five park entrances—north, northwest, west, south, and east—to the Grand Loop Road are also scenic. The road to the northeast travels through the Lamar Valley, where you're likely to see wildlife, including wolves, descendants of those released in the park in the 1990s. This road, the road from the north entrance, and the portion of the Grand Loop Road that connects them, are the only roads open in winter.

HIKING PARK TRAILS

The size of Yellowstone and its rich natural and cultural history demand an equally grand system of trails, and the park doesn't disappoint. Encompassing all its diverse habitats and history, the park's trails extend more than 1,000 miles and range from short, informative nature trails to a vast wilderness that would take a human lifetime to fully explore and appreciate. The following trails are representative of the park's diversity and are highly recommended.

Grand Canyon of the Yellowstone (North and South Rim Trails)

The stunning canyon carved by the Yellowstone River simply shouldn't be missed; the canyon is 20 miles long, more than a 1,000 feet deep, and includes two waterfalls that truly roar. With walkers in mind, a network of trails has been developed that take visitors to the most striking viewpoints; these trails

can be sorted into networks on the south and north rims of the canyon. The former network extends 3.5 miles and features several highlights, including the Upper Falls Viewpoint, Uncle Tom's Trail, Artist Point (one of the most photographed views in the park), and Point Sublime. Uncle Tom's Trail is a favorite—a steep, 500-foot descent into the canyon. The trails along the North Rim extend three miles and include the Brink of the Upper Falls Trail, Brink of the Lower Falls Trail, Red Rock Trail, Grand View Overlook, and Inspiration Point. The Brink of the Lower Falls Trail drops 600 feet into the canyon, ending at a viewing platform that lives up to the trail's name; this especially popular trail is not for the faint of heart. Roads more or less parallel the south and north rim trails, with parking lots that access several key viewpoints and the trails noted above. This makes it easy to walk only portions of the canyon trail networks if short on time (though there is no public transportation along these roads, so the trails must be walked out and back). However, walking the trails is a more peaceful way to experience this very heavily used portion of the park, offers a more-or-less continuous series of ever-changing views, and avoids the challenging issue of finding multiple parking places.

Upper Geyser Basin

Yellowstone's world-famous thermal features are scattered throughout the park, but most are concentrated in several major basins. Certainly, the Upper Geyser Basin along the Firehole River is the most famous of these areas, including the majority of the world's active geysers and featuring Old Faithful geyser, a real crowd-pleaser. A large network of trails winds through the basin, allowing a range of walking opportunities from a short stroll to Old Faithful to a five-mile exploration throughout the area. The visitor center that serves the Upper Geyser Basin predicts the time of the next eruption of Old Faithful—you'll want to be seated on the benches surrounding the geyser about 15 minutes before its eruption. After this up-close experience, stroll a bit around the geyser basin and consider climbing Geyser Hill to Observation Point for a very different view of the next eruption of Old Faithful. Don't forget to pay attention to the cultural components of this landscape (the area is a National Historic District), featuring the Old Faithful Inn (a National Historic Landmark); this is the largest log hotel in the world and a classic example of parkitecture, the distinctive rustic architectural style found in many US national parks.

Fairy Falls Trail

While you're in the Upper Geyser Basin/Old Faithful area, you might enjoy this longer but easy hike to one of the park's prettiest waterfalls, graceful Fairy Falls, that drops nearly 200 feet. This is an out-and-back trail of 4.8 miles (round-trip). As you approach the falls, note how the forest is recovering from the 1988 fire and now includes pines that have grown to substantial heights. Be sure to take the short spur trail to an elevated view of world-famous Grand Prismatic Spring, its bright colors caused by a variety of algae and bacteria adapted to extremely high temperatures. It's possible to extend your hike from Fairy Falls just a little to see impressive Imperial Geyser.

Mount Washburn
(Chittenden Road)

Mount Washburn is one of the most accessible high mountains in the park and one that offers a variety of attractions, including outstanding views, riotous wildflowers in season, and bighorn sheep. The shortest route to the top of this 10,243-foot peak is a pleasant walk up the old Chittenden Road; this well-graded gravel road is open only to hikers and bikers (though official vehicles use it infrequently). The walk ascends 3.1 miles and climbs nearly 1,500 feet, making for a hike of only moderate challenge. Along the way you're likely to be dazzled by wildflowers, perhaps the best in the park, snowdrifts that may last until August, and frequent sightings of bighorn sheep on the open slopes of the mountain and/or at its summit. The mountain marks the northern edge of the giant caldera that defines much of Yellowstone. At the summit of the mountain you'll find a fire lookout (one of several constructed in the early 1900s and still in use), a small visitor center, a telescope, restrooms, and expansive views all the way to the Teton Mountains to the south on a clear day. A trail of similar length ascends Mount Washburn from Dunraven Pass, but is a little longer and steeper in places; ascending the mountain on one trail and descending on the other is ideal, but requires someone to provide a ride back to your car.

Upper Gallatin River Trail
(also called the
Bighorn Pass Trail)

Most of the attractions and many of the finest trails in Yellowstone are heavily used, so it's refreshing to find some moments of solitude and quiet in the park. One place to look for these opportunities is in the relatively lightly visited northwestern corner of the park; here the famous Gallatin River rises and flows north out of the park and through its namesake national forest that borders the park. Start your walk at Bighorn Pass Trailhead and travel upstream as far as you like; you may find yourself walking farther than you originally envisioned up this broad, lush, meadow-filled valley. The trail is mostly flat and roughly follows the river and would make a lovely short backpacking trip (permit required).

Mary Mountain Trail
(also called the Nez Perce Trail)

This diverse and adventurous trail can be hiked in its entirety or just enough to get a lasting sense of why it's such an appropriate representation of Yellowstone. This route through the geographic heart of the park crosses much of the Hayden Valley, a place that mightily contributes to the park's reputation as the Serengeti of North America. The complete trail is just over 20 miles and must be done as a day hike, as camping is not allowed due to the presence of grizzly bears. The trail isn't difficult, as there is little elevation change, but it's long, trails made by bison can confuse walkers, and bison often accidentally knock down poles (or do they do this on purpose?!) placed to mark the trail in open meadows. The trail can also be boggy in places. The Hayden Valley is prime grizzly habitat, so exercise all NPS-recommended precautions. Check with rangers about current, on-the-ground conditions before walking this trail. Most visitors will probably not want to walk the trail in its entirety, so start

the hike at its eastern end just off the Grand Loop Road and walk as far as you like then retrace your steps, making this a glorious out-and back day hike of whatever length you choose.

SPECIAL PROGRAMS

Yellowstone has an extensive public education program for all visitors, delivered by experienced and knowledgeable park rangers. Many of these programs (e.g., interpretive walks) are concentrated around the park's 10 visitor centers, but some are conducted at the park's numerous visitor attractions. Check the park's official NPS website (noted below) and park newspaper for dates and times. The NPS's Junior Ranger Program is a favorite with children. The Yellowstone Forever Institute and the Expedition Yellowstone Field Institute conduct more intensive park-based educational programs; check their websites.

LOGISTICS

A big park like Yellowstone can be challenging to negotiate, but it has an unusually large infrastructure to support its several million annual visits. There are 12 developed campgrounds in the park that offer more than 2,000 campsites and 9 hotels/lodges, including the historic and iconic Old Faithful Inn and the historic hotels at Mammoth Hot Springs and Yellowstone Lake. Small stores and food services are located at many of the visitor services complexes located throughout the park. Backpacking is popular at the more than 300 designated campsites in the park's vast backcountry. Many more campgrounds, hotels/motels, and other visitor facilities and services are available in the park's surrounding gateway towns. While the park is open year-round, winter is long and severe and includes deep snow; the primary visitor use season is July and August (winter snows can take many weeks to melt and usually start again in mid-fall), though June and September can offer some relief from crowding. In winter, only the park's north entrance is open; this road, the northern section of the Grand Loop Road, and a portion of the road leading to the northeast entrance are plowed and open to cars. The rest of the Grand Loop Road is open to over-snow vehicles (snowmobiles, etc.). The park is known internationally for its wildlife, but visitors are prohibited from approaching/disturbing wild animals, as this can be dangerous; each year, park visitors are injured by wildlife when approaching too closely. The most up-to-date information about the park is available on the park's official website (nps .gov/yell) and the NPS app.

YOSEMITE NATIONAL PARK

Most people have at least seen a photograph of iconic Yosemite Valley and its remarkable convergence of natural features: nearly sheer granite cliffs that rise as much as 4,000 feet above the valley floor; the sparkling Merced River that meanders through the deep, old-growth valley forests; the internationally recognized granite features of Half Dome and El Capitan; and some of the highest and most dramatic waterfalls in the world. Yosemite Valley has to be one of the most strikingly beautiful places on the planet. But the valley is less than 1 percent of this remarkable park's three-quarters of a million acres. There's so much more to Yosemite than its namesake valley: three groves of ancient sequoias; the vast High Sierra portion of the park with its 13,000+-foot mountains and lush meadows; two federally designated Wild and Scenic Rivers (the Merced and the Tuolumne); and the colorful history and philosophy of John Muir, the unofficial "father" of the US National Park System. There's a lot to like about Yosemite, including its inscription as a World Heritage Site in 1984.

Geology is the place to start in Yosemite, as it's all there, right before your eyes. Tectonic forces in California's deep prehistory elevated the land into the mountains we now call the Sierra Nevada, Muir's "Range of Light" and "gentle wilderness." But it's the glaciers that shaped these mountains more recently, digging, scraping, and polishing. Yosemite and the other valleys in the park display the classic "U" shape associated with glacial action (flowing rivers tend to form V-shaped valleys). Actually, it was a series of glacial periods over the past two to three million years that sculpted much of the park. At one point, it's estimated that Yosemite Valley was covered in 4,000 feet of "flowing" ice, plucking away at the granite walls of the valley and polishing the park's signature domes. The distinctive domes of the park are the result of plutons—pools of molten rock beneath the earth's surface. As erosion stripped away the soil and other surface materials, the plutons began to cool and harden. The upper layers of the plutons experience this process first because they are the initial areas to be relieved of the weight and pressure of the surface materials. Consequently, they fracture or exfoliate, assuming a layered form much like an onion.

The park encompasses an especially wide range of elevations, from approximately 2,000 to more than 13,000 feet, and includes several vegetative zones. Many types of pines and firs occupy the park, depending on elevation; deciduous trees include black oaks and canyon live oaks. Large meadows are found at elevations of about 4,000 feet to 8,000 feet, and the park is generally well watered with many streams and lakes that are a result of deep winter snows. Wildflowers put on exuberant displays in spring and summer. Three groves of giant sequoias are found in the park at an elevation of about

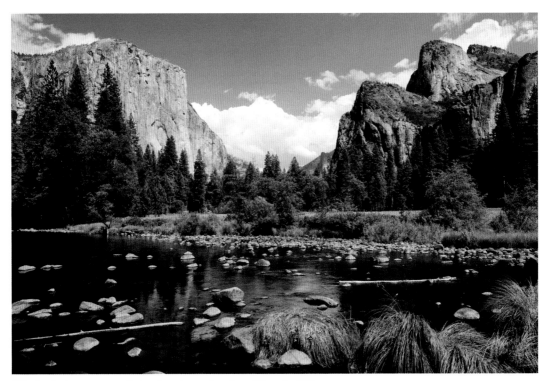
This classic photo captures the iconic and stunning view of Yosemite Valley.

4,000 feet; these trees are the largest living things on the planet, and many live 2,000 or more years. Yosemite's habitats support many species of wildlife; notable examples include mountain lions, black bears, bighorn sheep, coyotes, bobcats, red foxes, mule deer, spotted owls, pikas, and yellow-bellied marmots. More than 250 species of birds have been documented in the park.

The park's forests are highly susceptible to periodic wildfires, a natural and integral part of much of the Yosemite ecosystem. As with some other western national parks, the large fires Yosemite has experienced in recent years are partly due to the historic policy of extinguishing all wildfires as quickly as possible, leaving many forests with much dead and downed wood and making them highly susceptible to conflagrations. Climate change is also an important cause of these wildfires, creating unusually hot and dry conditions and allowing explosive populations of forest insects that kill many trees. Research has found that the park's ancient sequoias are serotinous, meaning their cones open to disperse seeds with the heat of a fire. It's especially ironic that extinguishing fires for many decades to protect the iconic sequoia groves has endangered their reproduction in the process; the National Park Service (NPS) is now allowing some natural wildfires (e.g., those started by lightening) to burn when they don't threaten people or their property, even setting periodic fires (called prescribed

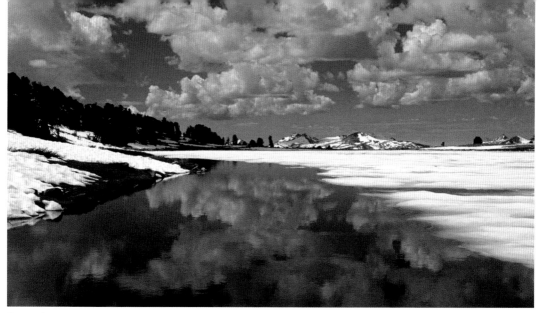
Some of the park's high-elevation lakes can remain ice-covered until midsummer.

burns) under appropriate conditions. Yosemite is an exemplar of this evolving approach to managing wildfire in the national parks.

Establishment and management of Yosemite tells a number of important stories about the nation's conservation history. Sadly, it begins with the horrific treatment of Indigenous people who visited and occupied the area for thousands of years. To deal with skirmishes between the area's Paiute and Miwuk Indians and California gold rush miners, the Mariposa Battalion of the US Army was sent to the Yosemite region, where they "discovered" Yosemite Valley. The Indian village in the valley was burned and the occupants removed. This made way for a nascent, mostly tacky tourist industry, including a host of inappropriate visitor attractions. Early conservationists were appalled at the damage being done to the area and lobbied Congress to grant Yosemite Valley and the Mariposa Grove of Sequoias to California to

be protected by the state, and this happened in 1864.

Later in the 19th century, John Muir traveled to Yosemite and devoted much of his adult life to exploring and protecting the area as well as other places that would eventually become national parks. His powerful writing and speaking helped convince the public and Congress to establish a much larger Yosemite National Park in 1890. Muir famously hosted President Theodore Roosevelt on a three-day camping trip at Yosemite's Glacier Point and convinced him to help arrange return of Yosemite Valley and the Mariposa Grove to the federal government and incorporate them into the new national park. Soon after, the US Army was directed to protect the park (the NPS wasn't established until 1916). Among the troops stationed in the park was the African American 9th Cavalry, known as the Buffalo Soldiers, who helped protect several of the early

national parks. It's ironic and unfortunate that contemporary Black Americans are so vastly underrepresented as visitors to Yosemite and most other national parks.

VISITOR ATTRACTIONS

Yosemite Valley, with its sheer granite walls, instantly recognizable granite features such at El Capitan and Half Dome, lovely Merced River, and some of the planet's tallest and most well-known waterfalls, is the scenic heart of the park, a place all visitors should see at least once. Not surprisingly, it's a busy place. Rise early on the day you enter the valley to find the loop road through the valley less congested and increase your chances of finding a parking spot. Then take the free shuttle buses to visit its major attractions.

Any hassles you might experience are worth the effort.

But Yosemite Valley is a small fraction of the park, so plan to spend much of your time in other locations. In particular, visit the park's High Sierra for dramatic views of the Sierra Nevada, punctuated with lush, graceful meadows; deep evergreen forests; and rushing rivers. Lovely Tuolumne Meadows and the surrounding landscape is an iconic example.

Just as Yosemite Valley is a small part of this much larger park, the developed portion of the park represents a mere 5 percent. The other 95 percent is wilderness. Here there are few visitor facilities with the exception of trails and campsites. This vast wilderness is the scenic backdrop for visitors traveling park roads and stopping at viewpoints and overlooks, as well as habitat for park wildlife.

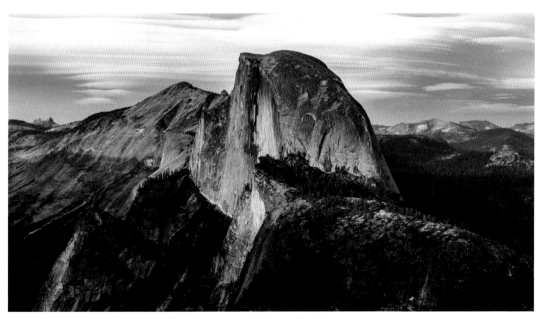
Half Dome may be the best example of glacial erosion in the National Park System.

But visitors can explore this wilderness up-close and personal by hiking some of the more than 800 miles of park trails (see some suggested hikes below).

Visitors will want to experience at least one of the three groves of giant sequoias, remarkable trees that are found only in this region of the Sierra Nevada. In terms of sheer mass, these are the world's largest living things. Some are estimated to be more than 2,000 years old and stand more than 200 feet high with a diameter of more than 25 feet (and circumference of more than 90 feet). The Mariposa Grove in the south of the park is the largest; a free shuttle bus from the nearby Mariposa Grove Welcome Plaza takes visitors to the grove, where there is a network of trails. The smaller Tuolumne and Merced Groves are found on the Tioga and Big Oak Flat Roads, respectively; both are worth visiting and can also offer moments of solitude.

The park is also known globally for its collection of world-class waterfalls, including Yosemite Falls, Sentinel Falls, Bridalveil Fall, Nevada Fall, Vernal Fall, Wapama Falls, Iilouette Fall, Chilnualna Falls, Ribbon Fall, and Horsetail Fall, scattered around the park. There are many more with less well-known names (or no names at all!). The park's two nationally designated Wild and Scenic Rivers—the Merced and the Tuolumne—are impressive; see the former in Yosemite Valley and along the park's El Portal Road and the latter at Tuolumne Meadows.

VISITOR CENTERS

Yosemite offers a range of visitor centers (also called "welcome centers" and "discovery centers") and associated museums, many located in Yosemite Valley; the Valley Visitor Center is the park's largest. Located on the east side of the valley, it features an information desk staffed by rangers and volunteers, a bookstore, a film about the park, and an exhibit hall focused on the park's natural and cultural history. A welcome center will soon be added adjacent to the Village Store. Close by is the Yosemite Museum, which features the cultural history of Yosemite's Native Americans, the Miwuk and Paiute people; demonstrations of traditional skills are presented. A gallery offers art exhibits periodically throughout the year. The Valley Wilderness Center issues permits for camping in the wilderness portion of the park; offers bear canisters (to keep food from bears and other wildlife), maps, and guidebooks; and provides advice on planning wilderness trips. The Happy Isles Art and Nature Center is a family-friendly facility that offers natural history exhibits, interactive displays, art workshops, and a system of short, diverse trails. The small Yosemite Conservation Heritage Center (formerly the historic LeConte Memorial Lodge) was the park's first visitor center, initially operated by the Sierra Club; it now features a library, a variety of environmental education and evening programs, and a children's corner. There is a small visitor center and a wilderness center at Tuolumne Meadows in the park's high country. The Wawona Visitor Center and the Yosemite History Center are near the southern entrance of the park.

DRIVING TOURS

Yosemite includes 214 miles of paved roads, nearly all of them especially scenic. The

following driving tours offer an excellent introduction to the park and include many of the park's most stunning vistas. All visitors will want to tour Yosemite Valley, an approximately 14-mile one-way loop road; drive into the valley on Southside Drive and back out on Northside Drive. Entering the valley from the park's south entrance along the Wawona Road allows you to see the classic view of the valley as you exit the road's mile-long tunnel; a small parking lot on the left allows for photographs of "Tunnel View," perhaps the most understated place name in the National Park System. Note Bridalveil Falls on the right, El Capitan on the left, and Half Dome in the distance. Allow lots of time for this 14-mile trip, as there's so much to see (and traffic will be heavy in the summer). Parking at trailheads and scenic views is available all along the road, and many of the park's primary visitor facilities and services are located at the eastern end of the valley.

Tioga Road is another drive that shouldn't be missed; this 47-mile scenic drive accesses the park's dramatic "high country." The road is a section of CA 120, which connects the park's Big Oak Flat Road and the east entrance of the park at nearly 10,000-foot Tioga Pass. Scenic highlights include Olmsted Point, impressive Tenaya Lake, and lovely Tuolumne Meadows. Observation points and trailheads are scattered all along the road. Because of its high elevation and abundant snowfall, the Tioga Road is closed from late fall through spring/early summer.

Other scenic drives include Glacier Point Road and the drive to the Hetch Hetchy area of the park. Glacier Point offers one of the finest viewpoints in the park,

including Yosemite Valley, Half Dome, and three major waterfalls, and is found at the end of this 16-mile road; the road is closed in winter beyond the Yosemite Ski and Snowboard Area. Hetch Hetchy is an isolated area in the park and was the site of one of America's great conservation controversies in the early 1900s—a proposed dam on the scenic Tuolumne River and its lovely valley, often called the "twin" of Yosemite Valley. Though the dam was constructed, it's still an interesting area with several nice hikes, and the 10-mile drive (from the park's Hetch Hetchy entrance) is scenic.

HIKING PARK TRAILS

With more than 800 miles of trails in this iconic park, how do you decide where to hike? Follow great rivers, climb to the top of waterfalls and granite domes, wander through groves of ancient forests and lush meadows, hike the famous John Muir Trail? The following recommendations are great places to begin.

Vernal Fall/Nevada Fall

This is a good first hike for every Yosemite visitor, a compact tour of so many of the features for which the park is internationally celebrated: granite spires and domes, a wild river, and world-class waterfalls. The park's trail system offers an appealing 5.8-mile lollipop route that gains 2,000 feet as it follows the rushing Merced River to Vernal Fall and then Nevada Fall. Start at the trailhead for the iconic John Muir Trail (see below), turn left on the Mist Trail to the top of Nevada Fall (bring a rain jacket to shield you from

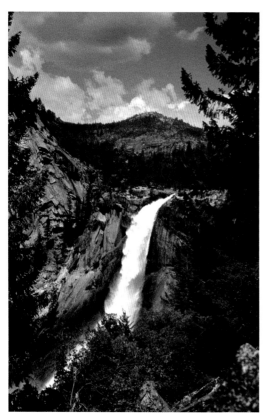

Yosemite is known for some of the highest and most dramatic waterfalls in the world; this is Nevada Fall, a half-day hike from Yosemite Valley.

Mariposa Grove

The Mariposa Grove is the largest collection of giant sequoias in the park, home to more than 500 mature trees, and the area is laced with trails. The Grizzly Giant Loop Trail is an easy walk of about two miles (round-trip) where you'll see several named trees, including the Grizzly Giant. This is the oldest and tallest sequoia in the park, standing more than 200 feet high.

Lyell Canyon

Switching geographic focus to Yosemite's vast High Sierra, there's no better place to begin than Lyell Canyon, a sublime example of John Muir's "gentle wilderness." The trailhead is just off the Tioga Road near Tuolumne Meadows, and the hike follows the Lyell Fork of the Tuolumne River for 5.6 miles to the junction with the trail to Vogelsang Pass, making this an out-and-back hike of 11.2 miles (of course you can shorten the hike by simply turning around at any point). This easy hike follows a sparkling river that pools and meanders through the area's extensive meadows with views to the surrounding mountains. There's no adequate way to describe the beauty of this place—you'll just have to see for yourself.

Half Dome

All serious hikers have heard of Half Dome, certainly one of the most iconic hikes in all the national parks. Distinctive Half Dome is the scenic symbol of Yosemite, appearing on the California state quarter and driver's license, and on the logo of the Sierra Club and the North Face company. This is a challenging

the spray of the waterfalls, especially in spring and early summer), and return on the John Muir Trail. A shorter alternative is to walk to the Vernal Fall bridge and enjoy the very best view of the namesake waterfall, a 1.6-mile round-trip. For a longer alternative (but nearly all downhill), start your hike at Glacier Point and follow the aptly-named Panorama Trail 10.4 miles to the top of Nevada Fall; then descend to Yosemite Valley via the John Muir Trail for a hike of 13.7 miles. The only rub is that you'll need a ride to Glacier Point to start this hike; be creative.

hike, especially if attempted as a day hike: 16 miles round-trip, nearly 5,000 feet of elevation gain, and an exposed section of cables that must be navigated to summit the dome. The first 3.5 miles are the same as the trail to the top of Nevada Fall (described above). Here you continue your hike around Little Yosemite Valley and then steeply up to the base of the dome, where you use fixed steel cables to reach the top. The rounded mass of rock you ascend falls steeply off on all sides; this is not a hike for the fainthearted. The summit is flatter than it appears from the valley and allows hikers to rest and appreciate the truly remarkable 360-degree view of the park. If you're day-hiking, you should start before dawn to help ensure that you're off the summit before afternoon thunderstorms develop. Perhaps a better plan is to make this a backpacking trip, staying a night or two at Little Yosemite Valley (a permit is required). This hike to the summit of Half Dome is so popular, it requires a permit, available by a lottery.

High Sierra Camps Loop

This unusual and remarkable multiday route offers access to some of the most strikingly beautiful portions of the Yosemite wilderness. Here the park provides a series of six "camps"—clusters of large, semipermanent tents and common areas—spaced an easy day's hike apart. The camps are located in a way that offers a six-day loop that totals about 50 miles. Each tent has four to six dormitory-style beds with mattresses and pillows and a wood stove. Employees, mostly energetic young men and women, prepare family-style dinners and breakfasts and serve them in large canvas-sided dining halls. Showers are available at some of the camps, though a dip in one of the many (admittedly icy) lakes and streams along the trail may be an even better alternative. All camps have restroom facilities. By using the camps, one can "backpack" through the Yosemite wilderness without having to carry a heavy pack! This system of camps offers a way of enjoying and appreciating the mountains that's more characteristic of Europe, with its extensive systems of huts. The landscape of the High Sierra Camps Loop is classic "High Sierra": mountains approaching 14,000 feet, smooth granite domes, spacious meadows that support a rich stock of wildflowers, deep pine forests, and a ready supply of inviting streams and lakes. It's not surprising that the High Sierra Camps are so popular that there's a lottery for their use. The camps are expensive, but you don't have to hike the whole circuit. You can walk this same route by means of a more conventional backpacking trip. *Note:* These camps haven't operated for a few years because of weather and other issues, and their future may be uncertain.

John Muir Trail

Most visitors can't be expected to hike the famous John Muir Trail, a world-renowned 211-mile route through the dramatic High Sierra (though it's definitely worth thinking about!). The trail travels 34 miles in Yosemite before exiting the park to the south and then making its way through two large wilderness areas and two more national parks (Sequoia and Kings Canyon). This trail can be a life-changer; it was for me.

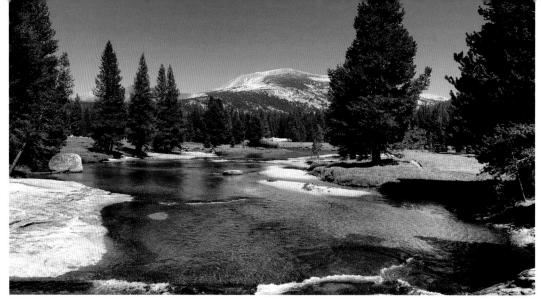

The walk along lovely Lyell Creek in Yosemite's High Sierra is a great introduction to the iconic John Muir Trail.

SPECIAL PROGRAMS

Like all US national parks, Yosemite offers a suite of ranger-led activities—interpretive programs, hikes, campfire talks, and the Junior Ranger Program. Find a list of scheduled activities in the park's free newspaper, at visitor centers, on the park's website (noted below) at "calendar," and on the NPS app. The Yosemite Conservancy, a nonprofit friends group, offers Outdoor Adventures and Yosemite Theater programs; see their website for a listing. The Ansel Adams Gallery offers photography walks. And the park's concessionaire offers bus tours and other programs; see their website and ask for information at park lodging facilities.

LOGISTICS

Visitor demand for Yosemite is high, but there's a relatively large infrastructure of facilities and services. The park includes 13 campgrounds scattered along the park's road system, and the vast wilderness portion of the park offers lots of room for backpacking trips (a permit is required). There are also eight lodging options, including the famous and historic Ahwahnee Hotel (arguably an attraction in itself). The park also includes the High Sierra Camps (described in the hiking section above). Commercial campgrounds and other lodgings are located outside the park, though sometimes at a distance. The park is open year-round, but long winters and deep snow limit the primary visitor season to May through September, with July and August especially popular. Waterfalls tend to peak in May, but high-elevation roads and trails may be snow-covered until mid-June or even July. Yosemite Valley can be hot and dry in the summer months. Free shuttle bus systems operate in Yosemite Valley, along the Tioga Road, and at the Mariposa Grove; these help relieve traffic congestion and offer shuttles to and from trailheads and other attractions. For the most up-to-date information, visit the park's official website: nps.gov/yose.

REFERENCES

Araoz, Gustavo. "How the World Heritage Convention Works." US National Park Service website (nps.gov/articles/how-the-world-heritage-convention-works.htm).

Ellin, Phyllis. 2022. "A History of Recent US World Heritage Nominations." *Parks Stewardship Forum* 38(3): 497–504.

Stott, Peter. 2011. "The World Heritage Convention and the National Park Service, 1962–1972." *The George Wright Forum* 28(3), 279–90.

———. 2012. "The World Heritage Convention and the National Park Service: The First Two Decades, 1972–1992." *The George Wright Forum* 29(1), 148–75.

———. 2013. "The World Heritage Convention and the National Park Service, 1993–2009." *The George Wright Forum* 30(1), 18–44.

US National Park Service. "World Heritage Sites in the United States: A Perspective from the National Park Service." US National Park Service website (nps.gov/articles/world-heritage-sites-in-the-us.htm).

———. "World Heritage in the United States" (nps.gov/subjects/internationalcooperation/worldheritage.htm).

———. *World Heritage Brochure* (nps.gov/subjects/internationalcooperation/world-heritage-brochure.htm).

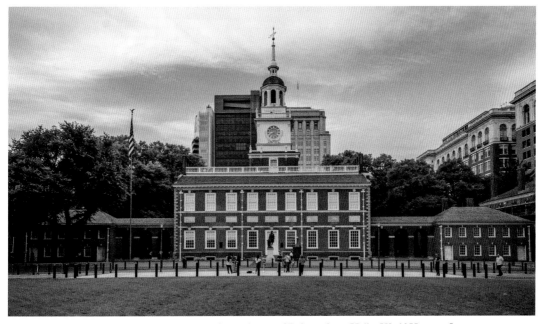

America's Declaration of Independence was signed in aptly named Independence Hall, a World Heritage Site.

PHOTO CREDITS

INDEX

ACKNOWLEDGMENTS

I'm indebted to several people and organizations for their help and advice in preparing this guidebook. US participation in the World Heritage Convention is administered by the US National Park Service Office of International Affairs, directed by Steve Morris and staffed by Jonathan Putnam and Phyllis Ellin. Thanks to Steve for his guidance throughout my preparation of this guidebook, and to all three for their careful review of the introductory chapter on the World Heritage Convention and its associated programs, including the World Heritage List. Appreciation is also expressed to the managers of the US World Heritage Sites for their careful review of the chapters I prepared on their sites, adding their personal and professional insights and correcting any errors or misinterpretations on my part. And of course I appreciate all their good work in protecting these sites and kindly making them available to visitors. Dr. Mechtild Rössler is former director of the World Heritage Centre, and I appreciate her generous endorsement of the book that appears on the back cover. Thanks to the editors and production staff at Globe Pequot, an imprint of Rowman & Littlefield, for supporting preparation of this guidebook and skillfully guiding the manuscript to publication; thanks, in particular, to Kate Ayers, assistant acquisitions editor, and Meredith Dias, senior production editor. As always, thanks to my wife (and frequent coauthor), Martha, for all her advice and kind assistance.

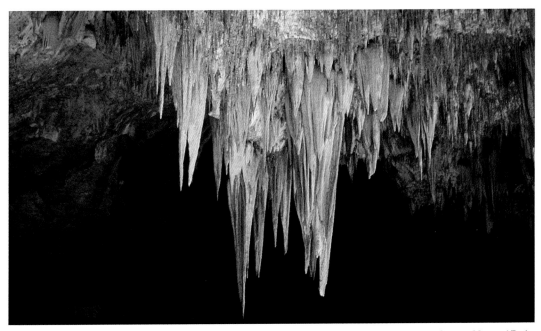

A group of huge stalactites known as The Chandelier hangs from the ceiling of the Big Room of Carlsbad Caverns National Park.

ABOUT THE AUTHOR

Robert Manning is Steven Rubenstein Professor (emeritus) at the University of Vermont, where he taught the history, philosophy, and management of national parks and conducted a long-term program of research for the US National Park Service. He's founding director of the university's Park Studies Laboratory and has authored a dozen scholarly books on the national parks. He's also written a half dozen popular books on national parks, hiking, and related topics, including *A Thinking Person's Guide to America's National Parks, America's National Heritage Areas: A Guide to the Nation's New Kind of National Park, Walks of a Lifetime in America's National Parks*, and *Walks of a Lifetime from Around the World*.

The author kayaking at Glacier Bay National Park and Preserve.